Pablo Picasso

1881–1973

Anatoli Podoksik

Pablo Picasso
1881–1973

Raphael's great superiority is the result of his capacity to feel deeply which, in his case, destroys form. The form in his works is what it should be in ours: only a pretext for the transmission of ideas, sensations, diverse poesies.

Honoré de Balzac. *Le Chef-d'œuvre inconnu.*

Grange
BOOKS

Text: Anatoli Podoksik
Page layout: Stéphanie Angoh

© Confidential Concepts, worldwide, USA
© Sirrocco, London, UK, 2004 (English version)
© 2004 Picasso Estate / Artists Rights Society, New York, USA

Published in 2004 by Grange Books
an imprint of Grange Books Plc
The Grange Kingsnorth Industrial Estate
Hoo, nr Rochester Kent ME3 9ND
www.Grangebooks.co.uk
ISBN 1 84013 570 0
Printed in Singapore

Contents

Life and work 7

Notes 142

Biography 144

Bibliography 156

Index 158

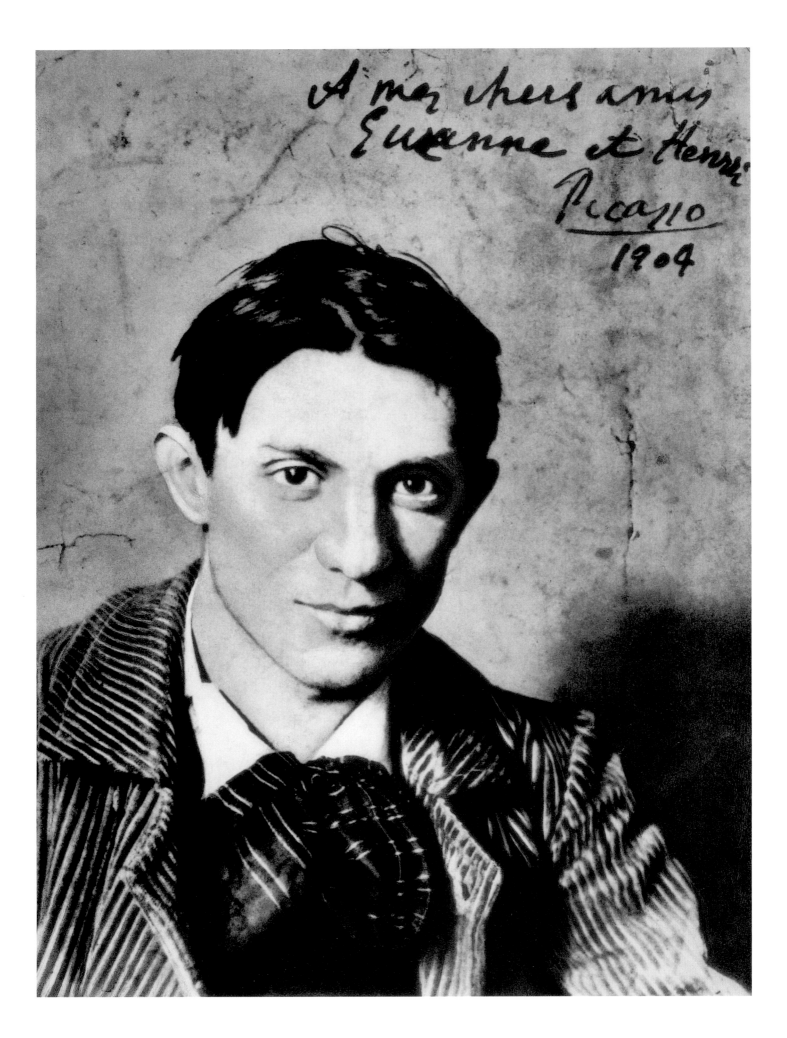

Life and Work

Although, as Picasso himself put it, he "led the life of a painter" from very early childhood, and although he expressed himself through the plastic arts for eighty uninterrupted years, the essence of Picasso's creative genius differs from that usually associated with the notion of "*artiste-peintre*". It might be more correct to consider him an artist-poet because his lyricism, his psyche, unfettered by mundane reality, his gift for the metaphoric transformation of reality are no less inherent in his visual art than they are in the mental imagery of a poet. According to Pierre Daix, "Picasso always considered himself a poet who was more prone to express himself through drawings, paintings and sculptures."[1] Always? That calls for clarification. It certainly applies to the 1930s, when he wrote poetry, and to the 1940s and 1950s, when he turned to writing plays. There is, however, no doubt that from the outset Picasso was always "a painter among poets, a poet among painters".[2]

Picasso had a craving for poetry and attracted poets like a magnet. When they first met, Guillaume Apollinaire was struck by the young Spaniard's unerring ability "to straddle the lexical barrier" and grasp the fine points of recited poetry. One may say without fear of exaggeration that while Picasso's close friendship with the poets Jacob, Apollinaire, Salmon, Cocteau, Reverdy, and Eluard left an imprint on each of the major periods of his work, it is no less true that his own innovative work had a strong influence on French (and not only French) twentieth-century poetry. And this assessment of Picasso's art — so visual and obvious, yet at times so blinding, opaque and mysterious — as that of a poet, is dictated by the artist's own view of his work. Picasso once said: "After all, the arts are all the same; you can write a picture in words just as you can paint sensations in a poem."[3] He even expressed the following thought: "If I had been born Chinese, I would not be a painter but a writer. I'd write my pictures."[4]

Picasso, however, was born a Spaniard and, so they say, began to draw before he could speak. As an infant he was instinctively attracted to the artist's tools. In early childhood he could spend hours in happy concentration drawing spirals with a sense and meaning known only to himself; or, shunning children's games, trace his first pictures in the sand. This early self-expression held out promise of a rare gift.

The first phase of life, preverbal, preconscious, knows neither dates nor facts. It is a dream-like state dominated by the body's rhythms and external sensations. The rhythms of the heart and lungs, the caresses of warm hands, the rocking of the cradle, the intonation of voices — that is what it consists of. Now the memory awakens, and two black eyes follow the movements of things in space, master desired objects, express emotions. Sight, that great gift, begins to discern objects, imbues ever new shapes, captures ever-broader horizons. Millions of as yet meaningless visual images enter the infantile

Pablo Picasso, Photograph, 1904.
Dedicated to Suzanne and Henri Bloch.

Portrait of the Artist's Father, 1896.
Oil on canvas and cardboard, 42.3 x 30.8 cm,
Museo Picasso, Barcelona.

Academic Study, 1895.
Oil on canvas, 82 x 61 cm,
Museo Picasso, Barcelona.

world of internal sight where they strike immanent powers of intuition, ancient voices, and strange caprices of instinct. The shock of purely sensual (visual-plastic) impressions is especially strong in the South, where the raging power of light sometimes blinds, sometimes etches each form with infinite clarity.

And the still mute, inexperienced perception of a child born in these parts responds to this shock with a certain inexplicable melancholy, an irrational sort of nostalgia for form. Such is the lyricism of the Iberian Mediterranean, a land of naked truths, of a dramatic "search for life for life's sake",[5] in the words of Garcia Lorca, one who knew these sensations

well. Not a shade of the Romantic here: there is no room for sentimentality amid the sharp, exact contours and there exists only one physical world. "Like all Spanish artists, I am a realist", Picasso would say later.

Gradually the child acquires words, fragments of speech, building blocks of language. Words are abstractions, creations of consciousness made to reflect the external world and express the internal. Words are the subjects of imagination, which endows them with images, reasons, meanings, and conveys to them a measure of infinity. Words are the instrument of learning and the instrument of poetry. They create the second, purely human, reality of mental abstractions.

In time, after having become friends with poets, Picasso would discover that the visual and verbal modes of expression are identical for the creative imagination. It was then that he began to introduce elements of poetic technique into his work: forms with multiple meanings, metaphors of shape and colour, quotations, rhymes, plays on words, paradoxes, and other tropes that allow the mental world to be made visible. Picasso's visual poetry attained total fulfilment and concrete freedom by the mid-1940s in a series of paintings of nudes, portraits, and interiors executed with "singing" and "aromatic" colours; these qualities are also evident in a multitude of India ink drawings traced as if by gusts of wind.

"We are not executors; we live our work."[6] That is the way in which Picasso expressed how much his work was intertwined with his life; he also used the word "diary" with reference to his work. D.-H. Kahnweiler, who knew Picasso for over sixty-five years, wrote: "It is true that I have described his œuvre as 'fanatically autobiographical'. That is the same as saying that he depended only on himself, on his *Erlebnis*. He was always free, owing nothing to anyone but himself."[7] Jaime Sabartés, who knew Picasso most of his life, also stressed his complete independence from external conditions and situations. Indeed, everything convincingly shows that if Picasso depended on anything at all in his art, it was the constant need to express his inner state with the utmost fullness. One may, as Sabartés did, compare Picasso's œuvre with therapy; one may, as Kahnweiler did, regard Picasso as a Romantic artist. However, it was precisely the need for self-expression through creativity that lent his art that universal quality that is inherent in such human documents as Rousseau's *Confessions*, Goethe's *The Sorrows of Young Werther* and Rimbaud's *A Season in Hell*. Let it also be noted that Picasso looked upon his art in a somewhat impersonal manner, took pleasure in the thought that the works, which he dated meticulously and helped scholars to catalogue, could serve as material for some future science. He imagined that branch of learning as being a "science of man — which will seek to learn about man in general through the study of the creative man."[8]

But something akin to a scientific approach to Picasso's œuvre has long been current in that it has been divided into periods, explained both by creative contacts (so-called influences, often only hypothetical) and reflections of biographical events (in 1980 a book called *Picasso: Art as Autobiography*[9] appeared). If Picasso's work has for us the general significance of universal human experience, this is due to its expressing, with the most exhaustive completeness, man's internal life and all the laws of its development. Only by approaching his œuvre in this way can we hope to understand its rules, the logic of its evolution, and the transition from one putative period to another.

The works of Picasso published in the present volume — the entire collection in Russian museums — cover those early periods which, based on considerations of style (less often subject matter), have been classified as Steinlenian (or Lautrecian), Stained Glass, Blue, Circus, Rose, Classic,

Study of a Nude, Seen from the Back, 1895.
Oil on wood, 22.3 x 13.7 cm,
Museo Picasso, Barcelona.

9

"African", proto-Cubist, Cubist (analytic and synthetic)... the definitions could be even more detailed. However, from the viewpoint of the "science of man", these periods correspond to the years 1900-1914, when Picasso was between nineteen and thirty-three, the time which saw the formation and flowering of his unique personality.

There is no question about the absolute significance of this stage in spiritual and psychological growth (as Goethe said, to create something, you must be something); the Russian collection's extraordinarily monolithic and chronological concentration allows us to examine, through the logic of that inner process, those works which belong to possibly the least accessible phase of Picasso's activity.

By 1900, the date of the earliest painting in the Russian collection, Picasso's Spanish childhood and years of study belonged to the past. And yet certain cardinal points of his early life should not be ignored.

Málaga must be mentioned, for it was there, on 25 October 1881, that Pablo Ruiz Picasso was born and there that he spent the first ten years of his life. Although he never depicted that town on the Andalusian coast, Málaga was the cradle of his spirit, the land of his childhood, the soil in which many of the themes and images of his mature work are rooted. He first saw a picture of Hercules in Málaga's municipal museum, witnessed bullfights on the Plaza de Toros, and at home watched the cooing doves that served as models for his father, a painter of "pictures for dining rooms", as Picasso put it. The young Pablo drew all of this (see *Pigeons*) and by the age of eight took up brush and oils to paint a bullfight (see *The Picador*). His father allowed him to draw the feet of the doves in his pictures, for the boy did this well and with real knowledge. He had a favourite pigeon with which he refused to part, and when the time came for him to start school, he carried the bird in a cage to classes. School was a place that demanded obedience — Pablo hated it from the first day and opposed it furiously. And that was how it would always be: a revolt against everything that felt like school, that encroached upon originality and individual freedom, that dictated general rules, determined norms, imposed outlooks. He would never agree to adapt to his environment, to betray himself or, in psychological terms, to exchange the pleasure principle for reality.

The Ruiz Picasso family never lived an easy life. Financial difficulties forced them to move to La Coruña, where Pablo's father was offered a position as teacher of drawing and painting in a secondary school. On the one hand, Málaga with its voluptuous and gentle nature, "the bright star in the sky of Mauritanian Andalusia, the Orient without poison, the Occident without activity" (as Lorca put it); and, on the other, La Coruña on the northern tip of the Iberian peninsula with its stormy Atlantic Ocean, rains and billowing fog. The two towns are not only the geographical, but also the psychological poles of Spain. For Picasso they were stages in life: Málaga the cradle and La Coruña the port of departure.

When the Ruiz Picasso family moved to La Coruña in 1891 with the ten-year-old Pablo, a somewhat rural atmosphere reigned over the town; artistically speaking, it was far more provincial than Málaga, which had its own artistic milieu to which Picasso's father belonged. La Coruña did, however, have a School of Fine Arts. There the young Pablo Ruiz began his systematic studies of drawing and with prodigious speed completed (by the age of thirteen!) the academic Plaster Cast and Nature Drawing Classes. What strikes one most in his works from this time is not so much the phenomenal accuracy and exactitude of execution (both of which are mandatory for classroom model exercises) as what the young artist introduced into this frankly boring material: a treatment of light and shade

Portrait of the Artist's Mother, 1896.
Pastel on paper,
Museo Picasso, Barcelona.

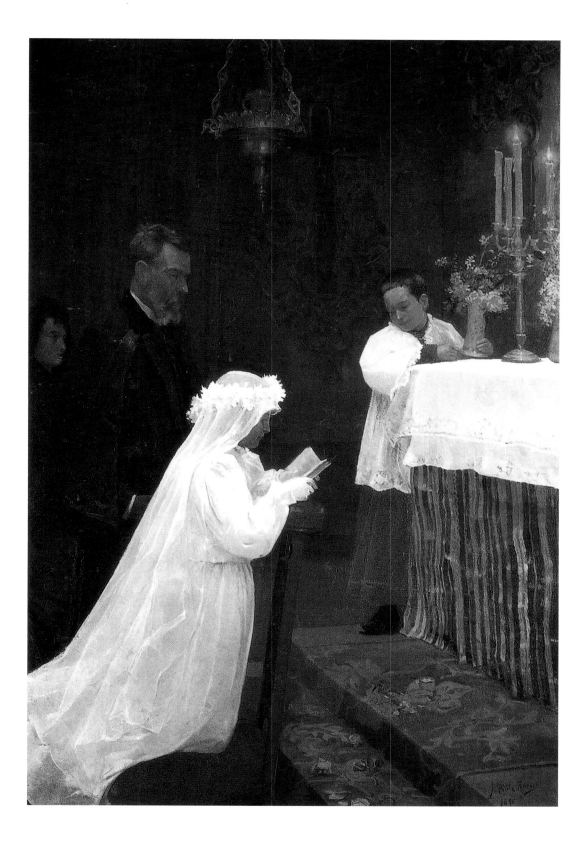

that transformed the plaster torsos, hands and feet into living images of bodily perfection overflowing with poetic mystery.

He did not, however, limit his drawing to the classroom; he drew at home, all the time, using whatever subject matter came to hand: portraits of the family, genre scenes, romantic subjects, animals. In keeping with the times, he "published" his own journals — *La Coruña* and *Asul y Blanco* (*Blue and White*) — writing them by hand and illustrating them with cartoons. Let us note here that the young Picasso's spontaneous drawings have a narrative, dramatic quality; for him the image and the word were almost identical. Both of these points are extremely significant to the future development of Picasso's art.

First Communion, 1896.
Oil on canvas,
Museo Picasso, Barcelona.

At home, under his father's tutelage — the good man was so impressed by his son's achievements that he gave him his palette, brushes and paints — during his last year in La Coruña, Pablo began to paint live models in oils (see *Portrait of an Old Man* and *Beggar in a Cap*). These portraits and figures, free of academic slickness, speak not only of the early maturity of the thirteen-year-old painter, but also of the purely Spanish nature of his gift: a preoccupation with human beings, whom he treated with profound seriousness and strict realism, uncovering the monolithic and "cubic" character of these images. They look less like school studies than psychological portraits, less like portraits than universal human characters akin to the Biblical personages of Zurbarán and Ribera.

Kahnweiler testifies that in his old age Picasso spoke with greater approval of these early paintings than of those done in Barcelona, where the Ruiz Picasso family moved in the autumn of 1895 and where Pablo immediately enrolled as a student of painting in the School of Fine Arts called La Lonja. But the academic classes of Barcelona had little to offer in the way of developing the talent of the young creator of the La Coruña masterpieces; he could improve his craftsmanship on his own. However, it seemed at that time that "proper schooling" was the only way of becoming a painter. So as not to upset his father, Picasso spent two more years at La Lonja during which time he could not but fall, albeit temporarily, under the deadening influence of academism, inculcated by the official school along with certain professional skills. "I hate the period of my training at Barcelona," Picasso confessed to Kahnweiler.[10]

However, the studio which his father rented for him (when he was only fourteen) and which gave him a certain freedom from both school and the stifling atmosphere of family relations was a real support for his independence. "A studio for an adolescent who feels his vocation with overwhelming force is almost like a first love: all his illusions meet and crystallize in it," writes Josép Palau i Fabre.[11] It was here that Picasso summarized the achievements of his school years by executing his first large canvas: *The First Communion* (winter of 1895-1896) — an interior composition with figures, drapery and still life, displaying beautiful lighting effects — and *Science and Charity* (beginning of 1897) — a huge canvas with larger-than-life figures, something akin to a real allegory. The latter received honourable

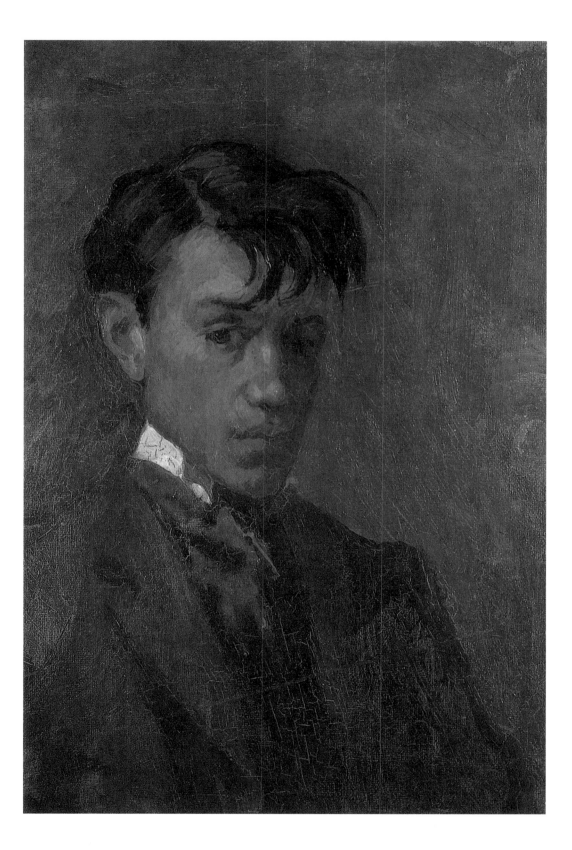

mention at the national exhibition of fine arts in Madrid and was later awarded a gold medal at an exhibition in Málaga.

If one assesses the early Picasso's creative biography from the standpoint of a *Bildungsroman*, then his departure from home for Madrid in the autumn of 1897, supposedly to continue his formal education at the Royal Academy of San Fernando, in fact ushered in the period of post-study years — his years of wandering. Moving from place to place, Picasso began the haphazard travel that is typical of this period and corresponds to the inner uncertainty, the search for self-identity and the urge for independence that denote the forming of personality in a young man.

Self-Portrait, 1896.
Oil on canvas,
Museo Picasso, Barcelona.

Pablo Picasso's years of travel consisted of several phases within a seven-year period, from sixteen to twenty-three, from his initial departure to Madrid, the country's artistic capital, in 1897, to his final settling in Paris, artistic capital of the world, in the spring of 1904. As it had during his first visit, on his way to Barcelona in 1895, Madrid to Picasso meant first and foremost the Prado Museum, which he frequented more often than the Royal Academy of San Fernando in order to copy the Old Masters (he was particularly attracted by Velazquez). However, as Sabartés was to note, "Madrid left a minimal imprint on the development of his spirit."[12] It might be said that the most important events for Picasso in the Spanish capital were the harsh winter of 1897-1898 and the subsequent illness that symbolically marked the end of his "academic career".

In contrast, the time spent at Horta de Ebro — a village in the mountainous area of Catalonia, where he went to convalesce and where he remained for eight long months (until the spring of 1899) — was of such significance for Picasso that even decades later he would invariably repeat: "All that I know, I learnt in Palarés's village."[13] Together with Manuel Palarés, a friend he had met in Barcelona, who invited him to live in the family home at Horta, Pablo carried his easel and sketchbook over all the mountain paths surrounding the village, which had preserved the harsh quality of a medieval town. With Palarés, Picasso scaled the mountains, spent much of the summer living in a cave, sleeping on beds of lavender, washing in mountain springs, and wandering along cliffs with the risk of plunging into the turbulent river far below. He experienced nature's power and came to know the eternal values of a simple life with its work and holidays.

Indeed, the months spent at Horta were significant not so much in the sense of artistic production (only a few studies and the sketchbooks have survived) as for their key role in the young Picasso's creative biography, with its long process of maturing. This basically short biographic period merits a special chapter in Picasso's *Bildungsroman*, a chapter portraying scenes of bucolic solitude spent amid pure, powerful and life-giving nature, reflecting feelings of freedom and fulfilment, offering a view of natural man and of life flowing in harmony with the epic rhythms of the seasons. But, as is always the case in Spain, this chapter also includes the brutal interplay of the forces of temptation, salvation and death — those "backstage players" in the drama of human existence.

Palau i Fabre, who described Picasso's first stay at Horta, notes: "It seems more than paradoxical — I nearly said providential — that Picasso should have been reborn, so to speak, at that time, when he left Madrid and the copying of the great masters of the past in order to strengthen his links with the primitive forces of the country."[14]

Another point: the value of the young Picasso's experience at Horta de Ebro is that it should provide scholars with food for thought, regarding both the question of his Mediterranean sources and Iberian archaism at a crucial moment of his formation in 1906 and his second trip to Horta ten years later (1909), which marked a new stage in his artistic development: Cubism. After his first stay at Horta de Ebro, a matured and renewed Picasso returned to Barcelona, which he now saw in a new light: as a centre of progressive trends and as a city open to modern ideas. Indeed, Barcelona's cultural atmosphere was, on the eve of the twentieth century, brimming with optimism. Calls for a Catalan regional renaissance, the agitation of anarchists, the latest technological wonders (the automobile, electricity, the phonograph, the cinema), and the novel idea of mass production served as a backdrop for the growing certainty in young minds that the new century would usher in an unparalleled flowering of the arts. It was therefore not

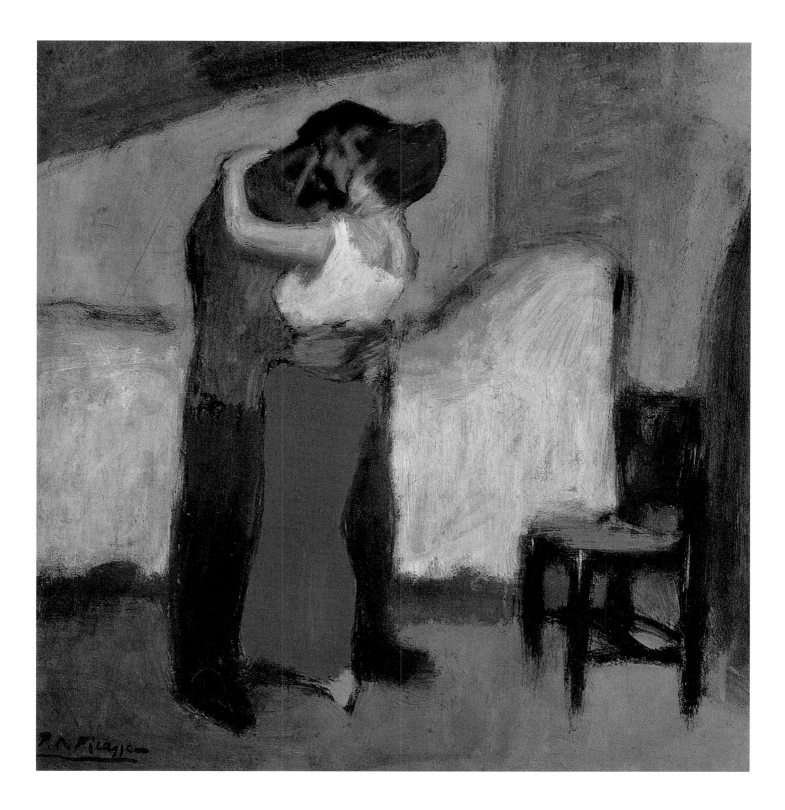

surprisingly in Barcelona, attracted to contemporary Europe, and not elsewhere in patriarchal, lethargic Spain, that Modernism appeared. The Catalan version of cosmopolitan, artistic *fin-de-siècle* tendencies combined a broad spectrum of ideological and aesthetic influences, from Scandinavian symbolism to Pre-Raphaelism, from Wagner and Nietzsche to French Impressionism and the style of popular Parisian journals.

Picasso, who was not yet eighteen, had reached the point of his greatest rebelliousness; he repudiated academia's anaemic aesthetics along with realism's pedestrian prose and, quite naturally, joined those who called themselves modernists, that is, the non-conformist artists and writers, those whom Sabartés called "the élite of Catalan thought" and who were grouped around the artists' café Els Quatre Gats.

Rendez-Vous (The Embrace), 1900.
Oil on cardboard, 52 x 56 cm,
The Pushkin Museum of Fine Arts, Moscow.

15

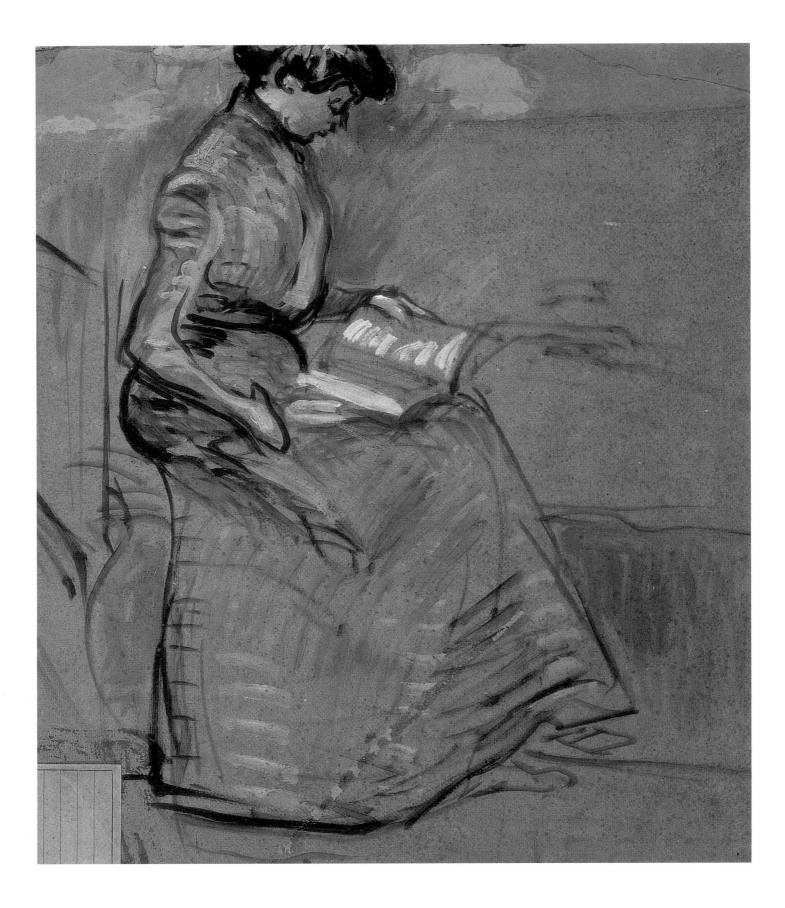

Reading Woman, 1900.
Oil on cardboard, 56 x 52 cm,
The Pushkin Museum of Fine Arts, Moscow.

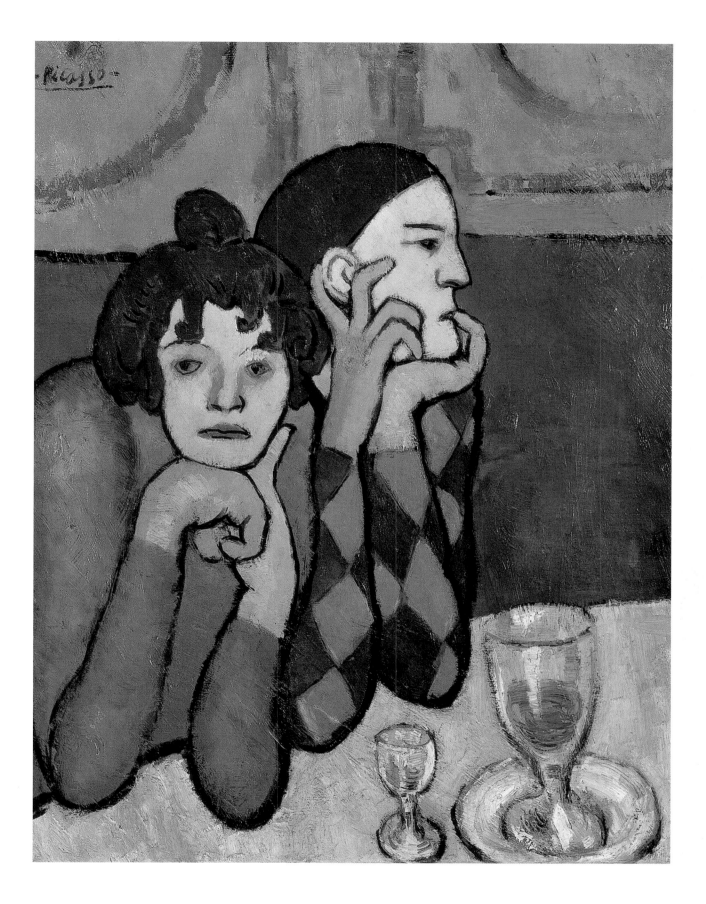

Harlequin and his companion
(*Two Performers*), 1901.
Oil on canvas, 73 x 60 cm,
The Pushkin Museum of Fine Arts, Moscow.

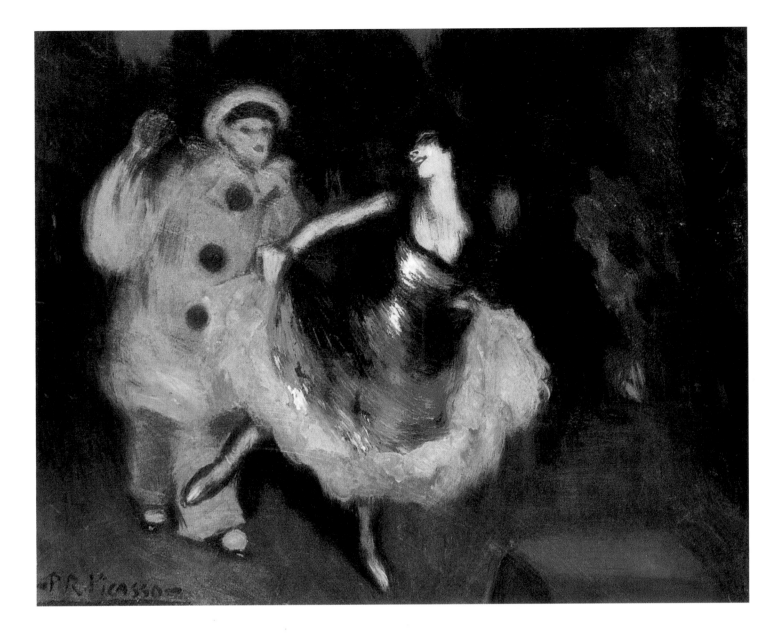

Pierrot and Dancer, 1900.
Oil on canvas, 38 x 46 cm,
Private Collection.

Much has been said concerning the influence of Barcelona modernism on Picasso's turn-of-the-century work, regarding which Cirlot notes: "Critics find it very useful to be able to talk about 'influences' because it enables them to explain something they do not understand by something they do, often completely erroneously and resulting in utter confusion."[15] Indeed, the issue of temporary influences of style (Ramón Casas, Isidro Nonell, Hermenegildo Angladay Camarasa), which tends only to obscure the authentic, natural elements of Picasso's profound talent, should be eliminated from our consideration. Barcelona modernism served to give the young Picasso an avant-garde education and to liberate his artistic thinking from classroom cliches. But this avant-garde university was also merely the arena for his coming-to-be. Picasso, who in 1916 compared himself with a tenor who reaches a note higher than the one written in the score,[16] was never the slave of what attracted him; in fact, Picasso invariably begins where influence ends. True, during those Barcelona years Picasso was much taken with the graphic "argot" practised by contemporary Parisian magazines (the style of Forain and Steinlen, who drew for *Gil Bias* and *La Vie Parisienne*, among others). He cultivated the same kind of sharp, trenchant style, which excludes the superfluous and yet, through the interplay of a few lines and dots, manages to give living expression to any character or situation, depicted through ironic eyes. Much later, Picasso was to say that in essence all good

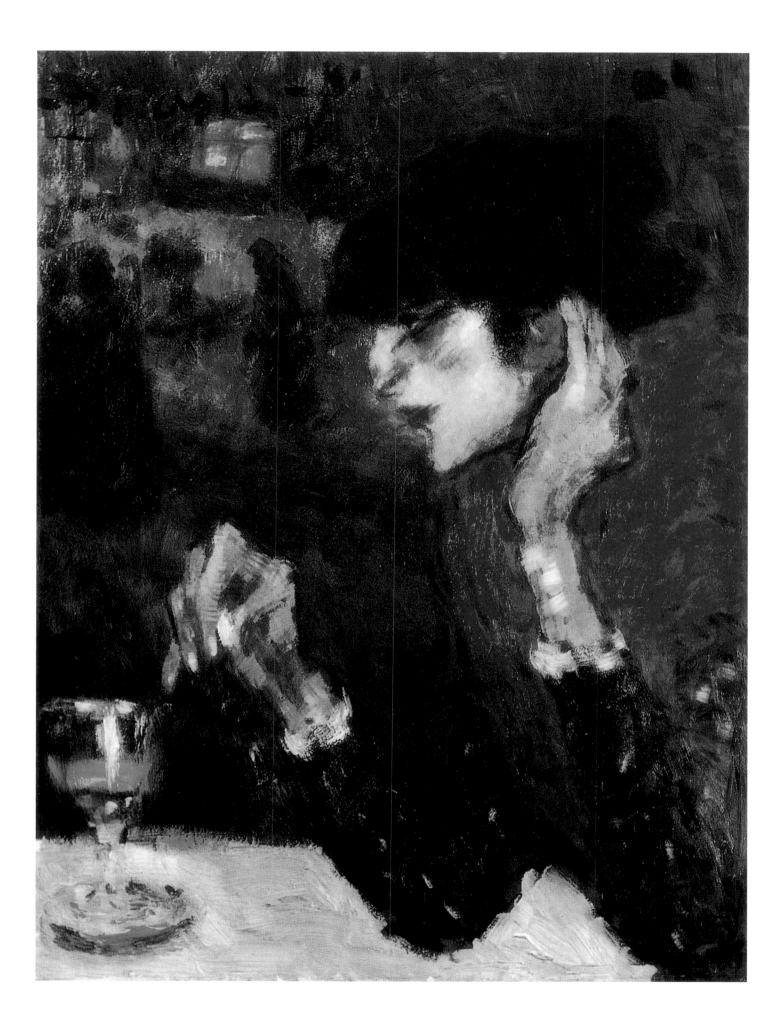

The Absinthe Drinker, 1901.
Oil on cardboard,
Melville Hall Collection, New York.

portraits are caricatures; during his Barcelona years he drew a wealth of caricature portraits of his avant-garde friends — as if caught up in a frenzy of graphic inspiration. He seems to have been trying to conquer his model, to subject it to his artistic will, to force it into the confines of a graphic formula. It is also true, however, that the literary, narrative quality of the boy Pablo's handwritten and illustrated La Coruña journals find their way into this new, modernistic form.

During 1899 and 1900 the only subjects Picasso deemed worthy of painting were those which reflected the "final truth": the transience of human life and the inevitability of death (see *The Kiss of Death*). Bidding the deceased farewell, a vigil by the coffin, a cripple's agony on a hospital bed, a scene in a death room or near a dying woman's bed: repentance of a neverdo-well husband... a long-haired poet steeped in sorrow... a lover on bended knee... a grief-stricken young monk. All these were versions of that same theme (the Museo Picasso in Barcelona has no less than twenty-five such graphic works and five painted sketches). Finally he executed a large composition called *The Last Moments*, which was shown in Barcelona at the beginning of 1900 and later that same year in Paris at the Exposition Universelle. Picasso then re-used the canvas for his famous Blue Period painting *La Vie* (the earlier work was only recently discovered thanks to X-ray examination).[17] Everything in *The Last Moments* is theoretical: its morbid symbolism, its characters (the young priest standing at the dying woman's bedside) and even its style, which bespeaks the artist's affinity with the "spiritual" painting of El Greco, then considered the founding father of the anti-academic, modernist tradition. That painting belonged to Picasso only to the extent that he himself belonged to that period, the period of Maeterlinck, Munch, Ibsen, Carrière. The marked resemblance between the Symbolist *The Last Moments* and *Science and Charity* of Picasso's school days is not accidental. Notwithstanding the youthful preoccupation with the theme of death, its quasi-decadent embodiment here creates the impression of an abstract exercise, as do many of the works Picasso produced in the Catalan modernist style. Decadence was foreign to Picasso; he inevitably looked at it with an ironically raised eyebrow, as a manifestation of weakness and lifelessness. He passed too rapidly through modernism and, having exhausted it, found himself at a dead end, without a future. It was Paris that saved him, and after only two seasons there he wrote to his French friend Max Jacob in the summer of 1902 about how isolated he had felt in Barcelona among his friends, "local painters" (he sceptically underlined these words in his letter), who wrote "very bad books" and painted "idiotic pictures".[18]

Picasso arrived in Paris in October 1900. He moved into a studio in Montparnasse, where he remained until the end of the year. Although his contacts were limited to the Spanish colony, and even though he involuntarily looked at his surroundings with the eyes of a highly curious foreigner, Picasso immediately and without hesitation found his subject, becoming a painter of Montparnasse.

A joint letter by Picasso and his inseparable friend, the artist and poet Carlos Casagemas, bears the date of his nineteenth birthday (25 October 1900). Written a few days after Pablo's arrival in Paris, it records their Parisian life; the pair inform a friend in Barcelona of their intensive work, of their intention to exhibit paintings at the Salon and in Spain, of their going to café-concerts and theatres in the evening; they describe their new acquaintances, their leisure activities, their studio. The letter exudes high spirits and reflects their intoxicating delight with life: "If you see Opisso, tell him to come, since it's good for saving the soul — tell him to send Gaudí and the Sagrada Familia to hell... Here there are real teachers everywhere."[19]

The Absinthe Drinker, 1901.
Oil on canvas,
The Hermitage, St. Petersburg.

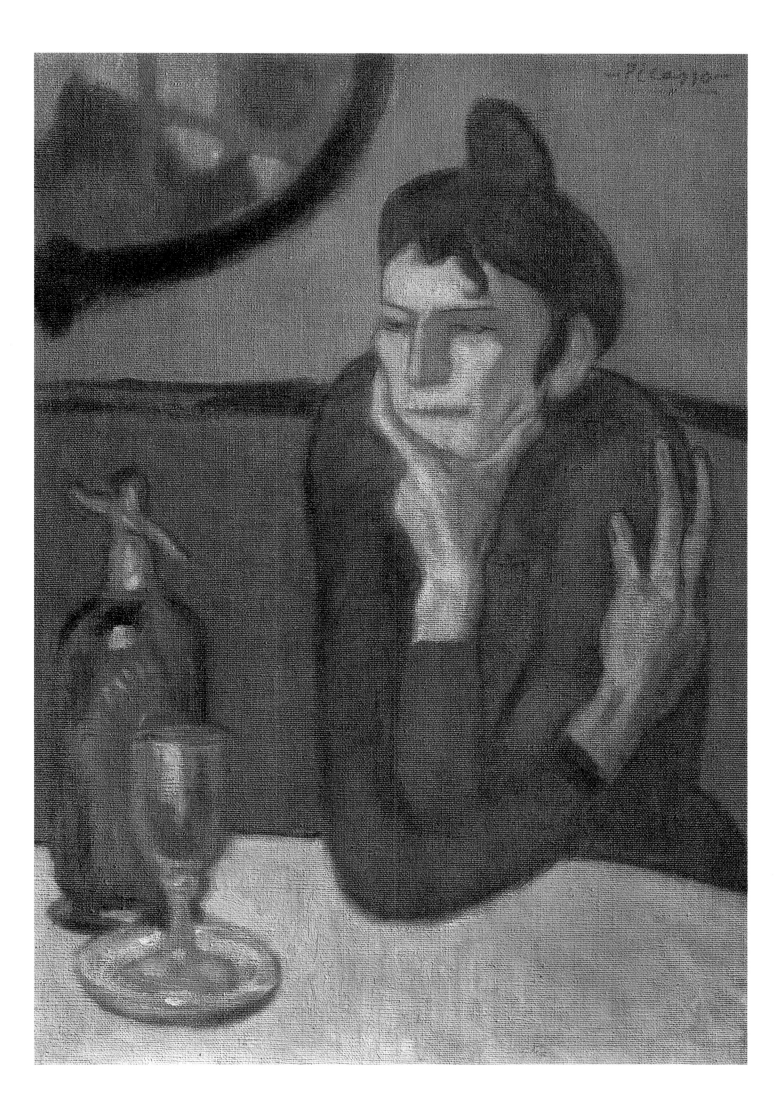

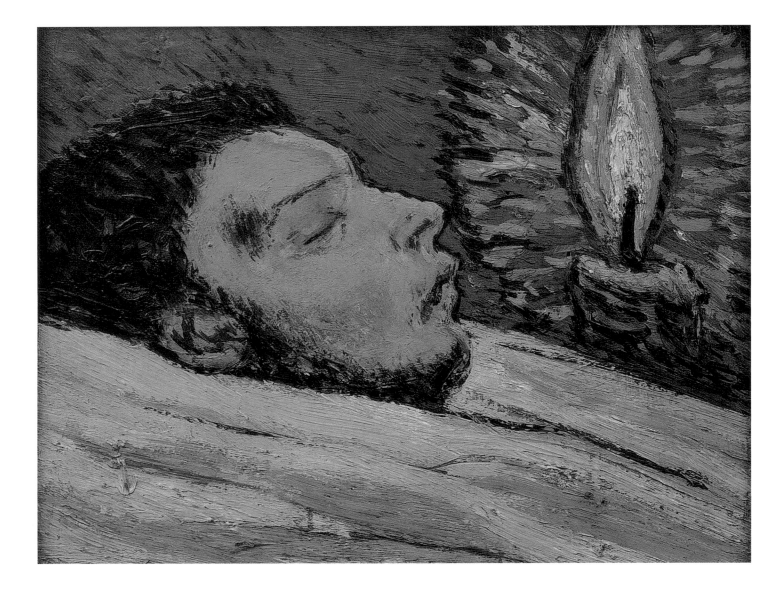

Vast exhibition halls of paintings at the Exposition Universelle (number 79 in the Spanish section was: Pablo Ruiz Picasso, *Les Derniers Moments*), the retrospective *Centennale* and *Décennale de l'art français*, great shows with paintings by Ingres and Delacroix, Courbet and the Impressionists, up to and including Cézanne; the gigantic Louvre with its endless halls of masterpieces and sculptures of ancient civilizations; whole streets of galleries and shops showing and dealing in new-style painting… "More than sixty years later," recalls Pierre Daix, "he would tell me of his delight at what he then discovered. He suddenly took measure of the limits and stiffness of Barcelona, Spain. He did not expect it."[20] He was staggered by the abundance of artistic impressions, by this new feeling of freedom, "not so much of customs," noted Daix, "…as of human relations."[21]

Picasso's "real teachers" were the older painters of Montmartre, who helped him discover the broad spectrum of local subject matter: the popular dances, the café-concerts with their stars, the attractive and sinister world of nocturnal joys, electrified by the glow of feminine charms (Forain and Toulouse-Lautrec), but also the everyday melancholy and nostalgic atmosphere of small streets on the city outskirts, where the autumn darkness heightens the plaintive feeling of loneliness (Steinlen — with whom, Cirlot says, Picasso became personally acquainted). However, it was not because of Zola's mystical appeal (which Anatole France said inspired Steinlen), nor due to a taste for bizarre life-styles, nor due to the satirical impulse that Picasso entered his so-called Cabaret period. This subject matter attracted him because it afforded the possibility to express the view that life is a

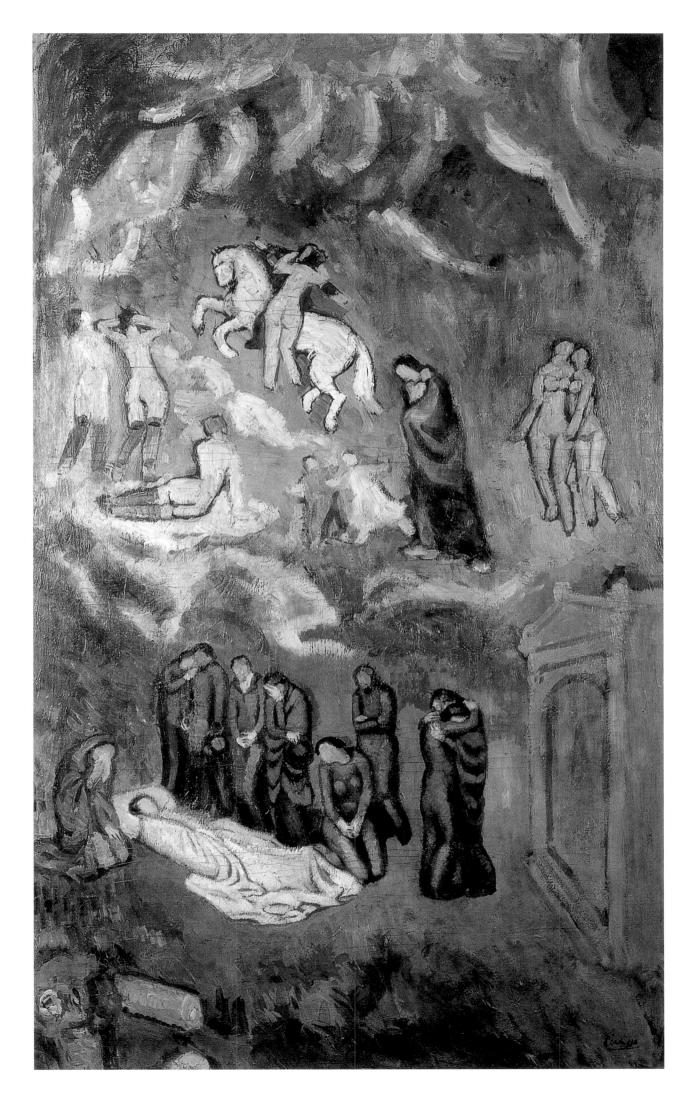

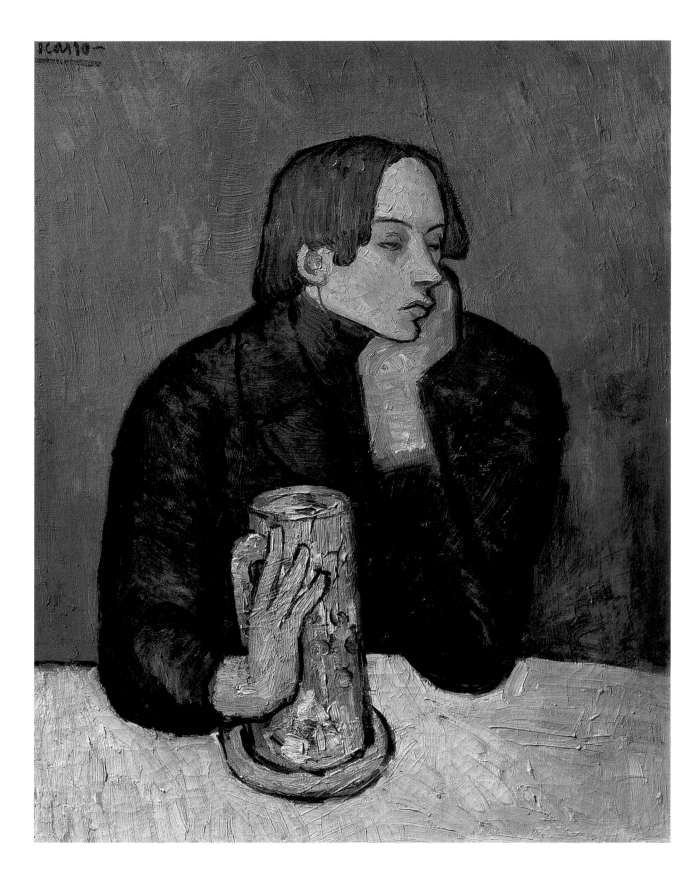

Portrait of the poet Sabartés (*Glass of Beer*),
1901.
Oil on canvas, 82 x 66 cm,
The Pushkin Museum of Fine Arts, Moscow.

drama and that its heart is the sexual urge. And yet the direct, expressive and
austerely realistic treatment of these subjects reminds one not so much of
French influences as of Goya's late period (for instance, such pictures as
Third of May, 1808).

This is especially true of the Moscow canvas *The Embrace* — the
absolute peak of the 1900 Paris period and undoubtedly one of the young
Picasso's masterpieces. Ten years prior to the creation of that painting, in
1890, Maurice Denis jotted down what was to become a famous aphorism:
"A picture — before being a horse, a nude, or an anecdote — is essentially a

flat surface covered with colours assembled in a certain order."[22] This, however, is especially hard to keep in mind with regard to Picasso's *The Embrace*, so alien is it to any aesthetic preconsideration, so triumphant is the internal over the external. This is all the more amazing considering that, as "a flat surface covered with colours assembled in a certain order", the picture is close to the works of the Nabis (perhaps not so much Denis himself as Vuillard and Bonnard) in its muted, modest colours, the silhouetted patches, the private, intimate atmosphere. But this unaffected exterior hides a pathetic, passionate emotion, and that, of course, is neither the Nabis nor even Toulouse-Lautrec.

Yakov Tugendhold saw the embracing couple as a "soldier and woman",[23] while Phoebe Pool described them as "a workman and a prostitute".[24] Daix reads the scene differently: "Home from work, the couple are together again, united in frank eagerness, in healthy sensuality and human warmth."[25] Indeed, *The Embrace* is no meditation on the habits of society's lower orders, but speaks of a feeling so lyrical and profound as to be extremely moving. Picasso's bold and inspired brush spurned superfluous details, leaving on the flat surface, as it were, the pollen or aroma of life itself, that is, an image of supreme poetic realism. In that same autumn of 1900, in Paris, the artist produced three other versions of the same motif: two of them (which clearly preceded the third) titled *Lovers in the Street*, and the third called *Brutal Embrace*, which, while similar in composition and staffage, is antithetical to the Moscow picture in the shocking vulgarity of the subject, the number of genre details, and the sarcastic mood. Picasso's artistic expression was direct in character, and whatever his means, they always corresponded exactly to his intentions. At the age of nineteen he examined the theme of sexual relations. His mind operated in contrasts: Le Moulin de la Galette at night is the public sale of love; the women of his café-concerts are as decorative as artificial flowers; the idylls on the outer boulevards are somewhat clumsy in the tenderness of their tight embraces; and love in a poor garret is not the same as in the almost identical room of an experienced priestess of Venus.

Love was also the underlying reason for the artist's sudden departure — one is tempted to say flight — from Paris in December 1900: his friend Casagemas's ill-fated affair. Scholars of Picasso's works began to study the circumstances of this tragic love affair once it became clear that the artist produced paintings in Casagemas's memory both at the initial stage of his Blue Period (1901) and at its height (1903). Casagemas shot himself in a café on the Boulevard de Clichy in February 1901, after returning to Paris despite Picasso's attempts to help him find a measure of peace under the Spanish sun.

Picasso was at that time still in Madrid, where he had undertaken the publication of a magazine called *Arte Joven* (*Young Art*), four issues of which had appeared, and also painted society scenes and female portraits that emphasized the repulsive features of his models: their rapaciousness or doll-like indifference. Daix believes this was not without influence on Casagemas's drama.[26]

This short "society" period (to a certain extent, a young artist's reaction to the temptations of public recognition) ran itself out by the spring of 1901 when, after a stay in Barcelona, Picasso returned to Paris. An exhibition of his works was planned in the gallery of the well-known Art Nouveau dealer Ambroise Vollard.

Throughout May and the first half of June 1901, Picasso worked very hard, on some days producing two or even three paintings. He "had begun where he had broken off six months before"[27] but the scope of his Parisian

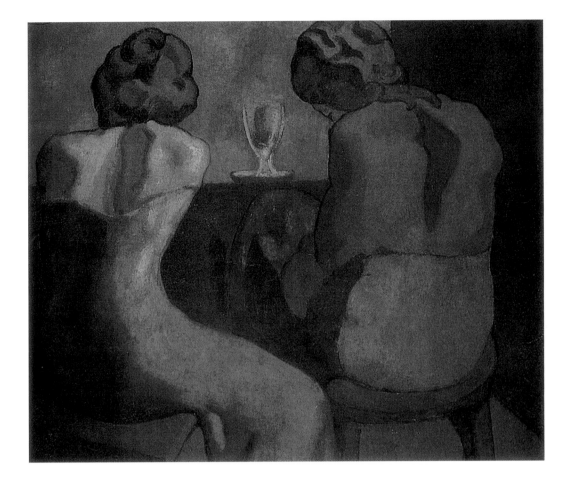

subject matter was now broader, while his technique was more avant-garde. Picasso painted not only the stars of the café-concerts and the courtesans of the demimonde, but also urban scenes: women selling flowers, upper-class couples out for a walk, crowds at the races, interiors of cheap cafés, children in their best Sunday clothes walking in the Luxembourg Gardens, passengers on double-decker buses sailing high above the Seine and the sea of Parisian squares. He used the Impressionist freedom of sinuous brushstrokes, the Japanese precision of Degas's compositions and Toulouse-Lautrec's posters, the heightened, exalted vividness of Van Gogh's colours, heralding the coming of Fauvism, which manifested itself fully only in 1905. But Picasso's so-called pre-Fauvism of the spring of 1901 was, once again, of a purely aesthetic, rather than of a subjective, psychological nature. As Zervos was justly to note: "Picasso took great care not to fall in with the eccentricities of Vlaminck, who used vermilions and cobalts in order to set fire to the Ecole des Beaux-Arts. Picasso used pure colours only to satisfy his natural inclination to go every time as far as his nervous tension would allow."[28]

Picasso exhibited over sixty-five paintings and drawings at the Vollard exhibition which opened on 24 June. Some had been brought from Spain, but the overwhelming majority were done in Paris. Jarring, often shocking subjects, spontaneous, insistent brushwork, nervous, frenzied colours (certainly not joyous, as Daix claims), typify the so-called Vollard style. But even though the exhibition was a financial success, many of the pre-Fauve Vollard-style paintings would be painted over in the very near future, thereby reflecting a change in their maker's mood.

"He that increaseth knowledge increaseth sorrow." As if in response to those words from Ecclesiastes, Picasso's outlook gradually took on tragic dimensions — the result of his personal experiences, but also predetermined by natural psychological development during this formative period. This new pessimistic outlook, firmly established by the autumn of 1901, may

Prostitutes at the Bar, 1902.
Oil on canvas, 80 x 91.4 cm,
Hiroshima Museum of Art, Hiroshima.

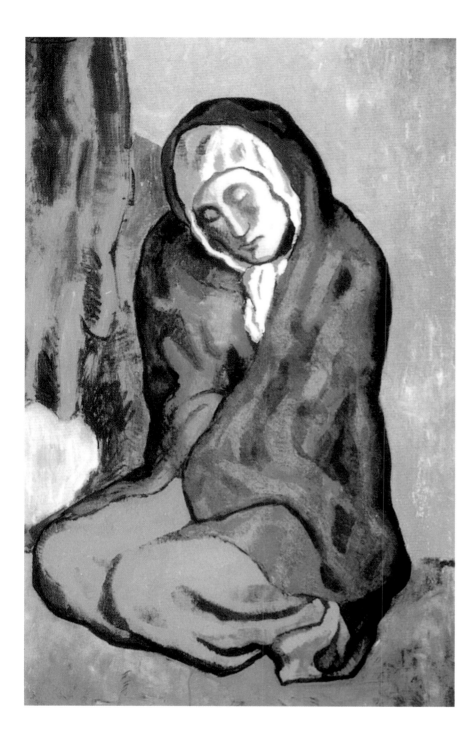

explain what Daix called the "violation of material appearances." [29] Indeed, Picasso's creative endeavours now turned towards the art of internally dictated, conceptual, generalized images. Instead of many subjects taken from the trivial external world, he concentrated on a few images, on his subjective inner reality rather than on the objectively tangible. Instead of responding to life with spontaneous and sharpened Fauve-like colours, he now painted somewhat abstract picturesque allegories with poetic and symbolic details and a compositional structure based on colour and rhythm. Here we find two canvases dating from this period — the autumn of 1901 — *Harlequin and His Companion* and *The Absinthe Drinker*. Both deal with one of the early Picasso's favourite subjects: people in cafés. From the viewpoint of style they are sometimes characterized as examples of the so-called Stained Glass Period (because of the powerful, flexible dark line dividing the major colour planes, typical of work of that period). This style of painting had close aesthetic ties with the Art Nouveau (it derives from Gauguin's Cloisonnism and the arabesques of Toulouse-Lautrec's posters —

Poverty-Stricken Woman, 1902.
Oil on canvas, 101.2 x 66 cm,
Hiroshima Museum of Art, Hiroshima.

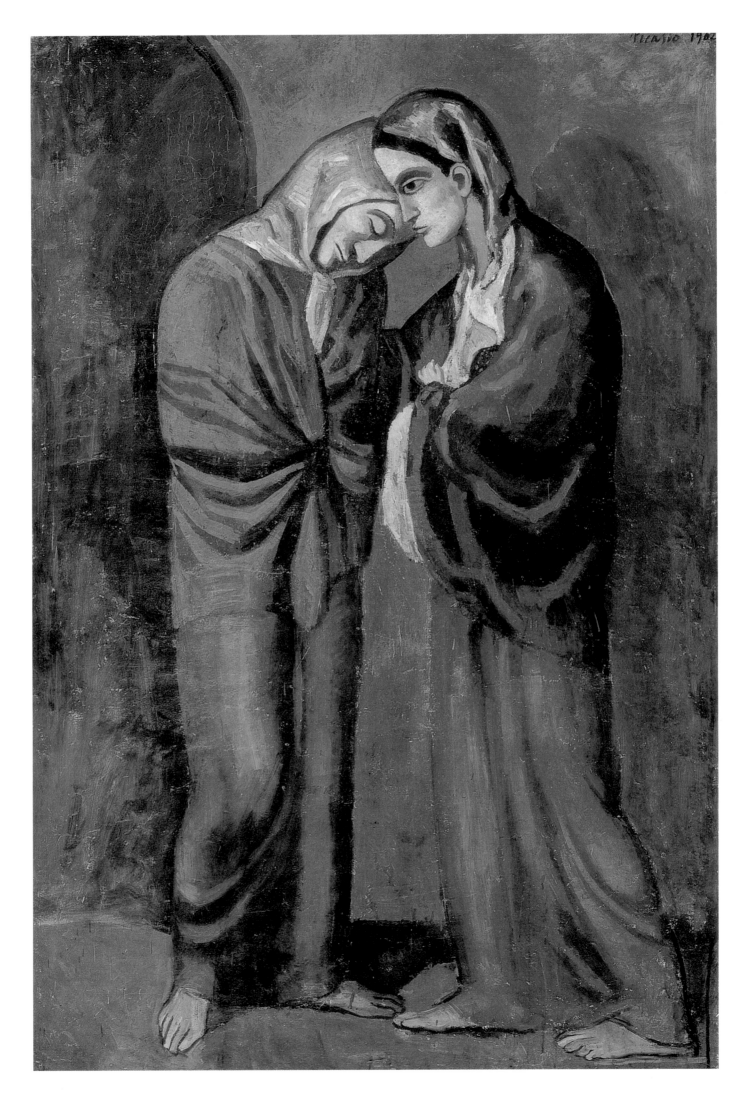

28

something Picasso rated highly at that time); here, however, it is a poetic testament to the predominance of the intellectual principle in Picasso's work, to concentrated and generalized thought. Earlier (from 1899 to the first half of 1901) when depicting a café scene in the style of turn-of-the-century art, Picasso was attracted by the modern city's "physiology", by the anomalies of actual existence; now, in the second half of 1901, the social aspect retreats far into the background, serving only to set off the universal symbolic meaning of the painted image. Thus, in *Harlequin and his Companion* (p.17) one recognizes the concrete, tangible reality of that period: it is set in a café that served as a kind of employment bureau for second-rate actors, a market where they were bought and sold. In the novel written about their lives by Yvette Guilbert, the famous café-concert star immortalized by Toulouse-Lautrec, we find a description of one such café and its clients that perfectly suits the characters of Picasso's painting: "These happy unemployed comics, these jokers in the streets, these singers, declaimers and eccentric dancers, all those who in the evenings, under lights, tomorrow perhaps, in some run-down place will share laughter and joy with a public that believes them to be happy and envies them… And they come here every day, to the Chartreuse, seeking any engagement, eyes open for the agent who will enter the premises… in need… of a soliloquist or a singer.

For there are also the women.

Poor girls!

Livid in the bright day's cruelty, with an obligatory smile, fleeting or frozen, reddened or grape-coloured, pallid from cheap powder, their eyelids blue, their eyes encircled by pencilled dark spectacles, they, too, standing on the sidewalk, attend upon the pleasure of the showman, who will be kind enough to make use of what remains of a youthfulness almost gone and a dying voice."[30]

But Picasso's café has no name, it is a shelter for the homeless. Harlequin, that artistic, nervous gymnast with the white painted face of a tragic Pierrot, and his companion, whose face is that of either a ghost or a Japanese Noh mask — these are somehow not people, but rather the divided bohemian soul made wise by the banality of "*commedia della a vita*". Certain contemporary scholars find an analogy between these, the earliest of Picasso's Italian comedy characters and the symbolic poetry of Verlaine's later years.[31] But speaking in broader terms, Picasso's own artistic expression is now subjected to the poetic principle; the eye reads the picture like a poem, becoming immersed in emotions and the symbolic association of colours, grasping the meaning of congruities, enchanted by the play of rhyming lines which, like the painting's colours, are cleansed of everyday prose and endowed with an exciting music.

There is, however, nothing accidental about the large unfinished glass of absinthe standing on the table before Harlequin: the bitter bright-green liqueur is an allegory of life's sorrows, additional testimony to the damnation of Harlequin-the-artist. In this period the idea of the *poète* or *artiste maudit* preoccupied Picasso. It dovetailed with his ideal of authentic art, with Paris, with the contemporary, with his own life. Baudelaire, Verlaine, Rimbaud, Gauguin, Van Gogh, Toulouse-Lautrec were all *maudit* — it was something inseparable from bohemian life and alcohol. As early as this painting, Picasso hit upon the idea of alcohol, first as a means of replacing the banality of the everyday environment with a different, internal, spiritual one; second, as a parallel, in its burning quality, to the *maudit* artists' art and poetry (Apollinaire, who had a spiritual bond with Picasso, called his first volume of poems, published in 1913, *Alcools*); third, as an elixir of wisdom, but also of mortal melancholy.

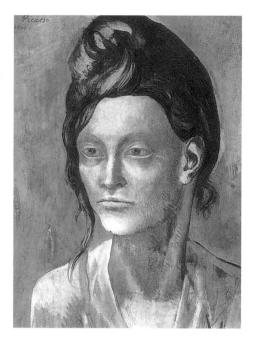

The Visit (*Two Sisters*), 1902.
Oil on canvas pasted on panel, 152 x 100 cm, The Hermitage, St. Petersburg.

Woman With a Helmet of Hair (*The Acrobat's Woman*), 1904.
Gouache on cardboard, 42.8 x 31 cm.
The Art Institute of Chicago, Chicago.

In that sense, *The Absinthe Drinker* is an even purer expression — both of these ideas and of a poetic form in which words are few but thoughts soar freely to transcend the mere theme of the painting.

The colours here are as coarse and poor as a hair shirt, but they are not prosaic; our mind's eye sees through the bleary blue, the hoarse red, the pale yellow and divines their noble essence: azure, crimson, gold. The visible in the painting is an allegory that impresses the viewer with its own, symbolic and universal aspect: the green absinthe represents bitterness and sorrow; the wall mirror, that symbolic screen of the woman's inner world, reflects vague blotches of colour — her thoughts; the woman herself, steeped by absinthe in numbness, hallucinations, and depression, sits in a hunched-up, twisted pose, reminding us of a Notre Dame gargoyle; she seems less a solitary drunkard in some forsaken Paris bar than the expression of the world's evil and its alchemic attribute — the bitter green elixir shimmering at the bottom of the glass.

In formal terms, *Harlequin and His Companion* and *The Absinthe Drinker* (p. 19 and 21) continue Gauguin's line, but emotionally and ideologically, they follow Van Gogh, who perceived his *Night Café* as a horrible place, "a place where one can perish, go insane, commit a crime."[32]

Generally speaking, one sees here the predominance of form in the composition and the sentimental themes that Daix defined as two of the three essentials of the new style ripening in Picasso throughout the second half of 1901.[33] The third — the use of monochromatic blue — gave this new style its name: the Blue Period. It came into its own in late 1901 and lasted to the end of 1904.

Even though Picasso himself repeatedly insisted on the inner, subjective nature of the Blue Period, its genesis and, especially, the monochromatic blue were for many years explained as merely the results of various aesthetic influences. When, however, after sixty-five years of obscurity, the paintings prompted by the death of his friend Casagemas in the autumn of 1901 saw the light of day, the psychological motive behind the Blue Period seemed to have been discovered.

"It was when thinking that Casagemas was dead that I began to paint in blue," Picasso told Daix.[34] And yet, the artist's "blue" thoughts about his friend's death followed six months after the event, and certain stylistic features and characteristic images of the almost-blue pictures of the so-called Casagemas death cycle were clearly formulated in paintings inspired by the artist's visit to the Parisian St. Lazare women's prison in the autumn of 1901. Considering Picasso's previous artistic history, these facts prompt us to see the events of his day-to-day existence only as the "developers" of internal crises marking major stages of his individuality, his coming-to-be, not as the actual reasons for these crises.

Carl Gustav Jung, the father of analytical psychology, interpreted Picasso's Blue Period as a descent into hell,[35] which corresponds to that special, inner state of adolescence in which the unconscious, life's bitter truths, and the heart of evil are all urgently considered issues. Sabartés, who was of the same age as Picasso and shared his views, confirmed this analysis when explaining the state of mind of their early youth: "We live through an age when each of us has to do everything inside himself, a period of uncertainty which we all see only from the viewpoint of our own misery. That our life with its torments and sufferings goes through such periods of pain, of sorrow, and of misery constitutes the very basis of his [Picasso's] theory of artistic expression."[36]

In reality this "anti-theoretical theory" (as Sabartés called it) was the summation of Picasso's views, shared by Sabartés and expressed by him in

La Vie (Life), 1903.
Oil on canvas, 196.5 x 128.5 cm,
The Cleveland Museum of Art, Cleveland.

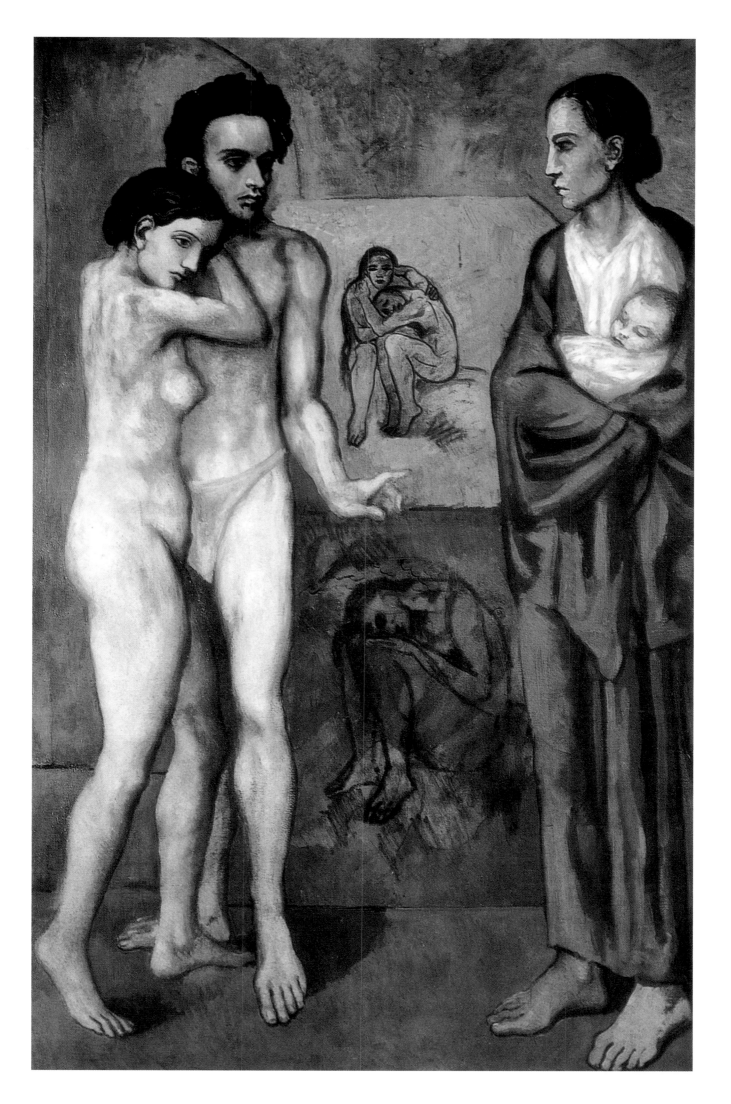

Nude Woman with Crossed Legs, 1903.
Pastel, 58 x 44 cm,
Private Collection.

the following manner: "If we insist on the artist's sincerity, we do not admit that it can exist free of pain… He [Picasso] believes Art to be the child of Sorrow and Pain… He believes Sorrow lends itself to meditation, while Pain is the substance of life."[37] But what is both amazing and unique here is that Picasso, seized by this viewpoint (known to all Romantics and called *Weltschmerz,* the leitmotif of a whole cultural era at the end of the eighteenth and beginning of the nineteenth century), between the ages of twenty and twenty-three, expressed it through a purely poetic metaphor — blueness.

Blue is cold, it is the colour of sorrow, grief, misfortune, inner pain; but blue is also the most spiritual of colours, the colour of space, thoughts and dreams that know no confines. Blue is beloved by poets.

Rainer Maria Rilke stood studying the paintings at the Salon d'Automne in 1907 and imagined someone writing the history of the colour blue in paintings throughout the ages — now spiritual, now gallant, now devoid of allegorical meaning. In one of his poems of the 1900s Picasso wrote, "You are the best of what exists in the world. The colour of all colours… the most blue of all the blues."

Rilke's exercise can be applied to the blue of Picasso's palette and to poetry alike, for the Blue Period as a whole, throughout its entire three years, resulted in an art that was heterogeneous and complex, not only in style but also in content.

The *Portrait of the poet Sabartés* (p.24), according to Sabartés himself, belongs to the time of the Blue Period's inception; it was created in Paris in October-November 1901, and depicts Picasso's friend from his Barcelona days when he had just arrived in Paris, a gigantic, dull, autumnal city in which he felt lost, homeless and alone. That is how the artist saw him when, arriving late for their meeting, he observed his friend sadly waiting in a café with a glass of beer. "In a glance, before I noticed him, he caught my pose. He then shook my hand, sat down, and we began to talk," Sabartés recalled forty years later in his book *Picasso, Portraits et Souvenirs*.[28] The portrait was done in the subject's absence, from memory, or, more accurately, from the inner model in the artist's mind, which had eclipsed the actual facts of the meeting. This model — the figure in the café — is a kind of commentary on a painted story. This time it is about the solitude of a poet, a myopic dreamer whose melancholy temperament and evident inclination for Northern symbolism (respected in Barcelona) are represented here by a huge mug of beer (instead of a glass of some liquor). To Sabartés the portrait looked like his own reflection in the blue waters of a mystical lake; in it he recognized the spectre of his solitude. For Picasso this was not simply the portrait of a friend, but the image of a poet which, in his view, was a mark of special distinction, a fact emphasized by the title he himself gave to the painting when Sergei Shchukin acquired it: *Portrait of the Poet Sabartés*. This is probably the first canvas by Picasso with so much blue (although it still stops short of being completely monochromatic), even though it is required neither by the subject's colouring nor by the play of light. The bluish tones range here from turquoise to the deepest aquamarine. This, it may be said, is the picture's actual subject, an expression of the state of mind of the poet, whose grief was a mark of his sincerity. The blue colour is abstract and universal, it makes Sabartés's figure, seated at a café table, a symbol of poetic melancholy that looms over the world's empty horizon.

Blue is the painting's metaphor for sadness and sorrow; however, towards the end of 1901, the desire to express these feelings more directly motivated Picasso to turn to sculpture. The predominance of form in his paintings, mentioned by Daix, undeniably testifies to this interest; Picasso began to sculpt not only because the medium made his plastic idea more concrete, but also because it corresponded to his need to impose strict limits on himself, to achieve the most ascetic means of expression. As everything but the lonely human figure gradually disappears from Picasso's painting, and as the tonality becomes a fully monochromatic blue, his inner model, static and tightly closed in on itself (for example, the figure in the café), arrives at a sculptural idea expressing depression. The painting *A Drunken Woman Drowsing*, produced in Barcelona during the first months of 1902, is a noteworthy instance of that development. In subject matter it continues along the lines of the Paris absinthe drinkers, yet its plastic character leads to the major work of 1902, *The Visit* (p.28): the bent,

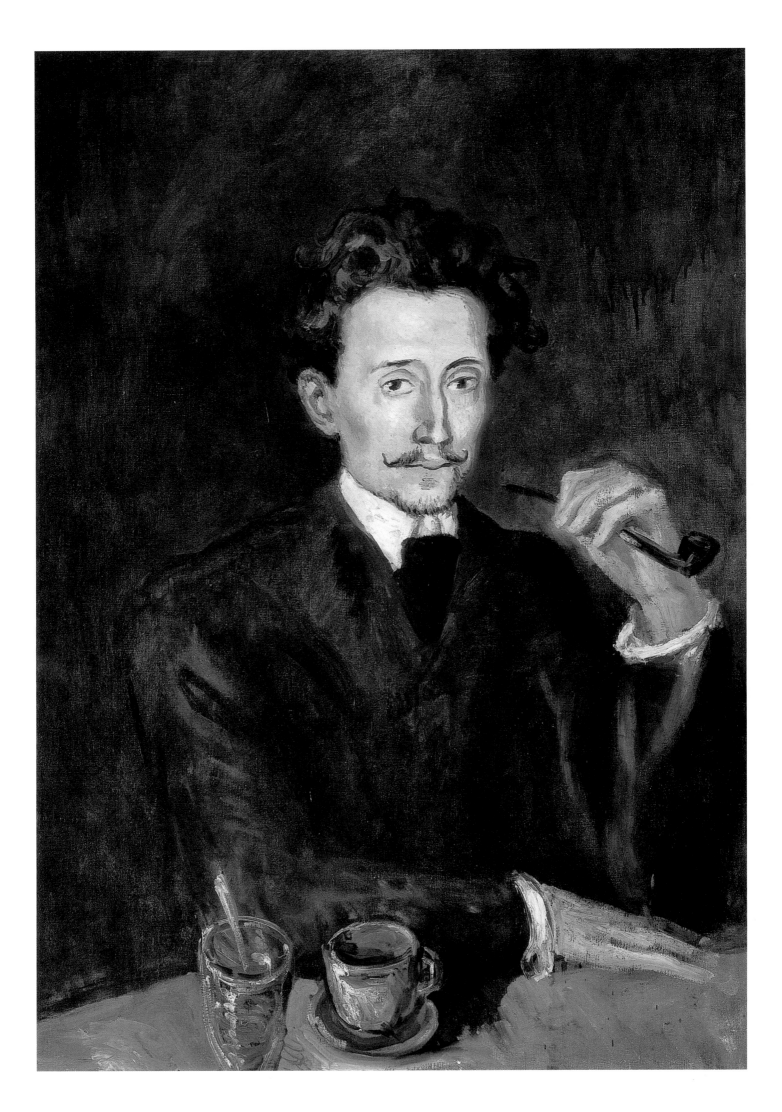

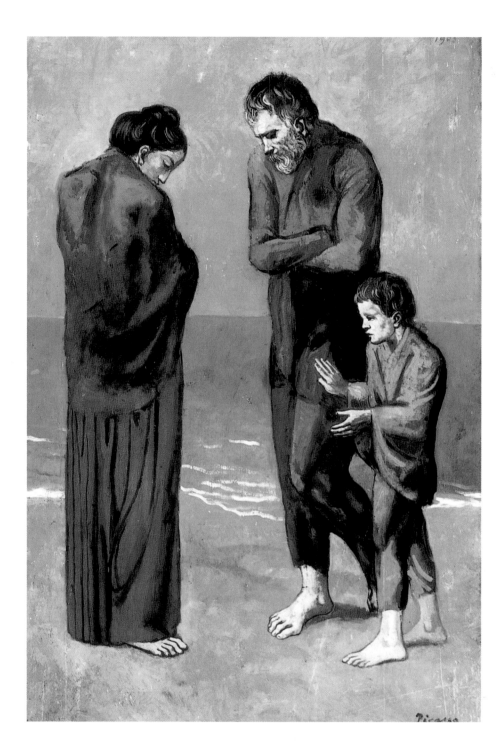

drooping figure, wrapped in the sorrow of its blue cape, totally withdrawn as a tightly closed shell. The genesis of this sculptural character may also be traced to the Paris works of the second half of 1901, in which the figures are, as it were, inscribed in the oval contours of a Romanesque archway. First and foremost among these is a "cycle" of women inmates and madonna-like "Maternities" (Daix), which in their own way reflect Picasso's impressions of visits to the St. Lazare prison in the autumn of 1901. The development of all these elements, both plastic and semantic, constitutes the background to the Hermitage painting *The Visit* (see *Seated Woman with Folded Arms; Crouching Woman with a Child* and *Seated Woman in Voluminous Clothing*). "The heart of the wise is in the house of mourning" — the words of Ecclesiastes seemed to echo the very thoughts of the twenty-year-old Picasso when he, continuing his quest for the Eternal Feminine and finding everywhere suffering and the tragic essence of existence, made his way to the St. Lazare prison.[39]

Portrait of Soler, 1903.
Oil on canvas, 100 x 70 cm,
Hiroshima Museum of Art, Hiroshima.

The Tragedy, 1903.
Oil on wood, 105.4 x 69 cm,
National Gallery of Art, Washington.

At the beginning of the twentieth century most of the inmates there were prostitutes. Amid the hustle and bustle of Belle Epoque Paris, St. Lazare prison stood out as a strange world, turned in upon itself, somehow timeless — an atmosphere reinforced by the twelfth-century architecture of its buildings. The monotonous rhythm of the vaults' arid arcades, of the long, echoing corridors with their processions of inmates, the sacral atmosphere of this former monastery — all these must have affected Picasso, susceptible as he was to such impressions. Did he know then about the plans of Van Gogh (at the time, his special favourite) to paint holy women from nature, giving them simultaneously the appearance of modern city dwellers and that of the early Christians? If he did not, then the coincidence is highly significant, for the young Spaniard, who observed the heartrending and touching scenes of women with their children (the inmates were allowed to keep their infants), developed the theme of the St. Lazare prostitute-mother into a modern-day Maternity. These Maternities can, hypothetically, be related to Goethe's myth concerning mothers, the great goddess-keepers of the prototypes of everything that exists (see *Faust*, Part II). This is not surprising, considering Goethe's influence on the culture of symbolism in general and, in particular, if one notes the many figurative allusions to the two closing scenes of Faust in a picture created at the same time as the St. Lazare Maternities, the large programmatic work *The Burial of Casagemas* (p.23). At any rate there is no doubt that Picasso, in the grip of his "blue" world outlook, found the universal in the concrete: symbolic, suggestive in meaning and piercing in emotion, an expression of universal sorrow. This was an existential emotion rather than an empirical one. That is why when depicting the women that he observed (or imagined?), Picasso furnished neither individual features nor social details, but expressed only the dark side of the Eternal Feminine: what he saw as the metaphysical, suffering essence of women. Even such mundane details as the hospital ward robes and the inmates' typical white caps were transformed into abstract capes and something similar to Marianne's Phrygian cap. Changed by the artist's perception, they become in Picasso's work only faint traces of St. Lazare's realities. However, their stubborn presence speaks of how powerfully the prison's harsh reality affected the imagery and very style of the Blue Period at least throughout the year of 1902.[40] Six months later, having returned from Barcelona to Paris, Picasso worked on a picture which he described, writing to Max Jacob, as "a St. Lazare whore and a mother". That picture was *The Visit*.

In the above-mentioned letter (as well as on the drawing that was enclosed with it, 2.6.436) Picasso calls the picture *Two Sisters*, which expresses his own personal view of the painting. The title *Two Sisters* must, of course, be understood as an allegory, a symbol, as two metaphysical aspects of one common feminine essence — the base and the sublime, as two courses of a woman's fate — "a St. Lazare whore and a mother". Judging by the sketches, Picasso's initial conception had a sentimental tinge, the story of how sacred Maternity appeared before a prostitute in the form of a pregnant woman holding an infant in her arms. Gradually, however, such secondary details as facial expression and gesture vanished, along with all particularities of exterior appearance and dress. Everything pertaining to the depicted event is generalized and frugal: the place is a wall with an archway; the characters' poses and gestures are constrained and passive; the faces are impersonal, their clothing indeterminate and vague. Picasso not only cut back on details, he consciously limited his means of expression to the point of asceticism. The indistinct and simple monochromatic blue corresponds to the composition's elemental quality, the generalized plastic and linear character.

Old Jew with a Boy, 1903.
Oil on canvas, 125 x 92 cm,
The Pushkin Museum of Fine Arts, Moscow.

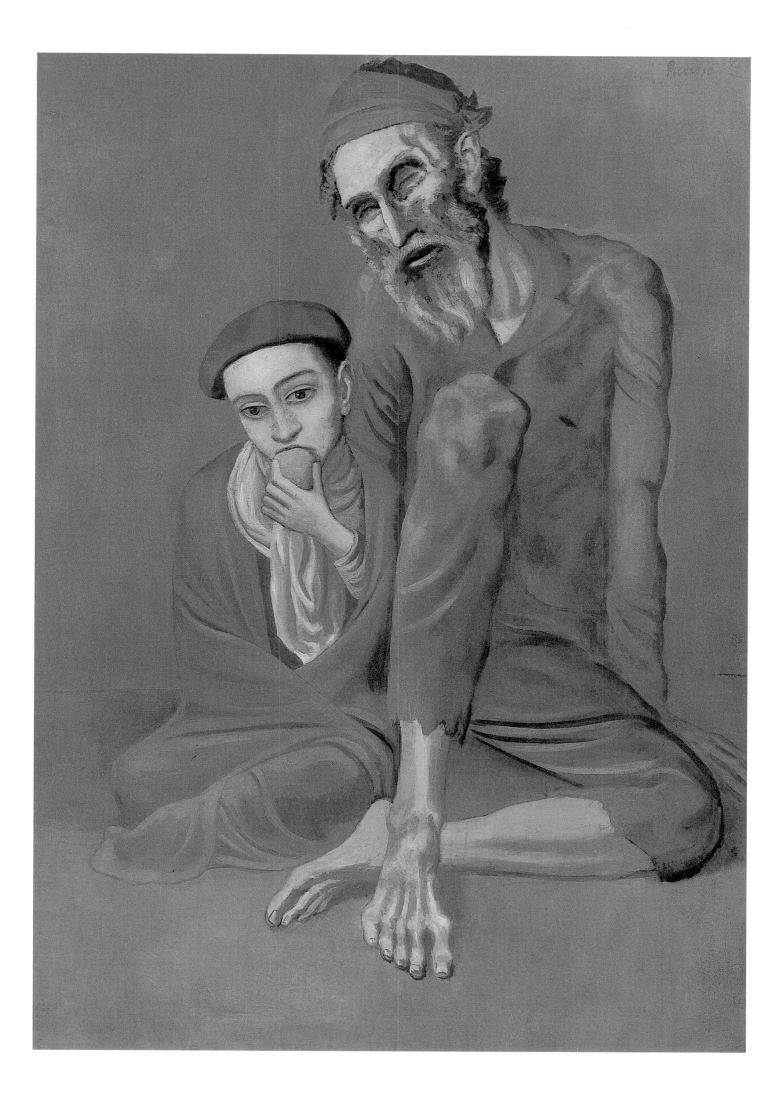

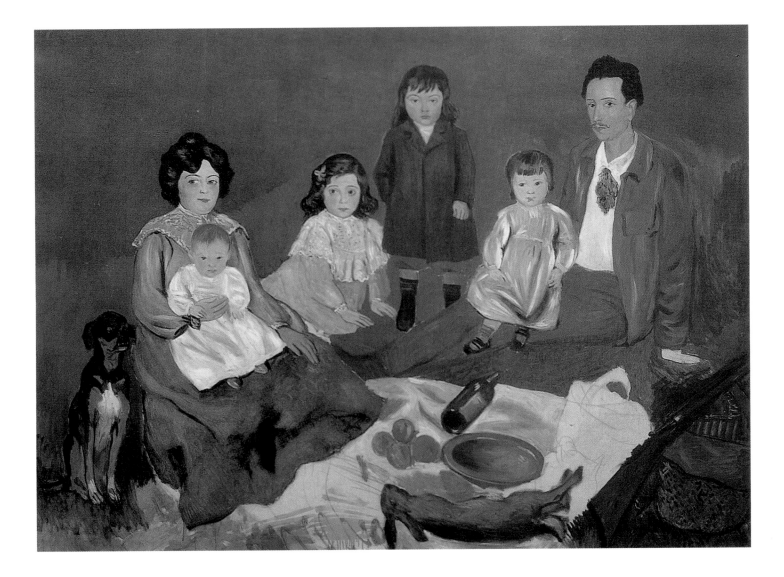

While simplifying the form, Picasso gave the content greater complexity and depth, turning the initial subject into a timeless, universal event — the mournful meeting of two symbolic sisters in another world. Their emblematic opposition (the lofty and eternal versus the lowly and fatal) is expressed through the painting's structure. The intense, deep sky-blue tones of the Mother figure correspond to her free-flowing plastic lines, while the lifeless grey-green shadings (the colour of damp clay) of the Prostitute correspond to the figure's rock-like volumes, the ragged rhythms of her pose, and the funereal shadows in the creases of her cape. The exalted maternal inspiration and sorrow expresses itself through the Mother's all-seeing, gaping eye. The Prostitute's deep, metaphysical death dreams show in her heavy, closed eyelids, the shadows on her waxen face, and her proximity to the yawning archway. Sergei Shchukin probably had *The Visit* in mind when he said that Picasso should decorate cathedrals. Even the picture's formal components seem to have antecedents in the traditions of sacred art: the composition being reminiscent of those on ancient burial stelae as well as of the medieval iconographic depictions of Mary and Elizabeth; the characters being linked with the noble, epic figures of Giotto and Masaccio or the spiritual images of Gothic statues; and the monochromatic colour originating in the supersensual blue-green tonality of Luis de Morales. Yet, on the contrary, sketches show that Picasso was not inspired by such ancient iconographic or stylistic traditions, but rather, by looking beyond them, he revealed his theme of two women meeting through a plastic idea that embodied the very archetype of

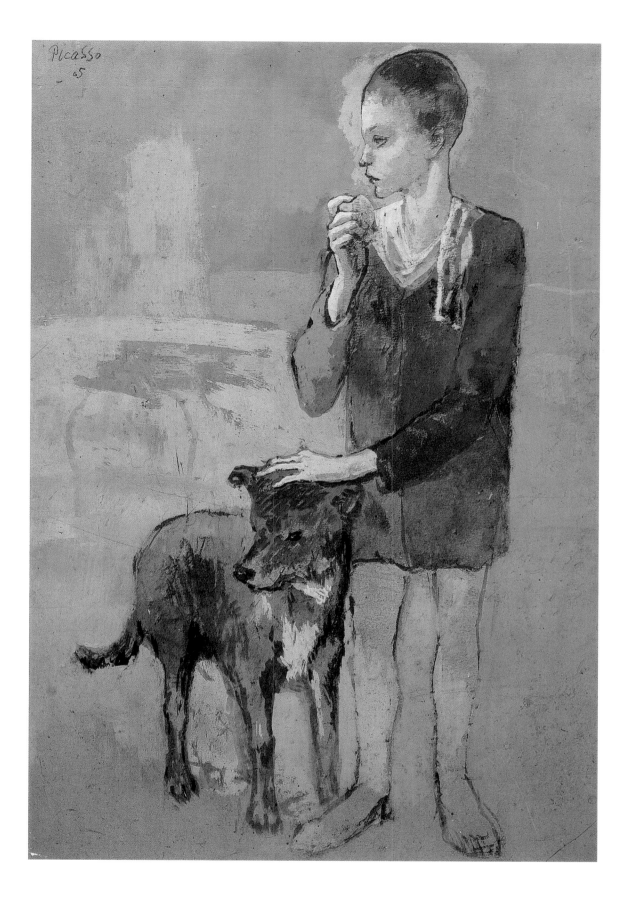

meeting. What was achieved in the sketches by the sisters' clasped hands was formulated in the painting by composition: the two figures bend toward each other and thus simulate an arch that "rhymes" with the dark archway in the background on the left, thus achieving an architectural unity for the two-part composition. Picasso simultaneously endowed the visual idea with the importance of a poetic metaphor: "meeting at an arch" (visits by charitable groups to the inmates were also one of the noteworthy features of St. Lazare, something that Picasso could have witnessed within its vaulted premises).

Boy with a Dog, 1905.
Pastel and gouache on cardboard,
57.2 x 41.2 cm,
The Hermitage, St. Petersburg.

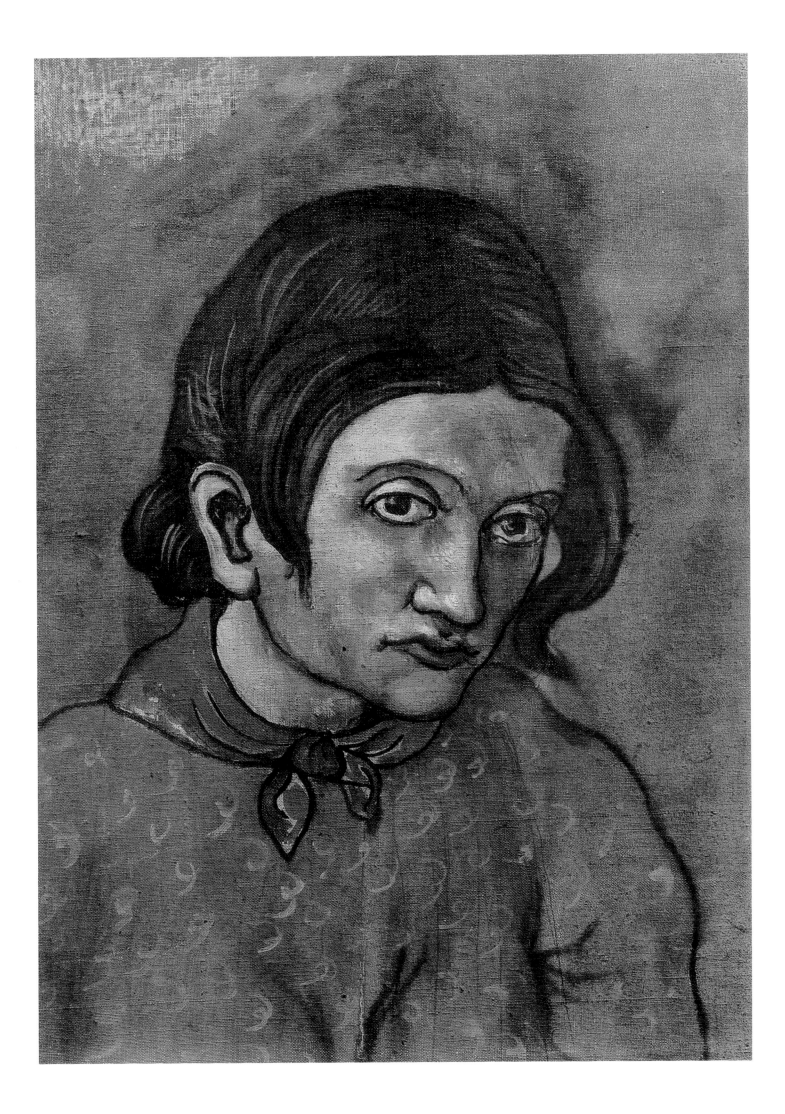

40

It may well be that in *The Visit* Picasso first discovered for himself the law of the associative and plastic equation of different objects. It would later become an active and important instrument of his poetic imagery, the poetry of metamorphosis, born during the Cubist Period and preserved to the very end.

The Visit, probably completed by the autumn of 1902, is the culmination of the first phase of the Blue Period, a phase dominated by the St. Lazare subject matter. During 1902, three-quarters of which Picasso spent in Barcelona, his art strayed far from reality into the area of transcendent ideas expressing only his subjective, spiritual experience. His characters were vague, anonymous, timeless (see *The Dead Man, Scene of Despair*). These are images of ideas: their visual definition has more to do with the plastic modelling of simple forms; the feeling for volume and broad linear rhythms are more typical of a sculptor (a sculptor, moreover, of ancient Assyrian reliefs) than of the inspiration of a painter, grounded in a sense of reality and the possibilities afforded by brush and colours.

This was a time when Picasso, as Daix noted, wished to achieve the merger of form and idea. His experiments did not, however, meet with the understanding of his closest associates in Barcelona, a fact he complained about in a letter (mentioned earlier in connection with *The Two Sisters*) to Max Jacob in Paris. He notes with irony that his friends — local artists — find too much soul and no form at all in his work. The fact that Picasso turned to his first Paris friend and a poet for understanding (they met during the Vollard exhibition in 1901 and quickly became close) at least in part explains his return in October 1902 to Paris, where he lived in poverty with Max Jacob. After suffering from the cold weather for three months, he left in mid-January 1903. "A terrible time of cold, privation and disgust. Especially disgust," Sabartés reports. "This is what he recalls with the greatest repugnance — not because of material hardship and privation, but because of the moral misery that he was made to feel by certain Catalan friends who lived in Paris and in better conditions."[41]

Yet, as with previous trips, this visit to Paris introduced something new to his art. In contrast to his terrible living conditions, during the winter of 1902-1903 the imagination of Picasso-the-artist lived in the realm of "pure and simple humanity" (Daix: "d'une humanité simple et pure"), a world of shepherds and fishermen whose life is hard and frugal, but yet reflects a heroic stoicism. This majestic world of philosophic clarity, calm wisdom, simple, powerful emotions, of nature's overarching spirituality, seems to echo the sound of some ancient myth, born from the ideals of Puvis de Chavannes, Gauguin and Alfred de Vigny, but also from his own memories of the time spent at Horta de Ebro a mere four years earlier[42] (see *The Mistletoe Seller; Head of a Picador*).

Not having the means to paint in oils in Paris, Picasso made drawings (see *Man with Raised Arms*); thus, when he resumed painting in Barcelona, his new graphic experience manifested itself in his greater attention to the problems of space, of human anatomy, of the tangible features of his characters, the range of which broadened considerably compared with 1902. In the most significant works of the first half of 1903 — *Poor People on the Seashore (The Tragedy)* (p.35), *La Vie* (p.31) and *The Embrace* (p.15) — Picasso developed the universal Blue Period themes of *Weltschmerz* and the Eternal Feminine as scenes of relations between individualized characters: men, women and children (see *Mother and Children on the Seashore*). The artist expressed his emotional experience in what might be seen as symbolic or mythological "blue" dreams, and this has led contemporary scholars of the Blue Period to psychoanalytical interpretations.[43]

Portrait of a Young Woman, 1903.
Oil on canvas pasted on cardboard,
The Hermitage, St. Petersburg.

41

And yet, as the pressure of Picasso's emotional crisis began to ease, his consciousness sought a way out in the external, in reality. This urge for the concrete was expressed in cityscapes, albeit muffled in the darkness of night, and especially in the portraiture which manifested itself in the middle of 1903. That was when the *Portrait of Soler* was created, following a portrait of Soler's wife and a group portrait of the entire family during a summer picnic. The three canvases actually work quite well as a triptych, although the Hermitage painting is of a more intimate and friendly character than the *Portrait of Senora Soler* or *The Soler Family's Luncheon on the Grass*, both of which are a subtle play on the typical stiff photo-portraits of those times. Benito Soler Vidal was a stylish tailor in Barcelona, a friend and patron of the arts and artists who frequented the Els Quatre Gats café, and a man who stood out in that city as a particularly snappy dresser. That is how Picasso depicted him: a melancholy dandy. Once again the mystical power of infinite blue was used to transport the subject from his mundane surroundings to those that best suited his noble countenance. Picasso surrounded Soler with cosmic light, turning his finely featured face into a sort of pale, heavenly body hardly touched by living colours. Picasso's artistic intention clearly takes precedence over the model's actual psychology; the *Portrait of Soler*, however, is significant in that it reveals the artist's desire to find a corporeal type expressing an inner sensibility. In that sense the Hermitage portrait leads to the unquestionable masterpieces of the autumn of 1903, among them *Old Jew and a Boy* (p.37).

Contact with external reality makes the theme of man's unhappiness concrete by dramatic images of poverty and physical infirmity: homelessness, hunger, old age, and blindness. Many authors have noted that beggars

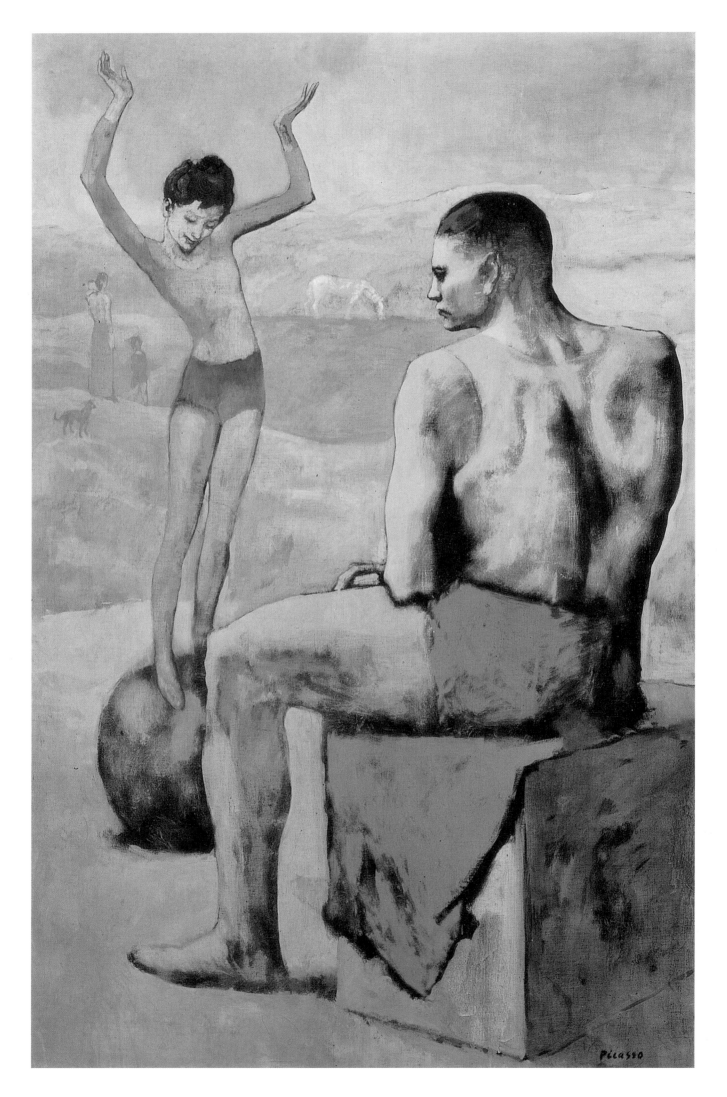

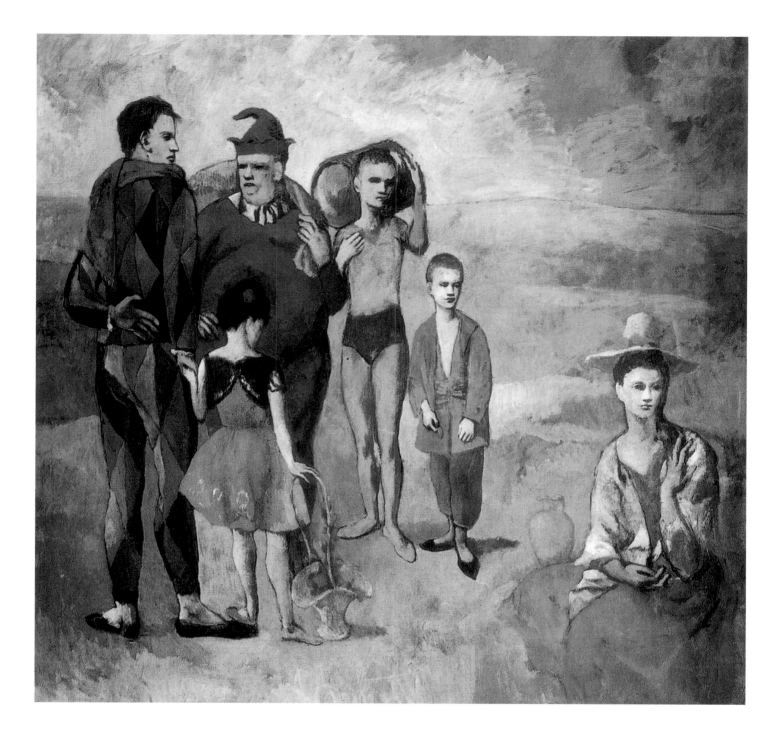

and cripples were a common sight in turn-of-the-century Barcelona and that Isidro Nonell, Picasso's artist friend, had previously been attracted to similar subjects with their particular "España negra" gloomy tonality. Picasso, however, again hits a note higher than the one written in the score: physical infirmity interests him only as a metaphor for spirituality honed by suffering. Picasso's imaginary "Sisyphean tribe" of the Paris winter of 1902-1903 was of stocky, "Doric" proportions, embodying the flesh and blood of those people's epic, massive origins; now, in the autumn of 1903, in Barcelona, his taste for pure, incorporeal, elongated lines (succumbing to their musical interplay, Picasso covers sheet after sheet with sketches of nudes, gestures, poses, and profiles) gave birth to manneristic, attenuated figures that remind some scholars of El Greco, Morales, Roman frescoes and Catalan reliefs. Other scholars link the artist's new mood to the philosophical ideas of Nietzsche, then popular among the symbolists of Barcelona, concerning the "birth of tragedy from the spirit of music".[44] Be that as it may, the secret logic of Picasso's creative instinct drew upon a jumble of linear melodies to

Acrobat on a Ball, 1905.
Oil on canvas, 147 x 95 cm,
The Pushkin Museum of Fine Arts, Moscow.

The Family of Saltimbanques (The Tumbler), 1905.
Oil on canvas, 212.8 x 229.6 cm,
National Gallery of Art, Washington.

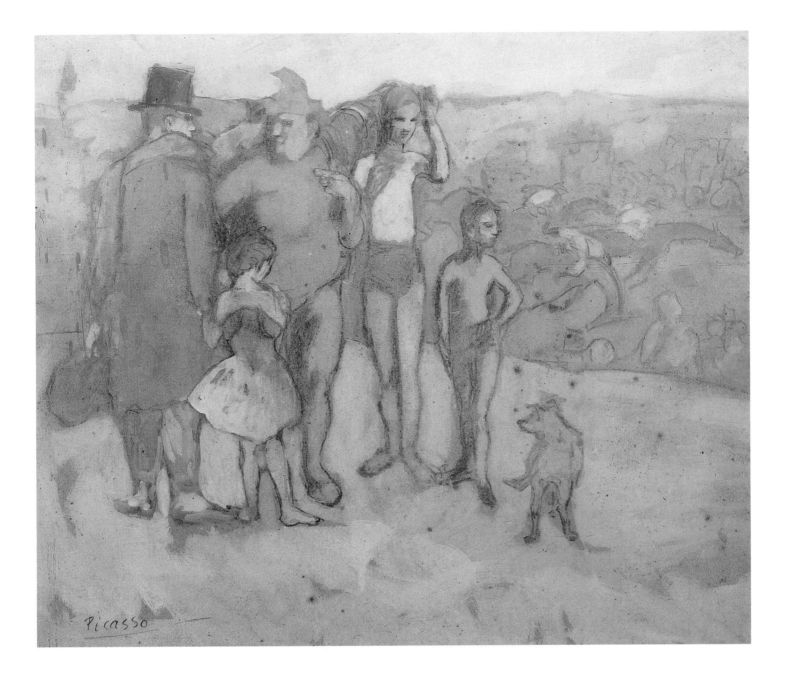

The Family of Saltimbanques (The Tumbler),
1905.
Gouache, charcoal on cardboard,
51.2 x 61.2 cm,
The Hermitage, St. Petersburg.

crystallize those angular contours — of ascetic figures, nudes, Spanish guitars, pure ovals of juvenile faces, sharp profiles with the singing mouths and empty eye sockets of the blind, the nervous, sensitive hands — which would appear in such paintings as *The Blind Man's Meal, Old Jew and a Boy, The Blind Man, The Old Guitarist* and *The Madman*.

Among these most "blue" paintings of the Blue Period, *Old Jew and a Boy* is perhaps the most monochromatic and homogeneous in tonality. But what does this blue mean now — ghostly, greyish-white, colder than ever before, the wraith-like figures of the old blind man and his youthful guide embodied by a mere increase of tonal density? Who are they, these figures whose Catalan prototypes were revealed in the multitude of "memory drawings" of Horta de Ebro which Picasso produced at that time? What is the meaning of the sensitive blindness of the one and the impassive, sightless gaze of the other? What parable will explain why they sit like this, one leaning on the other, on the edge of the world, of time, of life, or of slumber?... There are certain eternal images of mankind which express conditions, relations, conflicts of a general significance and which from time to time in history assume the character of "wanderers". The old blind man, made wise by suffering, the beggar who lost everything he had, the vagabond eternally

damned to move on, were once Oedipus, Job, Ahasuerus. Perhaps, though, they are only the incarnations of one archetype expressing the growth of spirituality as the corporeal wanes. In the nineteenth-century novels of Dickens and Dostoyevsky, humanity (the highest spirituality in those times) finds its piercing expression in the image of an old beggar with an orphan girl, an image both deeply touching and profoundly symbolic.

In *Old Jew and a Boy* the artist interprets the humanistic myth of the nineteenth century, but does it with a Biblical hopelessness for human fate. The painting shows us how Picasso's aesthetic crisis of the Blue Period was to be resolved. For here the striving to attain extreme expressiveness — which had necessitated the tangible interplay of lithe plastic forms, the complex linear rhythms, the mimetic contrasts of types, and, finally, the intensely ash-blue colour — this manneristic exaltation of form, is now based on the piercing power of a relationship. In that sense the motif of blindness in *Old Jew and a Boy* had a special importance for Picasso, as Penrose so profoundly realized. "In considering the act of perception, Picasso has always been amazed at the discrepancy between seeing an object and knowing it. Its superficial appearance is to him absurdly inadequate. Seeing is not enough, neither is the aid that the other senses can bring. There are other faculties of the mind which must be brought into play if perception is to lead to understanding. It is somewhere at the point of junction between sensual perception and the deeper religion of the mind that there is a metaphorical inner eye that sees and feels emotionally. Through this eye of the imagination it is possible to see, to understand and to love even without sight in the physical sense, and this inner seeing may be all the more intense when the windows of the outer world are closed." Penrose then quotes the mysterious words Picasso said in the 1930s: "In fact it is only love that matters. Whatever it may be. And they should put out the eyes of painters as they do to goldfinches to make them sing better."[45]

In saying that, Picasso perhaps was thinking about his blind Minotaur led by a little, defenceless girl, that later echos of his blind old man and orphan of 1903, united by the spirituality of love.

In 1904 the Blue Period, with its pessimistic, ingrown character and furious desire for an aesthetic absolute, reached its climax. This crisis of youth had to be replaced by a new stage in the process of individual development — the stage of self-building. Not accidentally, Picasso now set stock by external conditions, planning another trip to Paris to breathe different air, speak another language, see other faces and adopt another lifestyle.

In April 1904 he went back to Paris — for good, as it was to turn out. He moved into a studio building known as the Bateau-Lavoir (Laundry Barge), a nickname given to it by Max Jacob for its strange design. A dilapidated wooden house that clung to the heights of Montmartre, which was pastorally peaceful in those times, the Bateau-Lavoir became Picasso's home for the next five years, and the atmosphere of this bohemian nest, its texture of poverty, became the atmosphere and texture of his canvases of 1904-1908.

Picasso's life soon entered family waters, when he met and took up with the beautiful Fernande Olivier;[46] he acquired new friends and acquaintances. Home, family social circle — his relationship with life grew more solid and positive. Being with colleagues became less important to Picasso than meeting creative figures from other fields, especially poets, who included André Salmon and Guillaume Apollinaire.

Among Picasso's first Parisian friends were Suzanne Bloch, later a well-known singer, and her brother, the violinist Henri Bloch. In 1904 he gave the couple a photo of himself, executed a brilliant portrait of Suzanne, and presented Henri Bloch with a small canvas, *Head of a Woman with a Scarf.*

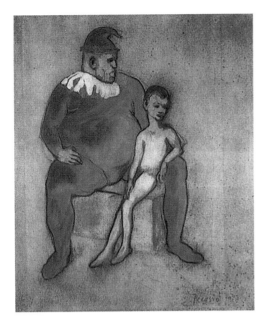

This work, usually dated to 1903, when Picasso was in Barcelona, is nevertheless more typical of his first Parisian months of 1904, when he used watercolours extensively and worked in the graphic arts.

The blue has now been diluted, it is nearly translucent and has red undertones; the drawing is strong and combines attention to detail with expressive stylization. At the same time (and this is characteristic of the end of the Blue Period), the source of the mood is now the individual psychology of the character. The woman's melancholy effacement is shown through her bent figure, the strand of hanging hair, her features and expression. This woman, however, with her cropped hair (like the prisoners of St. Lazare), is probably not a real person, but rather the fruit of Picasso's inspired improvisation, the closest forerunner of the blind man's famished companion in his 1904 etching *The Frugal Repast*.

Together with the naturalistic tendencies in Picasso's drawings, by 1905 there was a growth of the narrative element in his art as a whole. The Russian poet Alexander Blok noted (also in 1905) this kind of amazing interrelationship: "Often the basis of a sentence, the noun and the verb, coincide — the former with colour, the latter with line."[47] Picasso's line now became lively, sensitive to detail, yet light, sophisticated and nervous; it seems to sing the form's highest notes. Long, flexible bodies rendered at full length, raised, angular elbows, graceful extremities, refined profiles, unusual curves, angles, wrinkles. This is a line of lyrical timbre, it demands corresponding themes resembling blank verse, something intimate in mood and philosophic in content. The themes came from the world of travelling circuses, rich in its potential for lyrical and philosophical interpretation. And so it was, especially for Picasso, who perceived the world of the travelling circus as a metaphor for his own environment — the artistic Bohemia of Montmartre, which lived "poorly, but splendidly" (Max Jacob) in feverish excitement and hunger-sharpened sensitivity, in the brotherhood of companionable joviality and the wrenching melancholy of alienation. Picasso's vision was inspired and picturesque. This was a poet's vision, which in content and emotion was very close to the atmosphere of the *Little Poems in Prose* by Baudelaire, a spiritual mentor to both Picasso and his poet-friends. In their roles as social outcasts these young men also felt a bond with the fate of the *poète maudit*, and their examination of history would inevitably come to rest on Baudelaire — the heroic figure of a rebellious genius who proved to be for them like one of the lighthouses he once described. In fact, the Montmartre of these young poets and painters — a garret and an attic in Paris — was to a certain extent reminiscent of that squalid and yet magical double chamber (tinted in pink and blue) described by Baudelaire in one of his *Little Poems in Prose*.

The Hermitage painting *Boy with a Dog* (p.39) seems to be a direct response to another prose poem by Baudelaire, *Les Bons Chiens*: "I sing the dirty dog, the poor dog, the homeless dog, the stray dog, the dog saltimbanque, the dog whose instinct, like that of the beggar, the bohemian and the comedian, is so wonderfully sharpened by necessity, that kind mother, that true patron of all intelligence!" Like no one else, Picasso grasped Baudelaire's desire to "sing the good dogs, the poor dogs, the dirty dogs, those that everyone keeps at a distance as pestiferous and flea-infested, everyone except the poor, of whom they are the associates, and poets, who look upon them with a fraternal eye."

This same instinct, sharpened by need, this taste for the true values of life and the understanding of its philosophy, is also typical of the dog's comrade in Picasso's gouache — the boy who, though dressed in rags, has the delicate and angular grace of the Quattrocento. The animal is calm beneath the boy's hand, both turn their heads to one rhythm — thus the painter creates the feeling of warm contact between the solitary boy and the dog

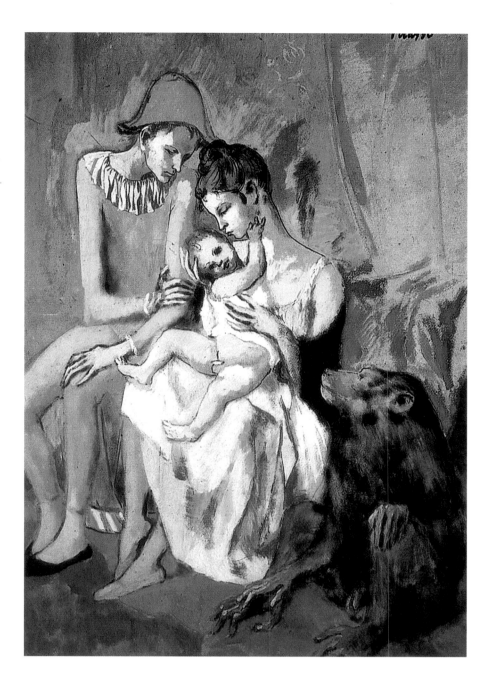

whose intelligent eyes seem to say, as in Baudelaire's verse: "Take me with you, and perhaps from our two miseries we shall create a kind of happiness!"

This mood of calm, sentimental melancholy was the *Leitmotif* of Picasso's works from late 1904 and the first half of 1905, the so-called Circus or Rose Period. And all the works of that period, including the gouache *Boy with a Dog*, are related, some more, some less, to the huge composition on the life of a travelling circus that the artist envisioned at the end of 1904. In essence all the work on this composition — all the conceptual changes, all the sketches and the development of certain motifs into separate paintings, in other words, all of its roots and branches — was what comprised the Circus Period, sometimes also called the Saltimbanque Period. One of the chief products, created towards the end of 1905, was the *Family of Saltimbanques* (p. 45, 46). Recent laboratory studies reveal the complex evolution of the painting in both concept and composition: before achieving the end result, Picasso painted no less than two independent works, revealed in four consecutive stages, on the same canvas.[48] The first of these four, *Saltimbanques*, known thanks to a watercolour sketch of the same name (Museum of Art, Baltimore) and to a drypoint, had a young acrobat balancing on a ball while an older companion, dressed as Harlequin, watches him practise his routine.

Acrobat Family with a Monkey, 1905.
Gouache, watercolours, pastel and Indian ink on cardboard, 104 x 75 cm,
Göteborg Konstmuseum, Göteborg.

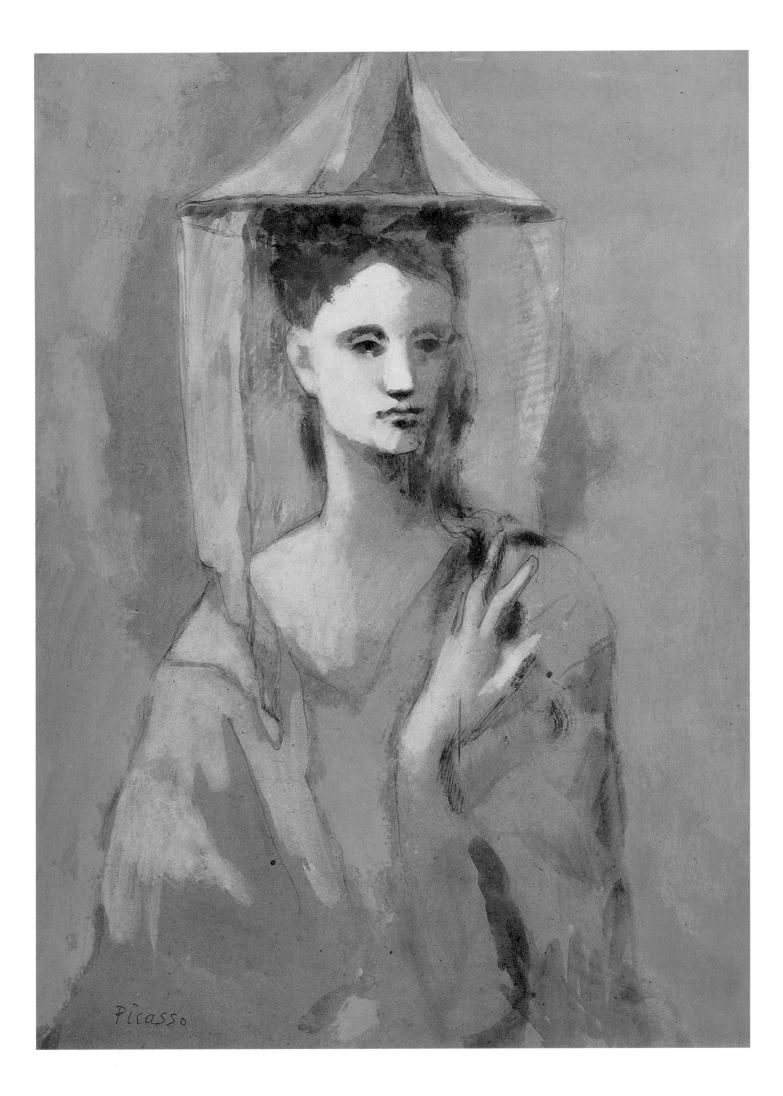

The central motif of that original composition was preserved and rethought in the famous painting *Acrobat on a Ball* (p.44). *Acrobat on a Ball* was painted only a few months after its source, *Saltimbanques*, and serves as a kind of answer by Picasso to Gauguin's question: "Where do we come from? What are we? Where are we going?" This composition, with its details full of intimate genre poetry and its frieze-like scope, did not, however, achieve the monumentality a canvas of such proportions demanded; it was rejected by its creater.

In his *Acrobat on a Ball* Picasso aimed at control and developed the composition in depth: the main characters and the staffage figures occupy successively retreating spatial planes on the naked landscape. For the first time in his work the image of space appeared (not as a mystical blue something or somewhere, but concrete, material) which consequently brought up the problem of spatial form (again, not expressive or symbolic, but plastic). Having appeared, the problem of form captivated the artist to such an extent that he lost interest in the subject *per se*. In *Acrobat on a Ball*, a simple episode in the life of travelling acrobats, the rehearsal of a number, becomes the arena for the tense interplay of forms.

Picasso's original intention was still quite literary: the departing mother, children and dog in the inhospitable landscape and, far off, a ghostly white stray horse determine the philosophical sphere of the reply to Gauguin's question: "Where from?... What?... Where to?..." However, the scene in the foreground looms larger than the significance of the

Woman of Majorca, 1905.
Gouache, watercolour on cardboard,
67 x 51 cm,
The Pushkin Museum of Fine Arts, Moscow.

Interior Scene: Nude Woman Beside a Cat and a Nude Man, 1905.
Gouache, charcoal on cardboard, 52 x 67.5 cm,
The Hermitage, St. Petersburg.

Boy Leading a Horse, 1906.
Oil on canvas, 220.3 x 130.6 cm,
The Museum of Modern Art, New York.

answer ("from infinity...", "artists...", "to eternity"), for in developing the features of his characters — the circus strongman and the girl-acrobat — Picasso turned to their differences. But the contrast between these two beings — the powerful athlete who sits squarely and rigidly on his cubic base, and the graceful, lithe acrobat balancing on the big ball — imperceptibly comes to express the antithesis of two very formal essentials: stability and the act of slipping, heaviness and lightness. To heighten this contrast the artist ignored reality, distorted normal proportions and angles, exaggerated the athlete's massiveness, turning him into a colossus, an indestructible monolith. His seated figure occupies a good half of the picture's surface.

The other half includes the youthful acrobat surrounded by the empty landscape. Precariously balanced, she is a graceful, S-like tree trunk with branching, thin arms raised high to the heavens in the music of gestures. Apollinaire's poem *Un Fantôme de Nuées* has the same image of the little street acrobat:

> And when he balanced on a ball
> His slim body became so delicate a music
> That none of the spectators could resist it
> A tiny spirit without humanity
> Everyone thought
> (Translated by Roger Shattuck)

The contrast between the characters is easily transposed to more abstract areas: Matter, chained by inertia, and Spirit, streaming and ethereal. It is for a reason that the athlete's broad back, clothed in an undershirt of "consumptive" colour (as Apollinaire called that shade of pink), is turned towards us, resembling in relief the ochre-coloured landscape; the girl, on the contrary, is linked with the pale sky covering this desert by both the washed-out blue of her tights and the Caryatid-like position of her arms. To be sure, different meanings may be seen in their opposition (as between the opposition of cube and sphere), for the thematic element has been so weakened that in this painting a simple event seems like a mysterious ritual. The colossal athlete is as impenetrably serious as a statue; a secret smile plays on the lips of the child-acrobat, who wears a carmine flower in her hair; the abstract landscape is reminiscent of certain mountainous areas in southern Spain.

But it was precisely these literary paths that Picasso's creative imagination followed as he realized the crucial need to renew the formal language of his art.

And if the prevailing enigmatic feeling of these works derives from their thematic obscurity, their poetry — which alone unites all the paintings contrasting pictorial elements — stems not from the theme, idea or object being depicted, but from the linear, plastic, spatial relationships within the works themselves, from the vitality of their forms. Of course, in this painting from the first half of 1905, the issue of form is still in its genesis, but its magnitude, complexity and potential can already be sensed. That is why the *Acrobat on a Ball* stands out among Picasso's creations as the seed of many further developments in the area of plastic form and imagery. The problem of form as related to a large canvas preoccupied Picasso throughout the Circus Period, up to and including the autumn of 1905, when the main work, *Family of Saltimbanques* (National Gallery, Washington) (p.45), was finally finished. Two sketches relating to it — *Family of Saltimbanques* (p.46) and *Spanish Woman from Majorca* — illustrate the development of the theme of the larger work, as well as the direction of Picasso's formal search.

Two Brothers, 1906.
Gouache on cardboard, 80 x 59 cm,
Musée Picasso, Paris.

Naked Youth, 1905.
Gouache on cardboard, 67.5 x 52 cm,
The Hermitage, St. Petersburg.

Family of Saltimbanques, a sketch for the entire composition, depicts five actors and their dog about to continue their travels. Their belonging to the artistic realm is denoted by their circus dress, while their being above the vanity of life is allegorically underlined by the furious horse race in the background. The dynamic, fragmentary racetrack scene is also needed to put the scale of the circus group into perspective. However, this composition, which was basically transferred in its entirety to the larger canvas, achieved true monumentality only in the final version, where, freed from the sketch's mundane allusions, it became filled with the poetry of understatement, and thrilling in its limitless space.

In 1912 Ludwig Coellen, the German author of one of the first critical assessments of Picasso's work, found a neo-Platonic explanation for the painter's interest in spatial problems: pure space is the source of all colours and forms, the birthplace of the spiritual essence of all phenomena.[49] But, as those who knew him best specifically stated, neither in 1905 nor later was Picasso concerned with ideas of philosophical or physical cognition; as an artist operating with visual and tangible forms and as a lyrical poet acting out of deeply felt personal experience, he instinctively understood the link between volume and spirituality; he "felt" space as an arena for the interplay of spiritual forces. Rilke, one of the most spiritual of poets, had good reason to dedicate an elegy to the *Family of Saltimbanques* which repeats the nostalgic strains of Gauguin's questions: "Where from?... What?... Where to?..."[50] Picasso's interest in spatial form, then, stemmed from the needs of his art and his method of expression. But in addition, this interest reflected the gradual appearance within himself of a new, "spatial" consideration of his own psyche, in which the questions "Where do we come from? What are we? Where are we going?" were ever more incessantly turned towards the self: Where am I from?... Considered within the framework of the individualization process, this question is normal for the phase of self-formation then being experienced by the twenty-four-year-old Picasso. Indeed, this subconscious, intuitive search for inner roots, which served as the psychological base for the new direction in Picasso's art, was at first perceived as the result of Ancient Greek and Roman influences and was called the Rose Classicism of 1905-1906, but is now interpreted, both more broadly and more deeply, as a "return to Mediterranean sources".[51] It was no coincidence that this return became so clearly marked after Picasso's stay in Holland in the summer of 1905, since there he had met with a really foreign country and he brought back paintings full of ethnographic curiosity (see *Dutch Woman Beside the Canal*). One of the first signs of this return to Mediterranean sources was the Spanish landscape background in the Washington *Family of Saltimbanques*, which he completed at this time, and the figure placed not far from the main group, the so-called "Spanish Woman from Majorca".

This mysterious character inherited its name from the Moscow sketch mentioned earlier: the name appears in the Shchukin catalogue of 1913. The figure as seen in the Washington painting does not lend itself to one, clear interpretation; however the classically and perfectly formed pitcher placed next to this mysterious companion of the Saltimbanques bespeaks her ties with Mediterranean culture. This classic attribute is absent in the Moscow sketch; nevertheless, in the colours of the sky and the yellow ochre and the half-length woman's figure, the work stands as an illustration of the purely Mediterranean. This so un-Spanish Spanish woman in a Majorcan veiled head-dress comes across like a prototype for one of the ancient Tanagra terracotta figurines. She has the graceful proportions, majestic dignity and alienated charm of an ideal from classical antiquity. But in her overly refined

lines and tonal sophistication we have yet to feel the real, purely plastic concern with form that was to grip Picasso as he delved deep into the Mediterranean sources of his artistic nature.

As a parallel development, the hieratically mysterious figures of the autumn of 1905 (*Spanish Woman from Majorca* belongs to this group) were to disappear from his art while the persistent preoccupation with sources led him to the theme of primal nudity and youthfulness. In the winter of 1905-1906 these themes would merge as Picasso imagined a large new composition with five naked boys and their horses on a deserted Mediterranean coast. But instead of this multi-figure composition, abandoned at the developed sketch stage and known generally as *The Watering Place,* Picasso completed only the canvas (perhaps originally meant for the group) *Boy Leading a Horse* (Z. 1.264) preceded by a multitude of sketches.

One of these sketches, the Hermitage's *Naked Youth* (p.54), has something of the air of an independent classroom study but one based on an imagined model, some ideal adolescent. Here is a youth on the verge of manhood whose body is flooded with sexuality but whose spiritual energy is yet dormant; thus, steeped in the process of physical flowering, he remains in a state of ennui and inertia. Picasso wanted to pose the figure like a statue, solidly and weightily, in contrast, as it were, with its relaxed, flowing stance, its displaced centre of gravity and the light tonality dissolving the sharpness of form. He made the proportions heavier, hardened the light, flowing silhouette with a clear, sinuous contour, applied a layer of white gouache, in all its tangible density. But while the youth's naked body recalls a warm, pink Greek marble — and his plastic clarity, the ideal of antique harmony — his solid figure with its large hands and feet is closer to the image of a peasant youth, to those descendants of an ancient Mediterranean race that Picasso would encounter in the summer of 1906 in Gosol, in the Spanish Pyrenees, than it is to any classical kind of beauty.

His trip to Spain was in itself very significant during that period of returning to his Mediterranean sources; the time spent in Gosol, a tiny mountain village near Andorra, is doubly important, for it shows clearly the sources and the emotions underlying the fascination with archaic Iberian art that so intrigued Picasso in the autumn of 1906 in Paris.

Gosol was for Picasso, probably, a second Horta de Ebro, the village where he had spent about a year when he was seventeen and from which, he professed, he brought back all his knowledge of life. The stark, wild nature of the eastern Pyrenees — land of shepherds and smugglers, living a life attuned to the natural surroundings, unchanged since pagan times, honest and strong characters reflected in the features of local faces, the assured stride and erect carriage of well-built bodies — such is the image of Picasso's Catalan Arcadia, a land to which he immediately belonged (see *The Adolescents, The Peasants; Peasant Woman with Loaves, Man, Woman and Child*). "In Spain I saw him so different from himself," Fernande Olivier would recall a quarter of a century later, "or rather, so different from the Picasso of Paris, joyful, less wild, more brilliant, animated, calm and controlled in his interests, finally comfortable. He seemed to reflect an aura of happiness in contrast to his usual character and attitude."[52]

Here, amid the mountainous, ochre-toned landscape, largely without vegetation (so amazingly foreshadowed in *Acrobat on a Ball, Family of Saltimbanques* and *The Watering Place*), with its background of large and small areas of untamed nature, there occurs a sharpening of the appreciation of simple, harmonious and reasonably constructed form, be it that of a human figure or man-made object. Continuing and delving deeper into the theme of youthful nakedness, Picasso now found his source not so

much in the ephebic type, as in the architectonics of simplified plastic forms, whether conceived as a youth, a boy, a woman, a portrait, or a clay utensil. But each of those plastic ideas lives the life of the image, charming in its spontaneity.

Such is the unpretentious *Still Life with Porrón (Glassware)*, with its four commonplace objects of peasant life: two made of glass, two of clay. The simple motif of this group of objects, frontally depicted in the style of Zurbarán, comes alive through the internal dynamic interplay of contrasts and resemblances: material and plastic, rhythmic and tonal. Yet at the same time, in the contrasts between the individual forms of the elegant carafe and the triangular Porrón, the squat casserole under its lid and the simple earthenware jug, one feels the hidden humour of an artist playing at transformation, which was so typical of Picasso's fantasy. Thus, an objective depiction of lifeless objects turns into a genre scene in which an ordinary table becomes the stage for the meeting of two couples: one glass, the other clay.

As is evident from *Still Life with Porrón*, the Gosol works reflect a subconscious, but logical, growth of two basic trends in the development of the artist's formal conception: the underlining of the original expressive simplicity of volumes and the increasingly complex compositional structure of the whole. These trends would acquire their greatest stylistic expression in Paris during the autumn of 1906 in conjunction with Picasso's discovery of, on the one hand, archaic Iberian sculpture dating from 1000 B.C., recently unearthed by archaeologists and exhibited in the Louvre[53] in the spring of 1906, and, on the other, the painting of El Greco, which Picasso saw with new eyes as a primarily visionary kind of art.

Still Life with a Porrón, Glassware, 1906.
Oil on canvas, 38.4 x 56 cm,
The Hermitage, St. Petersburg.

That both these basic models (their polarity notwithstanding) were Spanish must have had a special meaning for Picasso, considering his return to sources and search for his Iberian roots.

For Picasso, Gosol was the world of original creativity. Here, far from cultural centres, he must have felt the relativity and arbitrariness not only of the artistic techniques taught by academic studies, but even of generally accepted cultural norms and the whole European tradition supporting them. In this naked and primeval world, the artist's every motion, every contact with formless material must have been felt with startling sharpness; it was precisely here that Picasso must have fully perceived the depth of human experience hidden by simplicity of form and the intensity of spiritual, form-creating labour.

Naked Woman, 1906.
Oil on canvas, 151.3 x 93 cm,
The Museum of Modern Art, New York.

On the other hand, Picasso's artistic thoughts were very concrete: forms to him were not some abstractions but rather served to render the objects to which he related so profoundly. In Gosol, in the summer of 1906 the nude female form assumed an extraordinary importance for Picasso — a depersonalized, aboriginal, simple nakedness, like the concept "woman" (see *Two Nudes; Seated Nude with Her Legs Crossed, Standing Nude*). Whether or not the female nudes of Gosol (see also *La Toilette*) were Picasso's response to Ingres's *Bain Turc*, shown at the 1905 Salon d'Automne,[54] has yet to be proven. But from the viewpoint of the artist's internal world, their meaning was undoubtedly far more profound than a simple artistic reaction, and that is confirmed by the importance that female nudes were to assume as subjects for Picasso in the next few months: to be precise, in the winter and

Sitting Woman with Crossed Legs, 1906.
Oil on canvas, 151 x 100 cm,
Galerie Nardonie, Prague.

Self-Portrait with a Palette, 1906.
Oil on canvas, 92 x 73 cm,
Philadelphia Museum of Art, Philadelphia.

spring of 1907, when he developed the composition of the large painting that came to be known as *Les Demoiselles d'Avignon.*

Hastily leaving Gosol because of an outbreak of typhus, Picasso returned to Paris with his head shaved bald. Perhaps that led him to depict himself in the famous *Self-Portrait with a Palette* from the autumn of 1906 as a juvenile, youthful Adam-the-artist. It would be more true, however, to say that that was the way he felt. The gaze of this Adam-the-artist, with his powerful torso and arms, is not focused on the external; it looks inwards. His thoughts are metaphorically expressed by a palette containing four colours: black, ochre, white and rose; most of the palette is clean — the work still lies ahead, but his colouristic credo is too restrained to transmit all the fleeting temptations of sight. Picasso looks here as he did in a photograph taken when he was fifteen, and this projection of self-as-adolescent tells us that he saw himself as a novice, striving, for the first time, after what was to be his life's cause. That, it would seem, was the sum total of his return to Mediterranean sources; such were the acquired Iberian roots of his artistic nature.

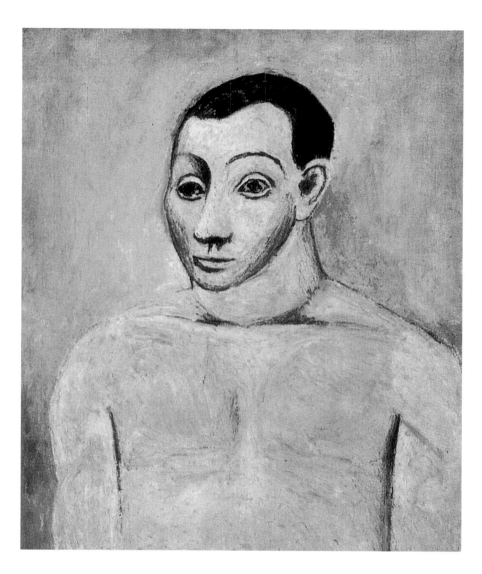

On 25 October 1906, Picasso turned twenty-five. That date marks the completion of one full cycle in his artistic development. Working in the spring of 1907 on *Les Demoiselles d'Avignon*, he was born anew as a painter. The Moscow and St Petersburg collections have only one work between them relating to this crucial moment in Picasso's artistic career — *Nude* (half-length) (p.67).

However, it is a peculiarity of that period that a large number of important events were concentrated in the very short span of a few months; hence, no one of Picasso's works (many of which have, moreover, been lost) can reflect a true picture of the whole. It is only in their entirety (and there are several dozen of them) that the creations of the spring of 1907 — the paintings, sketches, studies, drawings, sculptures, that is, the artist's total expression from that period — can truly reconstruct the story of Picasso's "second birth", a story that has yet to be fully understood even though there have been many attempts to do so. An understanding of the general character of the radical change that took place in 1907, to say nothing of its essence and direction, is achieved neither through references to individual influences (Iberian, African, Cézanne, El Greco, Ingres), nor by discussions of the lessons of Derain or Picasso's disputes with the Fauvism of Matisse, let alone by philosophical or literary influences, or any of the other generalities of that particular moment.

The young artists of the early twentieth century undoubtedly demonstrated an avant-garde spirit of aesthetic radicalism.

Self-Portrait, 1906.
Oil on canvas, 65 x 54 cm,
Musée Picasso, Paris.

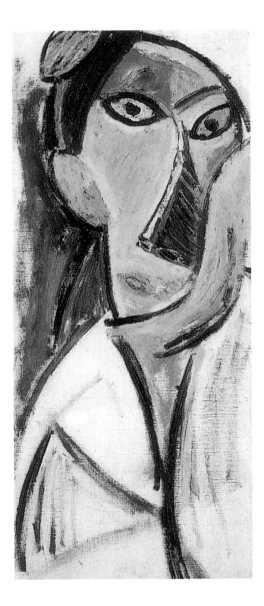

Yet even the leader of the Fauves, Matisse, was scandalized when he visited Picasso and saw *Les Demoiselles d'Avignon*; to him the painting was an abuse of modern art, as he could find no aesthetically justified explanation for it. Could the work indeed be qualified (at least in those days) as modern art? Many of its first viewers, at any rate, saw it as something Assyrian (that is how Wilhelm Uhde presented it to Kahnweiler). Douanier Rousseau, we know, noted in 1908 that Picasso worked in the Egyptian genre. It has now been proven that during his work on *Les Demoiselles d'Avignon* Picasso had two Iberian stone sculptures with which he "took counsel" in his experiments. As for modern Parisian painting *per se*, he had had no creative ties with it since 1901; beginning with his Blue Period, he travelled his own solitary road. Even Fauvism's scandalous triumph at the 1905 Salon d'Automne evoked not the slightest response in his art, which by then had entered the most harmonious and avant-garde phase of Rose Classicism. Picasso was always a solitary artist: "He was always free, owing nothing to anyone but himself" (Kahnweiler). From the vantage point of over four decades, here is how the artist himself explained the reasons and essence of the creative breakthrough of 1907: "I saw that everything had been done. One had to break, to make one's revolution and to start at zero."[55]

That break, however, that revolution, was neither instantaneously nor easily achieved. It was carried out amid the conditions of a new spiritual and creative crisis — one far more profound and all-embracing than ever before, because it touched on the technical, spiritual and pictorial possibilities open to the artist ("I saw that everything had been done"). It affected Picasso's future as an artist and, hence, his existence as an individual. This was a solitary, internal revolution, and perhaps nobody ever understood it as well as Apollinaire, who went through the same kind of rupture and revolution one year later. In *The Cubist Painters* (1913) Apollinaire summed up both his own and Picasso's experience in a theory of artistic creation based on a somewhat surprising criterion: weariness.

"There are poets to whom their muse dictates their works; there are artists whose hand is guided by an unknown being using them as an instrument. Such artists never feel fatigue, for they never really work and can produce abundantly day in and day out, no matter what country they are in, no matter what season; they are not human beings, but poetic or artistic machines.

Their reason is not a force inimical to them; they never struggle, and their works show no sign of strain. They are neither divine nor self-centred. They are like the prolongation of nature, and their works do not pass through intellect. They can move us without humanizing the harmonies they create. And there are other poets and artists who exert themselves constantly, who turn to nature, but who have no direct contact with her; they must draw everything from within themselves, for no demon, no muse inspires them. They live in solitude, and express only what they are able to enunciate time and again making effort after effort, attempt after attempt. Men created in the image of God will take a rest one day to admire their work; but what fatigue, imperfection, crudeness! Picasso began as an artist of the first type. Never has there been so fantastic a spectacle as the metamorphosis he underwent in becoming an artist of the second type."[56] While following the conceptual and compositional stages of the future painting *Les Demoiselles d'Avignon*, while watching the development of its separate images and the parallel appearance of ideas and pictures, we see how Picasso "formulates what he wishes to express", critically studies the creative process itself, stubbornly forces his hand to learn anew and to discard habitual virtuosity and an almost automatic mastery. "Never was labour less well paid

Head, Study for *Les Demoiselles d'Avignon*, 1907.
Oil on canvas, 96 x 33 cm,
Kunstmuseum, Bàle.

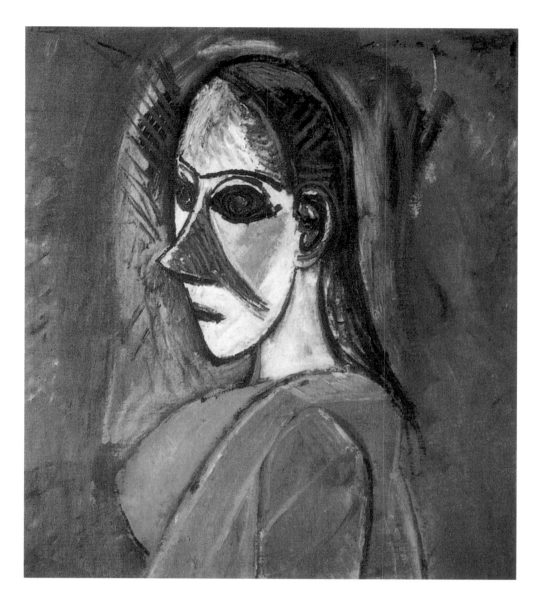

with joys," wrote Salmon,[57] who observed Picasso in his oppressed, troubled, agitated state of mind. Derain did not exclude the possibility of suicide.[58] Yet Picasso's solitude and seclusion were not demoralizing. Recalling that period, he said that work had saved him; indeed, will-power helped to overcome the vagueness of his goal as he laboured over the simplest studies and academic models. Each consecutive stage was a new step into the unknown, every step was a violation of the status quo, a transcendence of given limits, a broadening of possibilities. "But what fatigue, imperfection, crudeness!"

What did Picasso gain at the price of forgetting, with such difficulty, his former vision based on classic pictorial tradition? A new understanding of the plastic arts, in which their formal language stands in the same relationship to the forms of the visible world as poetic language stands to everyday speech. In 1907 Picasso, in fact, discovered what had only been implied in the theme of blindness during his Blue Period: the artist has an internal eye of imagination, it sees and feels emotionally (Penrose), and it is therefore essential to the artist "to realize that the world we see is nothing" (as he said many years later to Kahnweiler).[59]

Locked up in his studio, working through the night as was his habit, Picasso stubbornly concentrated on learning anew, changing his taste, re-educating his personal feelings. There is a reason why nearly all the works of 1907 have the simplest classroom character: studies of nudes, half-lengths,

Chest of a Woman,
Study for *Les Demoiselles d'Avignon*, 1907.
Oil on canvas, 65 x 58 cm,
Centre Georges Pompidou, Paris.

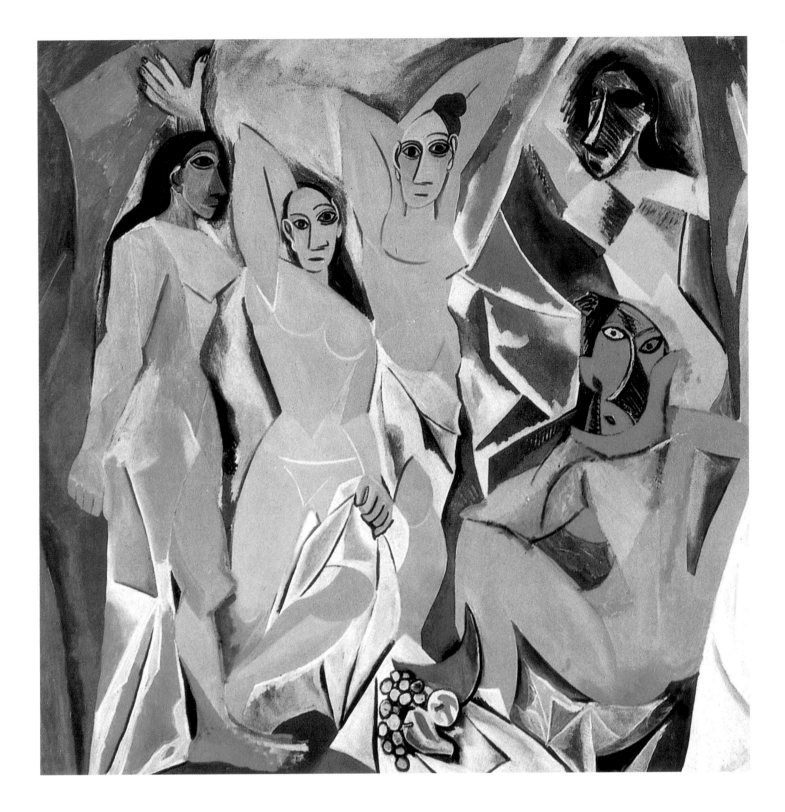

Les Demoiselles d'Avignon, 1907.
Oil on canvas, 243.9 x 233.7 cm,
The Museum of Modern Art, New York.

heads, still lifes; there is also a reason why all of this "academic" work was produced without models, by imagination only. "In those times I worked completely without any models. What I was looking for was something very different," Picasso wrote to Daix.[60] He was seeking the power of expression, but not in the subject matter, the theme or the object *per se*, but in the lines, colours, forms, strokes and brushwork taken in their own independent meaning, in the energy of the pictorial handwriting.

Here he found support in the pre-classic and non-classic experience of mankind: in archaic, "primitive" and "barbaric" artistic systems akin to his own view of himself as a new Adam. On the one hand, the awkwardness and monstrosity of certain 1907 pictures served to re-educate feeling, while, on the other, they corresponded to Picasso's pictorial philosophy at the

time. They both activated his emotional perceptions and imbued the image (thanks to their archaic associations) with a certain timeless atmosphere, a certain eternal background. However, this awkwardness may more accurately be ascribed to the feeling of aggressive destruction so typical of Picasso's revolutionary spirit in 1907.

André Malraux recalls Picasso's words concerning the need "to always work against, even against oneself",[61] and that, it seems, was also a discovery of the period.

This development prompts comparison with that of Arthur Rimbaud, who through the "deregulation of all senses" heroically broke out of his own body and time in an attempt to become clairvoyant, that is, to acquire the power and freedom of the creative spirit, unfettered by the routine forms of poetic vision.

The unknown was also the area of Rimbaud's aspirations and he considered novelty a great value (let us recall that Vladimir Mayakovsky, too, defined poetry as a ride into the unknown). But differing from Rimbaud, "a child brushed much too prematurely by the wing of literature" (Mallarmé) whose world fell to pieces when he repudiated art, Picasso encountered his revolution having, as it were, lived the lives of several artists, having gone through several phases of growth, several periods (which is why Apollinaire spoke about "forgetting after study").

In addition, Picasso's was the language of concrete visual forms, not the ephemeral material of the word which, equally susceptible to emotions and meanings, easily leads the imagination into areas of theory, of purely intellectual abstractions. In 1918 Apollinaire would write: "The formal quest has now taken on a great importance. It is legitimate. How could this quest not interest the poet, since it can produce. Nevertheless, it would seem that during this time Picasso pondered over the effect of the influence of the word on the imagination: seeing the reality of the letter and hearing speech, our inner eye discerns images and we feel the emotions they have created.

But if painting and poetry are the same in essence, then visual elements, cleansed of their ordinary descriptiveness and understood in their suggestive power, are capable of combining in metaphors similar to verbal ones and of bringing into poetic perception new, unknown images, new, captivating feelings, new discoveries in both thought and lyricism?"[62]

In 1907, while seemingly engaged in a purely formal quest, Picasso continually found in his new language various shades of pictorial meaning, amazing in their vitality and their almost psychological essence. The face of the Hermitage *Nude (half-length)* is as impersonal and schematic as a mask. Yet the slightly inclined head, the closed eyes and other fine mimetic touches seem to speak about a condition of lyrical reverie or sleepy rest, while the calm and controlled ratio of warm tones and the thick, fused density of the colour pigment correspond no less to the "moral condition" of the model than does the geometrically pure simplicity of the painting's plastic structure as a whole.

Among the great pictorial revelations of 1907 we find two masterpieces in the Hermitage collection: *The Dance of the Veils* (*Nude with Drapery*) (p.69) and *Composition with a Death's Head* (p.71). The title *The Dance of the Veils* is mere poetic licence, for in reality the canvas represents a nude against a background of academically abstract drapery academically counterpoised in a typical classroom position. However, in spite of the figure's relaxed and even somewhat languorous pose, the entire image is shot through with such varied and dynamically alive currents of energy that one involuntarily associates it with dance:

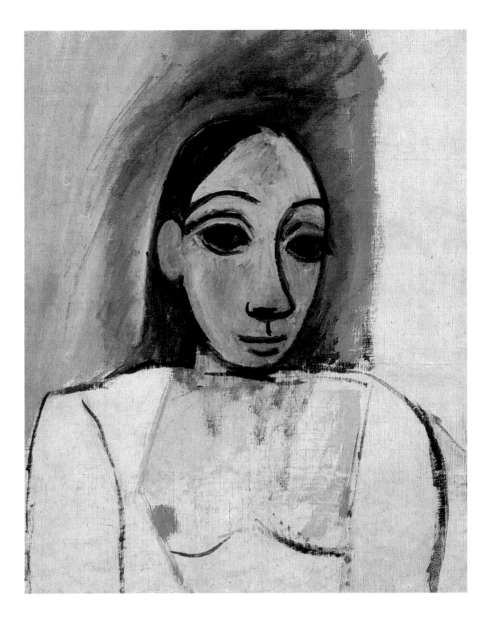

Chest of a Woman,
Study for *Les Demoiselles d'Avignon,*
1906/1907.
Oil on canvas, 58.5 x 56 cm,
Musée Picasso, Paris.

Avec ses vêtements ondoyants et nacrés,
Même quand elle marche on croirait qu'elle danse,
Comme ces longs serpents...

Baudelaire, *Les Fleurs du Mal,* XXV11

Without perhaps noticing it, Picasso in his *Dance of the Veils* returned in essence to the plastic concept of the *Acrobat on a Ball*: a triangle standing on its apex and precariously balancing on a round form (there a ball, here an inverted arc); but while in the 1905 painting it was only the subject, the young acrobat, who stands in precarious equilibrium, in the 1907 work the very tectonic structure is caught in the tense, dynamic balance, along with the troubled linear rhythm, the texture and tonality — in short, the form itself. Contradicting the academic rules of tectonic structure, Picasso used an effect that shocks the senses — an instability creating the impression of profound, organic distress. Yet, nevertheless, it is the form that gives the figure and background pictorial and dynamic unity, in spite of its destructive plastic concept and disharmonious polychromy, in spite of all its internal conflicts.

The tension of the form immediately grabs the viewer, who perceives it as the real subject of the painting. It is purely visual, and although it can be analysed in formal terms, no description can fully render the impression created by this form-subject, woven, as it were, like a straw basket, yet living

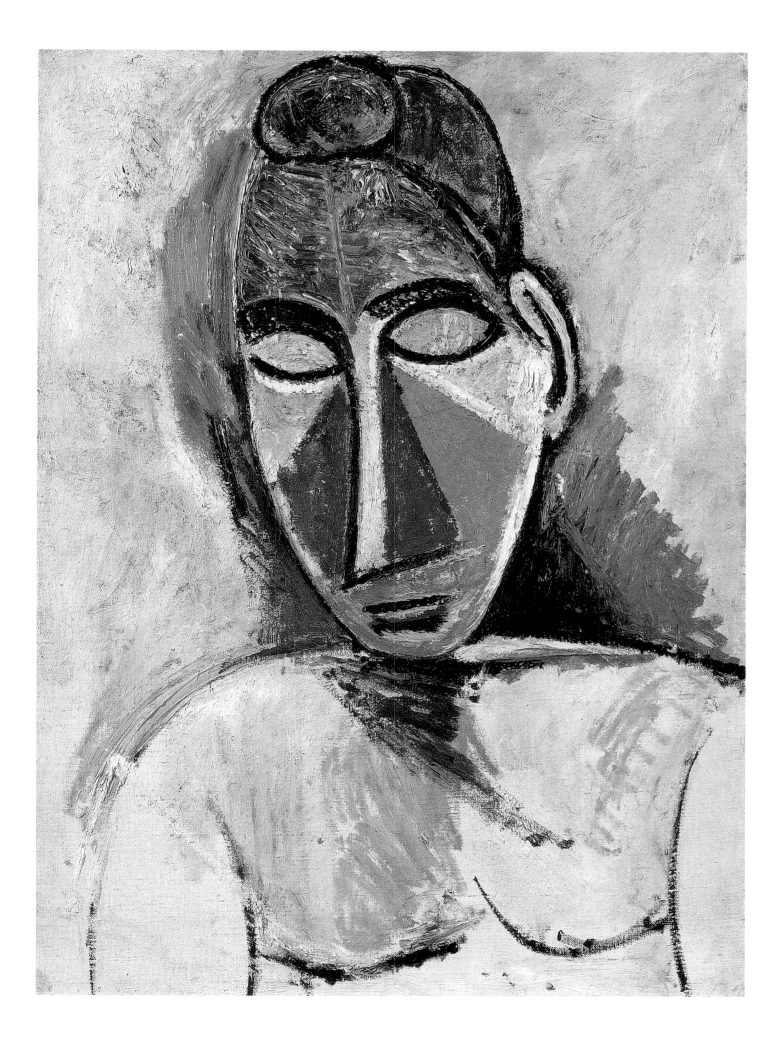

Nude (half-length), 1907.
Oil on canvas, 61 x 47 cm,
The Hermitage, St. Petersburg.

the brilliant life of a diamond that amazes us with its "luminous power" (Salmon).

The Dance of the Veils has traditionally — but groundlessly — been regarded in the context of African influences; the entire year of 1907 is referred to as the African Period. However, Picasso's "barbarism" of 1907 is not ethnographic in character, it is negativistic; a "working against, even against oneself", as he was to say later. *The Dance of the Veils* is polemically oriented on the European tradition of painting; it is literally full of various associations with that tradition, more often than not contradicting it. For instance, even without knowing that Picasso, while working on the Hermitage canvas, painted a copy of Ingres's *Grande Odalisque* in the same manner, one can feel the relationship with Ingres's *La Source*, famous for its powerful line. Finally, the texture of the brushwork bristles with such energy that the viewer is bound to think of the expressive, spontaneous technique of Van Gogh.

The same link with the European pictorial tradition, if not as simply discernible, is embedded in the concept of the *Composition with a Skull*, which is often, and not without reason, interpreted as Picasso's original variation on the Vanitas theme, so widespread in traditional Western painting. Indeed, the death's head, a traditional symbol of the vanity of life, is combined here with the palette and brushes, painting and books, as well as the pipe, as allegories of intellectual and sensual pleasure, characteristic of that genre.

At the same time, the pipe, book of verses, palette, brushes, painting and the skull could be ordinary objects in an artist's studio, and their being thrown together in disorder here is typical of a studio such as Picasso's in the Bateau-Lavoir (to say nothing of all the others he was to occupy). No spirit of wisdom, no ethical preaching of philosophy ("remember death", "all is vanity") comes from this still life.

On the contrary, the feverish funereal quality of its cold and strident tonalities, the collisions and broken lines of its jagged, sharp surfaces, the headlong fall of its diagonals, all reflect an exalted mourning of a purely personal kind. Much like a huge nugget of raw gold, the human skull serves only to give a final definition to the metaphorical meaning of the form: this is a requiem, though perhaps an unusual one. In the foreground, "face to face" with the death's head, stands an object as mundane as an empty household vessel — a small pail? a pot? — seen even more clearly and impressively in the sketch. In the composition, this object is no less meaningful than the skull — and, perhaps, not only in the composition. Not being a traditional attribute of the iconographic Vanitas theme, such an extravagance in this serious context must have had a very significant meaning, even for Picasso's unorthodox imagination. If the importance of the subject and the clearly agitated mood of the artist reflect a profoundly personal reason for painting this *Composition with a Skull*, then this object is the key to its meaning. Its secret may be read through a play on words: an earthenware jar — *jarra* in Spanish — suggests the work is dedicated to the writer Alfred Jarry, whose sudden death on 1 November 1907, could not but have affected Picasso.

In fact, the bold comparison in this memorial composition of a skull and an earthenware jar as two empty vessels is tragically grotesque and full of sorrow. We feel here not only the artist's emotions, but also something of the unconventional, shocking style of Jarry, who was to be remembered as literature's eternal impudent rogue.

It is not sufficient to understand the revolutionary upheaval of 1907 only as a search for untraditional formal approaches to traditional themes in art, only as a renewal of the language of the visual arts.

The Dance of the Veils, 1907.
Oil on canvas, 150 x 100 cm,
The Hermitage, St. Petersburg.

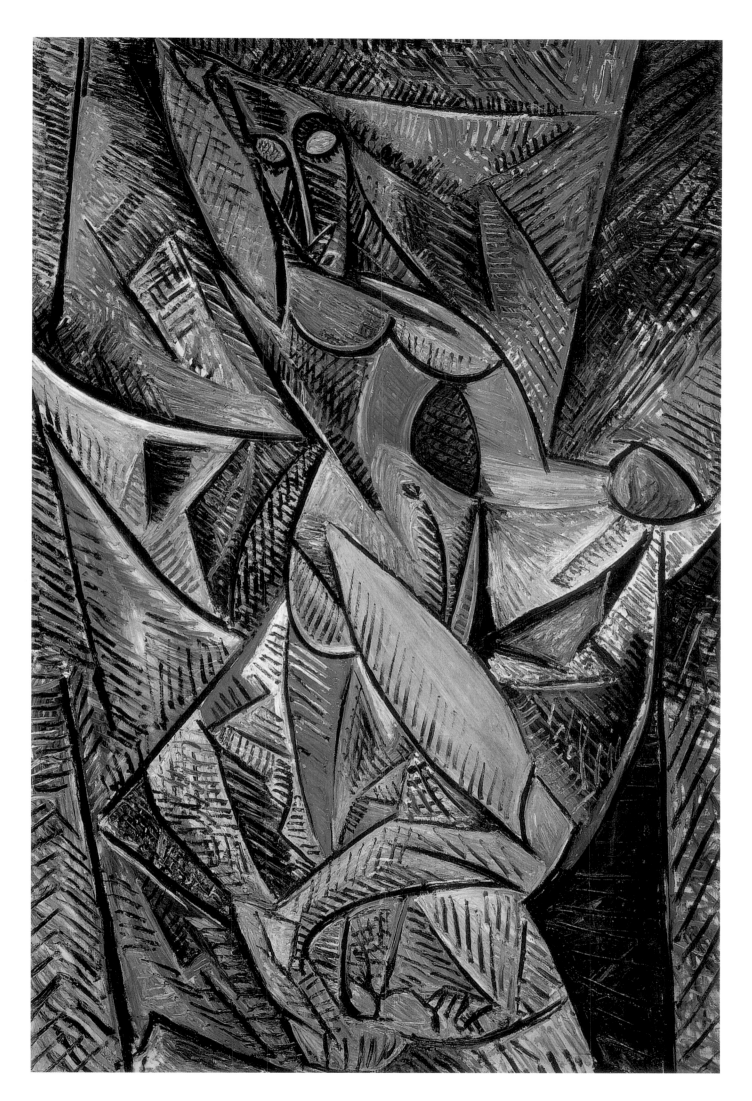

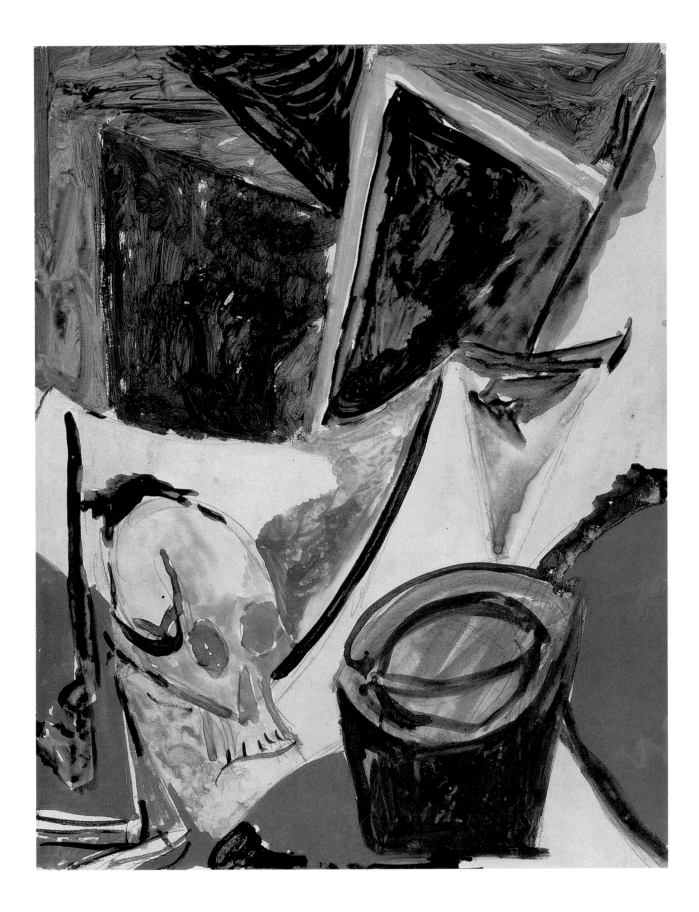

Composition with a Death's Head, Sketch,
1907.
Watercolour, gouache, pencil on paper,
32.5 x 24.2 cm,
The Pushkin Museum of Fine Arts, Moscow.

Composition with a Death's Head, 1907.
Oil on canvas, 115 x 88 cm,
The Hermitage, St. Petersburg.

Friendship, Sketch, 1908.
Watercolour, gouache on paper, 63 x 47.4 cm,
The Pushkin Museum of Fine Arts, Moscow.

The main achievement of Picasso's creative spirit — the result of this revolution and the foundation of his entire subsequent work — was the poetic metaphor, that is to say the creation of an image based on the most unexpected associations, on the interplay and power of imagination. The development of this new poetry would, during the Cubist Period, lead to such startling inventions as the inclusion of words as images in a visual context. That was when Picasso, as he was later to say, would paint with words. Perhaps the very first step in that direction was his requiem for Alfred Jarry, *Composition with a Death's Head*.

The appearance of this programmatic painting — this still life on the theme of death — on the eve of 1908 reveals Picasso's need to express his new creative consciousness in conceptualized works after a long period of re-evaluation and re-assessment.

Yet even though from the start of 1908 Picasso sketched and developed a multitude of subjects, each of which had the potential to lead to a significant composition, hardly any of them went farther than the preparatory stage, and those that did turned out differently from their original concept.

In spite of the attention paid over the past decade to Picasso's so-called early Cubist work and all the efforts made to achieve some order in the understanding of his evolution,[63] the clarity one would like to see in the general comprehension of the period of 1907-1908 is still lacking. The chronology is confused, reflecting a vague understanding of the artist's creative ideas, of their interrelationships and progressions. The issue of Picasso's pictorial philosophy at that time has hardly been examined and, in fact, its importance has yet to be fully appreciated. The formal approach, the preconceived view of works of that period as being proto-Cubist or pre-Cubist (as a proto-stage in the development of Cubism *per se*) does not allow scholars to assess the artist in his full significance. Yet it was precisely in 1908, at the height of "proto-Cubism", that visitors to Picasso's studio heard him speak not "of values and volumes", but "of the subjective and of the emotions and instinct".[64]

If one leaves aside the concept of proto-Cubism and looks upon the creative material of 1908 as a single entity, ignoring differences in sizes and techniques between paintings, sculpture, and minor sketches, then one sees their organic unity as a monumental ensemble — not of works as such, but of Picasso's creative ideas. One involuntarily thinks of some grandiose concept that was never achieved as a real project: something akin to Michelangelo's tomb of Pope Julius II, where individual sculptures — fragments (often incomplete) of the entire work — have long enjoyed their own separate museum existence, playing a role never conceived by the artist, mysteriously meaningful things-in-themselves, the independently valuable splinters of a non-existent whole. The same applies to Picasso's works of 1908, which startle one at first glance by their significance and power of expression; but for separate works to acquire their real meaning, one must restore the context of that art. Like Goethe, Picasso could have said (indeed, he did say, although in different words): "All my works are only fragments of one great confession; to understand them, one must know their origins, capture the moment of their conception."[65]

Turning from the paintings to the original ideas — sketches, drafts, studies — one sees everywhere not simply figurative compositions but, as it were, depictions of certain events, ideas for subjects, each with its own internal dramaturgy. It seems as though the new form itself - built on the expressive rhythm of strong, sinuous lines, on sharp, clean, articulated planes, on the internal equilibrium of the entire pictorial structure, this morphologically clear and monumentally impressive form — produced in the artist's

imagination impersonal, timeless, powerful images. What could be vaguely felt in the works of 1907 as something existing before time, as some background to eternity, now, thanks to the characteristics of form, becomes objective reality, emerges in the thematic solution itself. Picasso's creative thinking, however, had long before crossed the psychological frontier into the area of ideas that are alien to story-telling — poetic "novels" with narrative and psychological links — but from which prototypes of universal mythological thought emerge. Deeply involved throughout 1907 in the development of a new plastic anatomy for his painting, an anatomy based on the material of the human figure, Picasso imperceptibly, instinctively uncovers and then grasps the corporal-psychological differences of structure between the male and the female archetype: the square form (symmetry and static quality) of the one, and the rhombic form (the capacity for plasticity and the Gothicism) of the other. Basic morphological structure helps him to grasp the metaphorically expressed essential truth of natural phenomena.

By that time Picasso had already discovered African wooden sculpture in the ethnographic museum at the Palais du Trocadero and, like many other artists, had bought several statues and masks. For him these were not only works of incredible outward expressiveness, works in which others sought to find an explanation of his innovations. André Malraux cites Picasso as saying: "Their forms had no more influence on me than they did on Matisse. Or Derain. For them, though, the masks were sculptures like all others. When Matisse showed me his first African head, he spoke to me of Egyptian art."[66] Picasso, however, immediately saw in them magical objects with their own artistic idioms. And the discovery of African art staggered him by its correspondence to his own deeply personal attitude towards life, his own attitude towards creative work. Just as in the year before, the desire for self-realization had led Picasso to prehistoric Iberian sculpture, now the irrational, superstitious side of his complex nature led him to grasp the universal goals of art through the magical figures of spirits. During the autumn of 1907 the artist spent long hours carving strange, fetish-like figurines and primitive dolls and making sketches for future sculptures (see drawings and engravings). He was not alone in this passion, for Derain as well was occupied with carving at that time. Unlike Derain's wooden sculptures, however, those of Picasso bore not a hint of decorativeness. These were indeed fetish figurines, and they exude something grave, threatening, dramatic. The same figurines became the characters of his paintings near the beginning of 1908.

Such is the work *Friendship* (p.77), the motif of which was originally intended for a scene depicting bathing in a forest lake and was developed in a multitude of sketches and in several compositional versions. The Moscow gouache sketches for the Hermitage painting trace the characters' basic pictorial features: the feminine figure with the drapery hanging over her arm is delineated in light ochre tones; leaning on her shoulder, a dark male figure emerges. Picasso places the two in one block, as if carved from one piece of wood. He sees human anatomy as a plastic construction, the painting as a sculpture. "With these paintings — Picasso told me," the sculptor Julio González recalled, "it is only necessary to cut them out — the colours are only the indications of different perspectives, of planes inclined from one side or the other — then assemble them according to indications given by the colour, in order to find oneself in the presence of a 'sculpture'. The varnished painting would hardly be missed."[67]

In the completed *Friendship*, Picasso only gave the bodies greater density, more clearly underlined the relationship of form and planes, and somewhat subdued the tonality, thereby lending the colour scheme more

Woman Seated (Nude Woman Seated), 1907-1908.
Oil on canvas, 150 x 99 cm, The Hermitage, St. Petersburg.

74

severity and strengthening the powerful effect of unity, of the figures' common movement.

Perceiving the painting as a sculpture, Picasso approached the subject as a sculptor: if painting is always an illusion, something projected onto a screen, sculpture is always an objective reality, the image of the sculpture being present in the character of the object-thing. Although the title *Friendship* is frankly conventional, we can "read" the gestures of support and touch — both gentle and warm; we can see the unity and agreement of rhythm and the shared somnambulism of the characters. These qualities inject a psychological aspect, almost even a note of genre, into the impersonal image on the canvas. They are insufficient for a theme but enough for us to trace an associative course leading to Picasso's pictorial views during that proto-Cubist period.

The reason for, and meaning of, Picasso's proto-Cubism are normally explained as the artist's desire to radically simplify his pictorial vision of the objective world, to strip away the layers of illusion and reveal its constructive physical essence. It is usual in this context to cite the famous words Cézanne wrote in a letter addressed to the artist Emile Bernard that was published in the autumn of 1907: "Treat nature by means of cylinder, sphere, cone." Another of the generally assumed points of departure for so-called proto-Cubism is the African influence, which introduced simplification of

Friendship, Sketch, 1908.
Oil on canvas, 61.9 x 47.6 cm,
The Pushkin Museum of Fine Arts, Moscow.

Friendship, 1908.
Oil on canvas, 152 x 101 cm,
The Pushkin Museum of Fine Arts, Moscow.

anatomy and other expressive features. The combination of these two diametrically opposed influences — Cézanne's "perceptualized" art and black Africa's "conceptualised" art — is usually employed to explain the stylistic phenomenon of proto-Cubism as an art entirely preoccupied with the problem of space.

Yet when we dig deeper into the sources of Picasso's creative ideas — the sketchbooks of early 1908 — we find not objective reality geometrized for geometrization's sake, but rather a desire to lend adequate expression to the artist's subjective truth concerning the primary and most profound essentials of the human world. Using the language of words, Apollinaire (Picasso's alter ego) spoke of the same thing at the very same time: "But I had the realization of the eternal differences of man and woman" — this is repeated four times in a short, obscure, mysterious poem called *Onirocritique*, published in January 1908.

Picasso's proto-Cubism of 1908 began with this expression of the eternal differences between man and woman. During that time, drafts of two paintings appeared in his sketchbooks: a seated man and a seated woman, conceived as a pair.

The man is monolithically cubic, like an Aztec statue, with an accented frontal plane and a symmetrical structure: both hands are clasped on the torso, the head is inclined, the eyes are closed, and there is something morose in the entire figure, with its primitive power. The woman's plastic character is more complex: a hieroglyph stressing asymmetry, broken lines expressing suffering (see a ceramic tile of a later date). The male sketches were executed in oil only at the end of 1908 (see *Man Seated*). *Woman Seated* (p.75) was immediately created as a large canvas.

In this painting Picasso was hardly trying to solve the "spatial problem through a brutal geometrization that here gives the woman the semblance of a mechanical statue."[68] On the contrary, everything in *Woman Seated* is subordinated to expression: not only the figure's sorrowful pose, but also the primitive form and the brutal, graphic style, the depressing brownish colour and the drama of the tonal contrast, even the scarified brushwork — all are part of the metaphor of suffering. Deformation of body and expression have a pictorial meaning here: in these "distortions" one can see an attempt to express the nature of woman as a *machine à souffrir*, as Picasso himself was to say thirty years later.

The second antithesis to the seated man — another facet of woman, expressive but without suffering — is represented by *Woman with a Fan* (p.103), also originating from the same sketchbook. The harmonious principle of internal equilibrium holds sway in this work: mutual reflections, response patterns of form and rhythm, tranquil shadings of ochre, white and grey tones. First conceived as a portrait of Fernande Olivier, the painting preserved in its formal structure the tranquillity, classic clarity and majestic bearing of the model's character and physical type. And if the compact, reserved image reminds one of seated Egyptian statues, in a less literal way, deep inside, its monumental proportions prefigure the gigantic order of Picasso's so-called Classic style of the 1920s.

The third variation on the theme of seated women coming from that same sketchbook of the spring of 1908 led several months later to the painting *Nude in a Landscape (The Dryad)* (p.79), here emphasizing the dark, primitive nature of sex. The pose of the nude woman who, in the sketch, seems to be slipping powerlessly from her chair, became transformed in the painting into a threatening gesture of sexual aggression. Advancing on the viewer from the depths of a forest, as if from some niche, the figure is perceived as the incarnation of slumbering, powerful, blind nature, carrying in

its loins not only the power of life but the irrational energy of destruction as well. Often called *The Dryad*, this menacing nude is older than the minor forest deities of Ancient Greece — she is a relative of the great goddesses from mankind's most ancient mythologies.

Here Picasso, in fact, depicted not a woman but some kind of prehistoric female statue, with all its attendant sculptural crudeness and expressively savage distortions. At the same time, it appears that in the pictorial solution he aimed at the same dramatic effect of harshly etched nudity that is so striking in the sombre, melancholy darkness of seventeenth-century religious painting.

Nude in a Landscape
(Dryad, or Nude in the Forest), 1908.
Oil on canvas, 185 x 108 cm,
The Hermitage, St. Petersburg.

Obviously, there was a reason why these paintings struck their first Russian viewers as examples of cult art (whether "diabolical" or "barbarian" is of little importance now), just as there was a reason why Daix, sensitively exploring Picasso's Cubism, even from formal positions, kept returning to the ideas and works of Claude Lévi-Strauss on the subject of myth.[69] Without doubt, Picasso's proto-Cubism — coming as it did not from the external appearance of events and things, but from great emotional and instinctive feelings, from the most profound layers of the psyche — clairvoyantly (as Rimbaud would have said) arrived at the suprapersonal and thereby borders on the archaic mythological consciousness.

In formal terms, *The Dryad* may be seen as an interpretation of the traditional nineteenth-century theme of a bather in the open air. But in essence, delving deep into the meaning, Picasso strove to reveal behind its bucolic appearance woman's strong ties with the physical world, especially as they express themselves in her powers of generation.

The key work in which both the formal and the pictorial issues of Picasso's proto-Cubism were concentrated was his major canvas of 1908, *Three Women*. This, too, took its origins from the bathers theme which he began to work on about the end of 1907, probably under the influence of Cézanne's epic *Bathers*. Picasso conceived a composition involving bathers in a forest in which two figures of "friendship" emerge, as if from the wings of a theatre, from behind trees on the left and approach the banks of a lake or stream where a group of three naked bathers sit in a moored rowing-boat. The narrative element apparent in the motif of friendship and in the boat on the forest lake, as well as in the general concept, served once again as a springboard for the imagination, leading not to a story but into an anonymous and timeless mythic dimension.

But after going through several preliminary studies, Picasso discarded the narrative elements and, with them, the frieze-like scale of the composition. In *Three Women* (p.86) all that remains of the original concept of forest bathers is the general structure of the three-figure group on the right and the colour scheme: the red tonality of the bodies, the vibrant emerald tones of the vegetation and the silver-grey colour of the water, transposed to the flowing drapery near the figure on the left. As for the three gigantic nudes, who seem to have just emerged from some rock-like source, to be hewn from something more solid than flesh, they are both in spirit and structure more reminiscent of Michelangelo's slaves straining to emerge from the anguish of chaos than of bathers basking in the lap of nature.

Their existence borders on slumber, their somnambulistic poses speak of hidden, unconscious, instinctive driving forces: they have no power over their existence, but in it they are bound together by some design. Studying these figures, one must not ignore the differences which subtly but unequivocally separate one from the other in spite of their apparent homogeneity. These differences are not only the result of each of the figures having been executed at a different time, but also reflect their status as individual images; the compositional and conceptual unity and the internal dramaturgy of this strange scene, steeped in torpor, are built on their correlations. But what are these differences?

The figure on the right is expressly female in character; it is opposed to the one on the left — expressly male. Calling attention to this fact, Steinberg notes it would be more correct to call the painting *Two or Three Women*.[70] However, what follows from his interpretation is that the figure in the middle does not depict a woman, but is the personification of a "preconscious hominid, the reserved matrix whence humanity sunders

Woman Holding a Fan (After the Ball), 1908.
Oil on canvas, 150 x 100 cm,
The Hermitage, St. Petersburg.

81

forth, the he and the she of it." This American scholar thus treats the painting's content from a Freudian perspective as a myth of creation, a psychogram of the shaping of human life, in which the separation of the sexes is implicitly dominant. Yet it is precisely this sort of unequivocal and rationalistic interpretation that calls for caution in the case of Picasso's multivalent images, which (borrowing an expression from Goethe) cannot be divided by reason and still result in a whole number as a quotient. Here it is better to remain closer to the material.

Renouncing his original concept of the five-figure *Bathers in the Forest*, Picasso also dropped its thematic conflict no matter how vague it was, that is to say, the drama which was always important to him. He began to develop the three-figure motif of *Three Women*, and here the intermediate stage was the rhythmic version (as Daix called it) of the motif, with its powerful, dynamic image of a spiralling centrifugal vortex bordering on abstraction. Yet even this highly stylised image seemingly implied its own subject, its drama.

This becomes apparent after re-establishing certain links. As was noted earlier, at the beginning of 1908 Apollinaire revolutionized his creative outlook under Picasso's influence. He was inspired by the experience of painting — that is, by Picasso's experience — as many of his poems and writings on aesthetics during the spring of 1908 testify.[71]

Apollinaire's imagination then gave birth to the great image that became central to his poetry, the key to the transformation of his creative outlook. This image was that of an immense flame and the entire spectrum of its meanings and metaphors: from the light of his friend Picasso's starry eyes to the bonfire of faith that can destroy but also gives new birth to the phoenix of poetry, to the spark of reason, whose radiating creative power equals the divine, life-giving bounty of the Sun. This flame became the poet's beloved, red-headed beauty.

This image was first born in the spring of 1908 in Apollinaire's article on the principles of painting inspired by Picasso's new aspirations and called *Les Trois Vertus Plastiques*. In it the poet postulated the following: "the flame is a symbol of painting and the three plastic virtues burn with radiance." He then examines each of the three: purity, unity, truth. "Flame has a purity which tolerates nothing alien and cruelly transforms into itself whatever it touches. Flame has a magical unity; if it is divided, each fork will be like the single flame. Finally, it has the sublime and incontestable truth of its own light."[72]

What is important for us here, though, is the amazing historical and typological parallel between Apollinaire's image of this enormous flame as a metaphor of painting ("A surprising art whose light is without limits") and the rhythmic version of *Three Women*. This version may be seen as a possible metaphor of the flaming vortex cruelly transforming three women's bodies in its image; as such, the work has a magical unity of style and is graced with the supreme persuasiveness of a work of art. In that sense one must note the hot, terracotta red of the figures in all the studies, at times literally achieving a flame-like intensity, the triple unity of the arrow-like forms impetuously driving skyward, and the agonizing languor of the poses. As in Apollinaire's article, both a three-forked flame and a heraldic lily, the symbol of purity, are evoked.

Picasso must have known his friend's articles and verses. In the Bateau-Lavoir studio Apollinaire must have seen that immense canvas with its three red nude colossi, seemingly burdened with the mystery of their existence. Throughout 1908, owing to this new understanding, Picasso and Apollinaire were again reflected in each other's work. Once again, as during the Circus

period, their themes and methods had something in common: they both aimed to internalise all depiction and produce the image through layers of subjective association, through the play of metaphors, and both were unabashed by esoteric expression.

And when *Three Women* moves from the rhythmic-sketch stage and the emerald tonality of the *Bathers in the Forest* sketch reappears, when these flaming red bodies acquire their individual shapes and their barbarian, primeval nature is established, then, once again, there appears a parallel with Apollinaire's works of 1908, with his soon-to-be-published book *L'Enchanteur Pourrissant*. It, too, contains the motif of a dark, sombre forest with its slumberous mysteries, all revolving around the central idea of realizing the different natures of man and woman. The work itself is presented in the form of a myth, "the roots of which," as the author says, "reach very far, into the Celtic depths of our traditions."[73]

Three Women is one of those compositions that do not lend themselves easily to direct verbal interpretation: at the heart of the image is a secret that radiates a tension directed towards the viewer's emotional and intellectual life. In the late series *347 Etchings*, in which Picasso surrendered to the flow of memory and free association, there is sheet No. 38, which seems to echo that distant year of 1908. The aged artist sits in the gloom of his studio in front of a huge, towering canvas: he studies his work, in which three colossal nudes live in their own autonomous reality; one of them, with Cubist features in drawing and structure, stands with lifted elbows, studying the old painter, so small and illusory in comparison with them. According to scholars, *Three Women* preoccupied Picasso for many months in 1908,[74] and his efforts during that period evolved, as it were, against the background of this painting, which dominated the studio and bore the results of many other parallel works in both painting and sculpture.

The Bath, 1908.
Oil on canvas, 38 x 62.5 cm,
The Hermitage, St. Petersburg.

Versions and Projects for *Three Women*.

Thus, Picasso's interest in reproducing volumes on a flat surface was inseparable in 1908 from sculpture, and it was not before 1909 that the artist came into contact with Cézanne's purely pictorial experience, moving from the colouring of flat planes, inclined this way and that, to the modulation of volume by means of minute, form-creating daubs. The form of *Three Women* is a sculptor's creation, for one can indeed imagine its being cut out along dotted lines and rebuilt as a sculpture. As for *Peasant Woman* (full-length) with its powerfully hewn volumes and mass that seems to be charged with dynamite, it originated directly from work on a carved statue, three-dimensional studies for which appeared in the notebooks. Picasso's true sculptor's temperament, recognized by Julio González, causes him to be very laconic and to reject incidental features in order to lay bare the plastic essence of the image and emphasize its reality. Picasso called such an approach "surreality" and, even in the days of Cubism, considered himself a realist artist. For Picasso, sculpture also served to verify the feeling of reality, in the sense of physical validity, since for him "sculpture is the best comment that a painter can make on painting."[75]

Peasant Woman (half-length) is the portrait of the statue of a woman in whose house, situated in the village of La Rue-des-Bois, not far from Paris, the painter spent several weeks at the end of the summer of 1908. We know her name, and there may even be photographs of her somewhere, but they can hardly convince us more of the reality of Madame Putman's existence than Picasso does in *Peasant Woman*, with her coarse features and peasant body, shaped by the backbreaking labour of farming. The young Van Gogh depicted the same ungainly common types with a poignant realism, but in Picasso's monolithic peasant woman, executed so sparingly and with such precision, we encounter a super-realism that turns the peasant woman into some great chthonian goddess, petrified by insurmountable gravity, her face turned skyward in futility.

"A bottle on a table is as significant as a religious painting" — there can be no better description of the essence of Picasso's still lifes of 1908 than the one he himself gave in a conversation with Yakov Tugendhold in the early 1910s.[76]

And if scholars now cautiously speak not only of a return to the concrete but also of a dramatization of the surrounding space (Daix) in such works as *Green Bowl and Black Bottle* (p.90) and *Pitcher and Bowls*, those same still lifes in the Shchukin collection were perceived in Russia in the second decade of this century as some kind of spiritual revelation, "black icons" of sorts. Consisting not of symbolic or mysterious objects but of trivial utensils, these images seem, nevertheless, motivated more by a desire for self-expression than by an interest in material objectivity. Such, at least, were these initial works. As a matter of fact, they were like all the compositions, figures, and landscapes executed in Picasso's Paris studio in 1908 in that they were evidently not drawn from nature. We are shattered by the dramatic exaltation of *Green Bowl and Black Bottle*, an effect one would rather expect from a scene of passion and martyrdom. Forty years before Abstract Expressionism, the pictorial power of the painting's background predicted (and perhaps transcended) that later movement, with its "sorrow of final days", so sharply felt by the Post-Symbolist critics of Picasso in Russia. Such extraordinary dramatic power must have been accompanied by no less extraordinary psychological conditions. From Fernande Olivier's memoirs we know how deeply Picasso was shocked by the suicide of his Bateau-Lavoir neighbour, the German painter Wiegels, on 1 June 1908. While stylistically belonging to the summer works of that period, the *Green Bowl and Black Bottle*'s funereal black-and-red tonal chord may reflect Picasso's as yet unalleviated anguish. Yet in

the still life *Pitcher and Bowls*, painted soon after, controlled thought dominates over the drama of emotions. This fact is manifested in several ways: in the incontestable logic of the spatial plastic structure, as opposed to illusory perspective; in the monumental grouping of sculptured forms concentrated in an ascending spiral around a common axis; in the overall rhythm of curves and ovals; in the vibrant, yet solid equilibrium of the entire tectonic structure; in the painting's image; in the contained energy of the brushwork; and, finally, in the desire to achieve perfection in completeness.

Three Women, Sketch, 1908.
Watercolour, gouache on paper, 54 x 47.7 cm,
The Pushkin Museum of Fine Arts, Moscow.

Three Women, 1908.
Oil on canvas, 200 x 185 cm,
The Hermitage, St. Petersburg.

At the end of the summer of 1908, spent in the wooded countryside of the Ile-de-France, where old Corot's nymphs seem to crop up everywhere, the soothing surroundings of La Rue-des-Bois restored a sense of balance to Picasso's vision along with a certain almost naive simplicity. In the landscape *House and Trees* (*House in a Garden*) (p.93), created there, "a house is without doubt a house, and a tree is a tree."[77] Like a wood-carver of bas-reliefs, Picasso rendered the space of his landscape by junctures of broad parallel planes, accenting the three-dimensional depth through the counterplay of rhythmically receding trees, as majestic as monuments. But because of the calm, balanced structure of the composition and the restrained, natural colour scheme, we have the impression of a more objective view of a world than previously, a world with a road, a house behind a fence, a ploughed field, behind the tree to the right, and a low hill rising in the distance under a cloudy sky.

The still life *Pot, Wineglass and Book*, also probably painted in La Rue-des-Bois, has the same quality of objectivity and simplicity. The overall feeling is one of tranquil contemplation, of both the object-motif and the formal relations in the canvas. The eye easily takes in the forms, clear-cut but not harsh, the lines and surfaces, the uncomplicated compositional relationships of three objects and three planes.

The space that they engender has something of a Byzantine icon's unreal, relative quality and of Zurbarán's ascetic still lifes. However, in Picasso's still life, which is alien to symbolism and metaphysics, the refraction of the pot's edge in the wineglass immediately introduces an element of magic into a commonplace, inanimate world, transformed by an artist whose eye retains the ability to be surprised and who finds a new formal syntax in reality itself.

In the summer of 1908, Picasso at first turned to the still life genre because of his depressed state of mind and a desire to find support in the world of simple realities. Later, his inquisitive and creative penetration into the specifics of how painting might represent objective realities opened the way to a completely new method of plastic representation called Cubism. It is not accidental that the still life genre, with, as Georges Braque said, its concrete space which one can almost touch,[78] became the favourite subject of Cubist painting.

No other genre was so conducive to a concentrated analytical inquiry into the structural principles of the stable forms in a spatial ensemble, into the controlled rhythmic discipline of a rectangular surface. For Picasso it was normal and logical to move from the form of three-dimensional sculpture to the tangible, objective values of still life compositions. But this movement, in turn, presupposed a shift in his attention from problems relating to sculpture to problems of pictorial expressiveness.

The absence of exact dates, which makes it impossible to determine the absolute chronology of Picasso's proto-Cubism, is perhaps most vexatious for the period between his stay in La Rue-des-Bois in August 1908 and his departure for Horta de Ebro at the end of the spring of 1909.[79] When one considers as a whole all that was done over these eight months — that is, everything created on the very threshold of Cubism — one sees the artist's thoughts flowing in many directions, some of which led to and synthesized new trends, while others temporarily disappeared below the surface. What is needed here is a theory of evolution by which to organize the material and especially an appreciation of the impulse triggering the entire movement. Having a *post factum* knowledge of what might be called the ideal goal of this progression, Cubism, scholars observe the accumulation in Picasso's work between the autumn of 1908 and the spring of 1909 of those formal

features which mark the "most important and certainly the most complete and radical artistic revolution since the Renaissance".[80]

Just as African art is usually considered the factor leading to the development of Picasso's classic aesthetics in 1907, the lessons of Cézanne are perceived as the cornerstone of this new progression. This relates, first of all, to a spatial conception of the canvas as a composed entity (Maurice Denis), subjected to a certain constructive system. Georges Braque, with whom Picasso became friends in the autumn of 1908 and together with whom he led Cubism during the six years of its apogee, was amazed by the similarity of Picasso's pictorial experiments to his own; he explained that "Cubism's main direction was the materialization of space."[81] Not of traditional, optical, illusory space, created by Renaissance methods of perspective, but of a new space which Braque called "tactile, manual" and which he sought by means of still life compositions, tonal spectrums and Cézanne's modulated strokes. "The contact with Cézanne was at the origin of everything. It was more than an influence, it was an initiation. Cézanne was the first to have broken with scientific, mechanized perspective that had been practised by painters over centuries and which had excluded the possibility of any innovation."[82]

If, however, the landscapes and still lifes of the Master of Aix served Braque, first and foremost, as lessons in well-tempered space in which objects are nothing but plastic appurtenances, for Picasso these works constantly

La Fermière (half-length), 1908.
Oil on canvas, 81 x 65 cm,
The Hermitage, St. Petersburg.

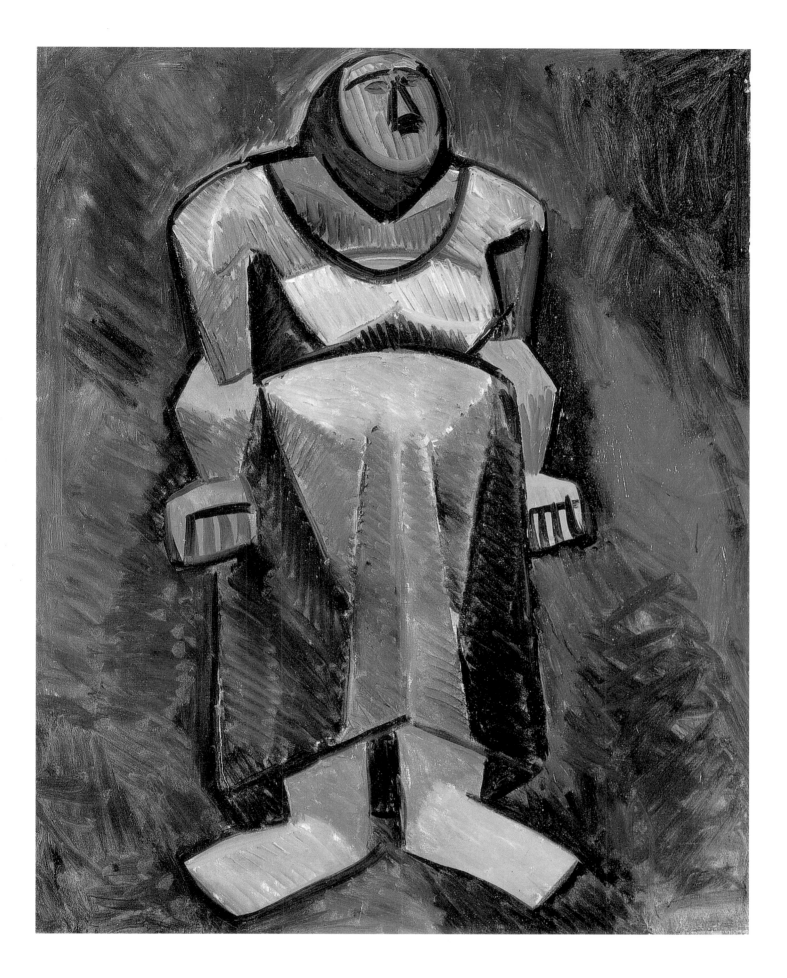

La Fermière (full-length), 1908.
Oil on canvas, 81 x 56 cm,
The Hermitage, St. Petersburg.

Green Bowl and Black Bottle, 1908.
Oil on canvas, 61 x 51 cm,
The Hermitage, St. Petersburg.

conveyed a feeling for the power of Cézanne's attitude towards his subjects: the controlled Romantic drama of feelings and emotions, achieved by a conscious pictorial method, whether it involves pears on a plate, a pine tree on a cliff, the massive Mont Sainte-Victoire, or nude forest bathers. And in Picasso's so-called Cézanne style (as opposed to Braque's, their technical and stylistic similarities notwithstanding) there always exists a Romantic, and often thematic, feeling for the reality of the depicted image, be it a still life, a landscape, or a figure (the latter held no interest for Braque). Cézanne called himself a primitive of Art Nouveau (like the great "primitives" in the museums). As early as 1904, having become friends with Cézanne, the painter Charles Camoin referred to him as a primitivist of *plein air*.[83] It was that primitive element in Cézanne's "wild and yet sophisticated nature" (Pissarro)

that Picasso, always sensitive to the instinctive, preconscious origins of art, must have sensed so keenly in Cézanne's paintings.

It was for the same reason that, for just a few francs in a third-rate shop, Picasso bought a portrait of a woman by Douanier Rousseau which had amazed him, a portrait that he might have heard about from his old acquaintance Alfred Jarry. In November 1908, Picasso gave a banquet in the Bateau-Lavoir honouring Rousseau. Mentioned in many memoirs, this sincere and touching celebration combined elements of popular carnival and bohemian farce. It was probably around the same time that Picasso painted a small group of still lifes revealing his preoccupation with Rousseau's art.

One was *Flowers in a Grey Jug and Wineglass with Spoon*. Picasso's bouquet seems to have been picked in Douanier's luxuriant tropical forests: the same

Decanter and Tureens, 1908.
Oil on cardboard, 66 x 50.5 cm,
The Hermitage, St. Petersburg.

exotic quality and sinister mystery are present in the various corollas and petals, in the oily leaves of these flowers. Yet at the same time the emphatically commonplace character and prosaic simplicity of the environment sombrely reflect the real fact. In their magnified and simplified details, awkward proportions, and drained colours, these plants are clearly reminiscent of those artificial wax flowers made by provincial artisans like, for instance, the parents of the beautiful Fernande Olivier. Picasso seems hypnotized by the pseudo-vitality of the artificial flowers.

As with some transformed being, he divines their other, real nature, then underlines it by comparing it with the unequivocally abstract contour of the goblet, icy in its transparency and yet recalling a flower on a stem. The artist emphasized the value of his motif precisely through the effect of almost solemn representation: the bouquet (which is not free of the coarseness of a cheap, popular decorative print) stands on a massive mahogany chest of drawers, as if on a pedestal, and seems to come to life through the dynamic nervousness of the flowers' "ears" and "eyes", turned this way and that, the "gestures" of their leaves, their muted yet colourful chord struck against the morose and constrained "Spanish" atmosphere of the background.

"To be able to see, that is to forget what things are called," Paul Valéry wrote,[84] describing the painter's vision. But Picasso, who knew how to see, had a deep personal conviction about never forgetting the name of what he depicted; he grasped the realities of his objects and found their corresponding pictorial equivalents. Throughout his entire career, the subject — the object-motif — was never irrelevant nor arbitrary, for it furnished the poetic impulse of creativity. Even though the Cubist method of total tactile examination provided both of the pioneers of Cubism with a way to completely master the object, the difference was that for Braque it was an object of artistic interest, while for Picasso it was an object of love. Could Picasso, then, ever neglect the pictorial for the sake of a purely aesthetic goal? Could he have been seduced by abstraction? His imagination was full of objects and themes of love, and, even on the very threshold of Cubism (in the winter of 1908-1909), the representational element clearly dominated over the problem of the structural unity of the work.

During this period of multiple and varied pursuits, Picasso does not even seem to have been concerned with the problem of "making a picture" (again differing from Braque); he seems to have had a mania for images, but in the actual process of work this image material, like wax, changes and is transformed, while in his hands, into new ideas. One must imagine the painter's working quarters (rare photographs help one do this), imagine him simultaneously "making" several canvases, doing them again and again, repainting them or taking his lead from something just discovered… This gave birth to series or, more accurately, families of paintings, drawings, sketches — still lifes, still lifes in interiors, heads, figures, figures in interiors with still lifes, thematic scenes, landscapes, and landscapes with figures forming scenic compositions.

Besides this penchant for the pictorial, several other factors made Picasso more receptive than before to the purely pictorial solution of painters, past and present. Among these were his discovery of Douanier Rousseau as a sort of pre-Renaissance example of the primitive consciousness, unspoiled by academic aesthetics, and also the beginning of his friendship with Braque ("It was as if we were married," Picasso said)[85] which ended his creative solitude and brought an element of the moderation and lucidity typical of the French school. Yet, all of these developments would appear natural in a period of active search and experimentation.

House in a Garden, 1908.
Oil on canvas, 73 x 61 cm,
The Hermitage, St. Petersburg.

Flowers in a Grey Jug and Wineglass with Spoon, 1908.
Oil on canvas, 81 x 65 cm,
The Hermitage, St. Petersburg.

Thus, the Hermitage *Nude in a Landscape* (p.79), coming from a series crucially important to the Analytical Cubism of the *Bather* (winter of 1908-1909), seems to be an answer to Matisse (for example, the canvas *Luxe II*, 1908), with his tendency to transform the figure into a flat, coloured arabesque — an organic part of the ripening decorative grand style. Conversely, Picasso is interested in the figure *per se*, the figure as a bodily apparatus which in itself is a powerful tool of expression, as Tugendhold put it so well. In that sense the Hermitage *Nude* is heir, paradoxical as this may seem at first glance, to certain studies by Degas, whose sharp and objective eye revealed a special "geometrical" rhythm and spatial articulation in mutually dependent human figures in motion in his series of nudes bathing, washing, drying, towelling, combing their hair or having it combed as well as in his depiction of ballet dancers.

It was in connection with such works by Degas that Paul Valéry recalled Holbein's "analytical" drawing of a hand: "the fingers have come together, half flexed, but have yet to be finished, and so the phalanges have the form of elongated rectangles, square in section."[86] Yet Picasso's pre-Cubist *Nude* is not as Cubist as Holbein's drawing; her anatomical distortions speak of an empirical feeling for detail rather than a preconceived constructive idea. The only constructive element is Picasso's artistic will which, heeding the universal law of internal plastic harmony, pulls together the nude's dissociated body parts, her different spatial aspects.

This amazing innovation (which, by the way, dates back to the ancient past — to the pictographic methods of Ancient Egyptian and Assyrian painters) not only established the method of Analytical Cubism, but also opened up a vast area of previously unknown possibilities for the pictorial metaphor. In that sense, the Hermitage *Nude* looks into the future and stands, as Zervos was to note, as the starting point for the poetic element in all of Picasso's subsequent work. Made of formal contradictions — frontal view and profile contours of the torso and left and right halves, lit-up masses balanced by a clear, linear body outline — this nude deliberately has something of Mannerism's unstable style. Its unorthodox anatomy, with its insect-like joints, elongated proportions, and narrowed limbs, seems to be a deliberate recollection of Cranach's angular Venuses, of the sophisticated elegance of the Dianas of the Fontainebleau School, or of the voluptuous curves of Ingres's Odalisques.

Matisse answered reproaches concerning the ugliness of the women in his paintings by saying that he made paintings, not women. Picasso, however, makes women in his paintings. Here he soberly constructs the figure of a female being with youthful forms and an angular gracefulness of motion; and he brings his creation to life by dynamic movements, by the pearly, cool light on the left, which splashes down on the nude's back and which harmonizes so well with the warm ochre tones of her body.

Picasso creates a different, male nature in the gouache *Man with Crossed Arms* (p.96), using the same pictorial manner of the winter of 1908-1909. This somewhat clumsy, but solidly assembled half-figure speaks less of Picasso's abstract formal pursuits than of his desire to achieve an expressive character, to reveal the essence in its physical concreteness: the larger-than-life head with its bulging forehead, the powerful neck, the crossed arms that bunch up the shoulders and thus emphasize the athletic and monolithic torso. Yet even now, on the threshold of a new stage in the development of his formal conception, the semantic polarization of Picasso's pictorial world of 1908, the basic meanings of his personal mythology, is still preserved.

Picasso, of course, did not know then that he was entering the period of Cubism. "To know that we were doing Cubism we should have had to be

acquainted with it. Actually, nobody knew what it was."[87] Internally experiencing his art, being the centre and source of that art, Picasso had a more integral, less vague understanding of his goals than did scholars writing about his work at the time. "The goal I proposed myself in making Cubism? To paint and nothing more. And to paint seeking a new expression, divested of useless realism, with a method linked only to my thought — without enslaving myself with objective reality."[88]

If the artist spoke of a quest for new expression, it is because that was his professional concern — to find adequate means of expression, an adequate language for the impulses inherent in his thinking. Yet he also said: "In the early days of Cubism we made experiments... to make pictures was less important than to discover things all the time."[89] Today, however, three-quarters of a century later, when the formal phenomenon of Cubism has been studied in depth and in sufficient detail, we can look upon Picasso's work of that time not only from the standpoint of the artist's self-development, but with an eye more educated and sensitive to the value of its content.

Man with Crossed Arms, 1909.
Watercolour, gouache and charcoal on paper pasted on cardboard,
65.2 x 49.2 cm,
The Hermitage, St. Petersburg.

Nude, 1908-1909.
Oil on canvas, 100 x 81 cm,
The Hermitage, St. Petersburg.

Indeed, almost every work between the winter of 1908 and the spring of 1909 has its own content, either relating to the development of some theme or, as in the case of the still lifes, situating its object-motif in an atmosphere that seems to vibrate with a strong current. *Bread and Bowl of Fruit on a Table*, for example, painted during this period, is a still life that is a transformation of the so-called *Carnival at the Bistro* theme, developed in several sketches. In another still life, the artist, as if in Cézanne's honour, depicted a pear, a lemon and Cézanne's hat amid the full folds of a draped cloth which has a luxurious yet controlled leaf-like pattern in the style of the Master of Aix (see *Still Life with Hat*).

The still lifes of that period simultaneously address the sense of reality, the artistic sense, and the viewer's imagination. While composed of real, even commonplace objects (usually fruit, table utensils), they are architectonically organized, and yet at the same time each reveals a certain energetic expression — an epic, dramatic, intimate quality — more to be expected of landscapes.

The Hermitage still life *Bowl with Fruit and Wineglass* is built like a panoramic view (seen from above) of a group of objects situated on the deserted plain of a round table. It was perhaps because he so prized this ambiguous feeling of still life/landscape that Picasso left the painting unfinished, preserving its ghostliness, refusing to make the objects materialize fully. Here, in this concept of still life, with its pauses of empty spaces and its logical interchange of planes, the overall effect reminds one of a landscape's illusory space. In another work, the landscape *House in a Garden*, Picasso created a three-dimensional impression on the principles of Braque's tactile, manual still life space. And yet in that work, the absence of any sort of analysis, the many smeared forms in the motif, the capriciously rhythmical lines of arabesques, do not speak of a search for real space, but rather tell us that spatial confinement is what the artist needs to heighten the drama of forces locked in battle. One force is Nature with the turbulent, vital energy of its greenery and the pathetic gesticulation of the dead tree; the other is the neatly arranged buildings with their blank walls and sharp, geometric edges.

This drama, heightened by the strictly controlled relationship of the cold mineral colours and the tension of the composition, balancing on a razor's edge, overwhelms the "inertia" of a pure landscape; the painting echoes, as it were, the conflicts of the real world. This final impression corresponds to Picasso's original idea: to make this piece of nature the background for a composition with figures, conceived in the winter and spring of 1909.

Referring to the transformation of the composition *Carnival at the Bistro* into the still life *Bread and Bowl of Fruit on a Table*, Pierre Daix believes Picasso "could not have better expressed the thought that, at that stage, every object or character is, above all, a certain spatial rhythm, a three-dimensional structure which plays its role in the composition through what it brings to the pictorial structure of the whole and not through its own reality. Here he again borders on abstraction. He will treat the *Woman with a Fan* (p.103) and *Queen Isabeau* (p.101) exactly like still lifes."[90] Such views, however, are hardly correct, for Picasso at that stage was still very far from abstraction. Actually his desire to achieve a full and unified plastic structure for the pictorial whole (for which he depends on Cézanne's modulated tones which model forms) does not contradict his fundamentally literary quality and does not negate the personal realities of the object and characters. Indeed, the metamorphosis of the figure scene into the *Bread and Bowl of Fruit on a Table* clearly reveals the semantic (not just the plastic) value of the

Compotier, Fruit and Glass, 1909.
Oil on canvas, 92 x 72.5 cm,
The Hermitage, St. Petersburg.

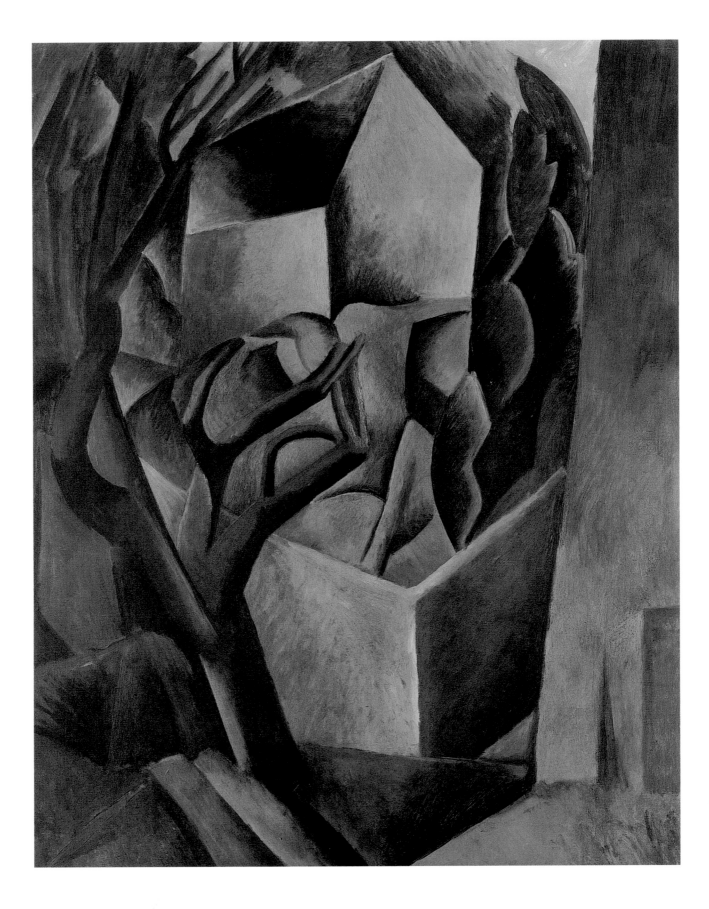

House in a Garden, 1909.
Oil on canvas, 92 x 73 cm,
The Pushkin Museum of Fine Arts, Moscow.

Queen Isabeau, 1908-1909.
Oil on canvas, 92 x 73 cm,
The Pushkin Museum of Fine Arts, Moscow.

still life's object-motifs for Picasso: a bowl of fruit has replaced the female figure in the composition, while the elongated loaves of bread and overturned cup replace the rhythms and forms of the two male characters. An allegorical still life? Whether it is or not, the characteristics of Picasso's objects and figures invariably relate to an internal meaning, as is apparent, for instance, in *Queen Isabeau*, *Woman with a Fan* and also *Woman with a Mandolin* (p.104).

The pseudo-historic Queen Isabeau, a direct descendant of the family of images belonging to the transformed bistro carnival, is semantically equivalent to Harlequin (one of the bistro group), who reappeared in Picasso's works after a three-year absence. This pensive female Harlequin in her green, leaf-patterned dress and with her pseudo-medieval head-dress is accompanied by a bowl in a vegetal form, "gothically" heaped with fruit. The allusion to natural forms serves as a metaphor of the eternal woman, in this case dressed as a medieval "fair lady".

The figure, the stylised arabesques and flat planes, the cool and somewhat mournful decorativeness, give the picture the quality of old tapestries, which Picasso found attractive because of their combination of generalized forms and chromatically graded tones. For Picasso sleep and dream are also elements of the eternal woman, but in this case Harlequin-Isabeau's pensive reverie over a book suggests the character's literary past. But why the Middle Ages? Of course, this choice has nothing to do with a new influence, but rather with a certain resemblance, felt by Picasso, between stylistic elements of early Cubism and naked, arrow-like Gothic structures. It also in part related to the mysterious atmosphere of medieval legends, which obsessed his friend Apollinaire, then preparing *L'Enchanteur pourrissant* for publication. Let us note the appearance in Picasso's works, during the winter of 1908-1909, of several more medieval motifs and scenes, just as imaginary as *Queen Isabeau*.[91]

Another fair lady, but of a different era, is depicted in *Lady with a Fan*, in whom some of Picasso's contemporaries recognized an American connoisseur of art. However the resemblance was accidental, even though the painting definitely has something of an actual portrait about it. An elegant woman, wearing a rather audacious hat and a jabot and holding an open fan in one hand and a folded umbrella in the other, sits in an armchair as if posing for the artist. Notwithstanding the obviously new pictorial language of the canvas, all its formal solutions have a wonderful unity that makes one forget the unorthodox manner and react only to the image, its individual expression. The pictorial space — satiated with the interplay of rhythmic planes, graded tonal perspectives and cold malachite and silvery-grey colours — is an attribute of the personality we read in the woman's features. Her fixed, sober gaze from under the brim of her enormous hat hypnotizes the viewer; her face, though somewhat generalized, retains its regularity of feature and is treated like a mask, cut and polished by light; the gesture of her hand, holding the umbrella, is both angular and affectedly refined; her entire figure reflects the fashionable style of a woman of the world, a sister of Alexander Blok's mysterious Unknown Lady (that was how the Russian Symbolist Georgy Chulkov perceived her).[92]

If, however, Harlequin-Isabeau's inclined head, downcast eyes and pseudo-historical details created the image of a queen from some romantic dreamland, what Chulkov calls a charming monster, then in this other lady we have two strains, differing in expression, two different halves of one mask. This combination of contemporary urban style with awkward, almost sharp rhythms lacking in plasticity creates the image of a mannequin with no more substance than what the eye can see, rather than that of eternal woman. And while Queen Isabeau's femininity was emphasized and

Woman with a Fan, 1909.
Oil on canvas, 101 x 81 cm,
The Pushkin Museum of Fine Arts, Moscow.

Woman with a Mandolin, 1909.
Oil on canvas, 92 x 72.5 cm,
The Hermitage, St. Petersburg.

expressed by the metaphor of plentiful vegetal allusions (the leafy ornament, the full fruit dish, the emerald green tonality), here the pictorial element characterizing the woman with a fan is an empty, jagged vase.

In *Woman with a Mandolin*, the interrelationship of the objects and the character is obvious because it is based on a thematic concept: a woman plays a musical instrument, while books serve as attributes of the intellectual atmosphere of music-making. On the other hand, the regulated and ordered lines of the bookshelves contrast sharply with the scarlet waterfall of the drapery and the folds of white cloth streaming along the back of the armchair. These rhythms find their response in the musician's emotional state as she obliviously gives herself to the torrent of music. Picasso rendered this fusion of music and emotion by shaping the contour of the woman's figure like that of a musical instrument (a sort of lute-*cum*-guitar, rather than a small, graceful mandolin) and by giving an analogous structure to the woman's head and the hemispherical body of the mandolin. For the sake of this analogy, Picasso analysed and recreated, with clear lines and simple planes, the sculptural plasticity of the musician's head; he presented it, unlike her hands, not in "flesh", but in "wooden" tones. He likened the woman's head to a mandolin, her body to a musical instrument, and he did so not just in the literary, but in the plastic sense as well. Let us note that fact as being of prime importance.

In *Woman with a Mandolin* Picasso was on the way to a discovery that would in the future radically transform the very principles of his art — the image presented as a visual metaphor. He stood on the threshold of the discovery of plastic poetry. A decade later the poet Blaise Cendrars, looking back on the period of Cubism, would note: "I do not say that Picasso made literature (like Gustave Moreau), but I insist that he was the first to introduce into painting certain 'procedures' which until then had been considered to be exclusively literary."[93] This comment pertains to a visual metaphor that Picasso himself called *trompe-l'esprit* and that was to dominate his work somewhat later, during the period of verbal inclusions and collages. Yet in such pictures as *Woman with a Mandolin*, there is still much of the *trompe-l'œil*, of the desire for plastic concrete form, for a spatially convincing ratio of volumes — which promoted Matisse, for instance, to consider Cubism "a kind of descriptive realism."[94] Basically, from the viewpoint of the development of literary methods, the shift from *trompe-l'œil* to *trompe-l'esprit* is the direction taken by Picasso's evolution of Cubism. The formation of this new creative spirit was accompanied by a renewal of the expressive means themselves and by a realization of their purity and power. Step by step, Picasso's Cubism freed painting from optical fiction, in order to make it a plastic language suitable for the creation of visual metaphors, to make it the language of poetry. The stylistic differences (even contradictions) between the works of the autumn of 1908 and the spring of 1909, discussed earlier, reflect the absence of any one evolutionary direction at the beginning of Picasso's Cubism (in that sense, Braque has greater integrity and consistency, but is also more formal). Evidently the theme remained the motivating impulse of his art at that time, although it did not always lend itself to verbal expression. "If the subjects I have wanted to express have suggested different ways of expression, I have never hesitated to adopt them."[95]

The evolution of Picasso's Cubism was to assume a certain measure of consistency and logic beginning with the canvases completed after the summer of 1909, a season spent at Horta de Ebro, to which he returned a decade after the happiest days of his early youth. In Horta Picasso felt reality with his entire body, with all his senses, with his very conscience; his art once more made contact with his environment. This contact was, however, effected

Factory in Horta de Ebro, 1909.
Oil on canvas, 53 x 60 cm,
The Hermitage, St. Petersburg.

with the help of his new "optics", which the artist uses to colour his perception in that stern, mountainous country with its pure, chilly air and cubic structures strewn over the rocky slopes. These "optics" were amazingly purist in their simplicity and clarity. They excluded the accidental, the formless and the secondary; they brought order to nature's chaos and at the same time sharpened to the limit the version of form as the interplay of spatial contrasts, turning a scene into a rich panorama of different aspects arranged according to the character of the subject. They were to serve as the basis of Cubism's formal vocabulary. Let us note, however, that the defining of volume by a detailed faceting of the form did not result from a preconceived analysis *per se*: it came from a feeling for the profound reality of this country, with its landscape baked to a hardened crust under the pitiless light of the Spanish sun. The integrity of that feeling guaranteed the paintings done at Horta de Ebro a certain unity of style, whether landscape, still lifes, or portraits.

The Hermitage possesses one of that summer's landscapes — *Factory in Horta de Ebro*. The title speaks for the reality of the subject, which, however, appears before our eyes cleansed by Picasso's vision and decorated by his

dream. The verdant palm trees that soften the grim view were, as the artist admitted, his own invention (they do not grow in Horta or in that region). The group of geometrically simple buildings seem to radiate their angular, fractionalized rhythms outwards like a musical theme that eventually spirals into a sort of spatial fugue. In their magical interplay of silvery-grey and ochre planes the landscape and factory are transformed into a prismatic mirage born from the air of the Catalan mountains, satiated with pure light. This light-carrying air differs from that of the North: it does not embrace and soften forms but brusquely shatters itself upon them. It is depicted here by the striking tonal accents of the sky, an integral part of the overall structure.

The paintings from Horta de Ebro are considered classics of Analytical Cubism. As early as his return to Paris that autumn, Picasso summed up the formal solutions they contain by turning to sculpture, which he called the painter's best commentary on painting. He made *Head of a Woman* in an analytical manner. Without violating the traditional principle of the integrated sculptural mass, Picasso models the surface in a series of spectacular slanted planes; these powerful muscular accents at the constructive joints create an

Woman Sitting in an Armchair, 1909-1910.
Oil on canvas, 100 x 73 cm,
Centre Georges Pompidou, Paris.

Nude Woman Sitting in an Armchair
(Young Woman),
Oil on canvas, 100 x 73 cm,
Centre Georges Pompidou, Paris.

interplay of rhythms, but they also rip open the epidermis of the sculptural surface (Kahnweiler). Recalling *Head of a Woman* decades later, Picasso told Penrose: "I thought that the curves you see on the surface should continue into the interior. I had the idea of doing them in wire." However, Penrose notes, "this solution did not please him, because, as he added, it was 'too intellectual, too much like painting'."[96]

This atmosphere of concentrated intellectual work in the studio is conjured up by *Young Lady*, produced in the winter of 1909-1910. By that time Picasso had moved from the dilapidated Bateau-Lavoir to a comfortable apartment-with-studio on the Boulevard de Clichy at the foot of Montmartre. The large studio window, looking north, let in the even silvery light so beloved by Corot and Cézanne; that partially explains the unexpected emphasis on colour values evident in the Hermitage painting. The same tones serve to breathe life into the seated nude, treated in a completely untraditional manner: she is a female-like crystal of flesh that at first stuns us with its "deformities". Picasso now painted standing close to the canvas, never stepping back to assess the general effect: it did not interest him. His work is more psychological than decorative. As the Russian critic Innokenty Aksionov was to note perceptively: Picasso stares his objects in the eye, as we look into our lover's face. He must turn his head to see two objects, and so he moves the width of the composition of his canvas into the depth."[97] That is what led Picasso — that painter by calling, innovator by nature, contradiction by temperament (Sabartés) — to such distortions, through which he seems to say: there are no beautiful objects, there is only art (Aksionov). The object of his pictorial studies was not superficial. Braque recalled Picasso and himself in those days: "We were particularly very concentrated."[98] Sometimes Picasso would visit the studios of his friends to draw living models, to become immersed in a given model's character, a woman with individual features, rhythms, proportions. Then, retiring to the seclusion of his studio, he made portraits of his recollections, clarifying their details by his own method. That explains, for example, the impression one receives from *Young Lady* of a concrete character, of an individual modern urban model; the longer one studies her, the more one understands who she is. But from the viewpoint of Cubism, this picture was just one link in a chain of studio works which led to the ever increasing disintegration of volume by means of values and its dissociation into small geometric planes — to the creation of the peculiar esoteric language of Analytical Cubism.

Picasso limited his expressive means to spatial lighting effects: values and planes. Both reflect the relativity of the analytical vision of painters; both are instruments to make order in their visual perception, to create depth on a picture's surface by the use of colour.

This is an enormously difficult problem. Cézanne always complained that perspective eluded him; he organized depth in his painting through receding planes of colour which, like the strips of a wicker basket, he wove into one pictorial whole, vibrating with the vitality of living forms. But colour is a special problem. "In colour," Braque said, "only the aspect of light preoccupied us. Are not colour and space interrelated? So we developed them together… And for that we were called abstract!"[99] Light and space are concrete in the artist's eye, but values and planes are almost as abstract as the letters that make up words expressing thoughts or denoting objects.

Angularly drawn smoky and semi-transparent planes, slanted this way and that, link up like metal pieces around a magnet and incomprehensibly merge in the instantly recognizable *Portrait of Ambroise Vollard*. The edges of flat planes become elements of the drawing and mark the characteristic features of the face, the details of clothing (buttons, jacket collar, handkerchief

in breast pocket), and aspects of the interior (the bottle on a table). As if trying to square the circle, Picasso builds the dome of his model's head out of superimposed planes. With energetic striation, he marks out the main lines and masses of Vollard's heavy, sleepy face: the small broken nose and the hard line of the mouth. Although there is no imitation in Picasso's plastic language (as early as 1910 he "does not make from, but makes with, nature, like nature"),[100] one cannot miss the staggering accuracy of the sophisticated tonal gradations; they give the portrait the power of life despite — or perhaps because of — the obviously relative nature of the forms that compose it. Vollard's face fascinates. Looking into its strong, hard features, one understands why Cézanne, who painted his portrait ten years earlier, called the successful art dealer from Rue Laffitte a slave merchant. However there is also a tragic element in Vollard's lethargic life mask: it was documented later in photographs, but it also appeared earlier during the periods of black melancholy and somnambulistic torpor characteristic of his nature. It seems he was in that state when he posed for Picasso. Generally considered a masterpiece of Analytical Cubism, the Moscow *Portrait of Ambroise Vollard* is a real masterpiece of psychological realism, illuminating a quality that was perceived in 1910 as one of the Spanish painter's paradoxes, when Metzinger noted: "Picasso openly declares himself a realist."[101]

Already in the *Portrait of Ambroise Vollard* a heightened care for tonal nuances demanded a brushwork technique reminiscent of the mosaic manner of the Divisionists; because of that technique, the material seems to give off a shimmering vibration regulated only by the constructive framework of vertical, horizontal and diagonal lines in the drawing, not all of which can be perceived by the eye. Throughout 1910 and 1911, Picasso and Braque, shoulder to shoulder, developed this hermetic art in which every picture was an autonomous slice of "pure reality" that did not imitate the environment. And even though these works had their own subjects, usually still lifes and the figures of musicians, the reality of this kind of painting was based on more complex, and not always concrete, feelings.

Decades later Picasso was to explain: "All its forms can't be rationalized. At the time, everyone talked about how much reality there was in Cubism. But they didn't really understand, it's not a reality you can take in your hand. It's more like a perfume — in front of you, behind you, to the sides. The scent is everywhere, but you don't quite know where it comes from."[102] In these hermetic paintings Picasso communicated a "scent" of reality that one can grasp through visual allusions: the contours of a glass, a pipe, the elbow-rest of an armchair, the fringe of a tablecloth, a fan, the neck of a violin. This was the concrete reality at the artist's fingertips — in his studio, in the streets, in cafés. Soon, in the summer of 1911, another kind of allusion from the real world entered Picasso's painting — street signs, newspaper headlines, words from book jackets, wine bottles, and tobacco labels, musical notes — all of which are thematically linked to the subject of the canvas.

Although such letters and words had appeared before in paintings (for instance, in those of Cézanne and Van Gogh, to mention only Picasso's closest predecessors), in such objects as a newspaper, a book, a sign and so on, the use of verbal elements by Braque and Picasso was of a different character and pursued a different aim. First, for both masters of Analytical Cubism, letters are flat forms that help create the spatial relations of the picture. They are also elements of the surrounding environment that participate in presenting the theme, supporting its subject, which they enter untransformed. Besides that, words and entire sentences, parts of words and syllables, are, to artists who live in close contact with poets (especially to

Ambroise Vollard, Photograph.

Portrait of Ambroise Vollard, 1910.
Oil on canvas, 93 x 66 cm,
The Pushkin Museum of Fine Arts, Moscow.

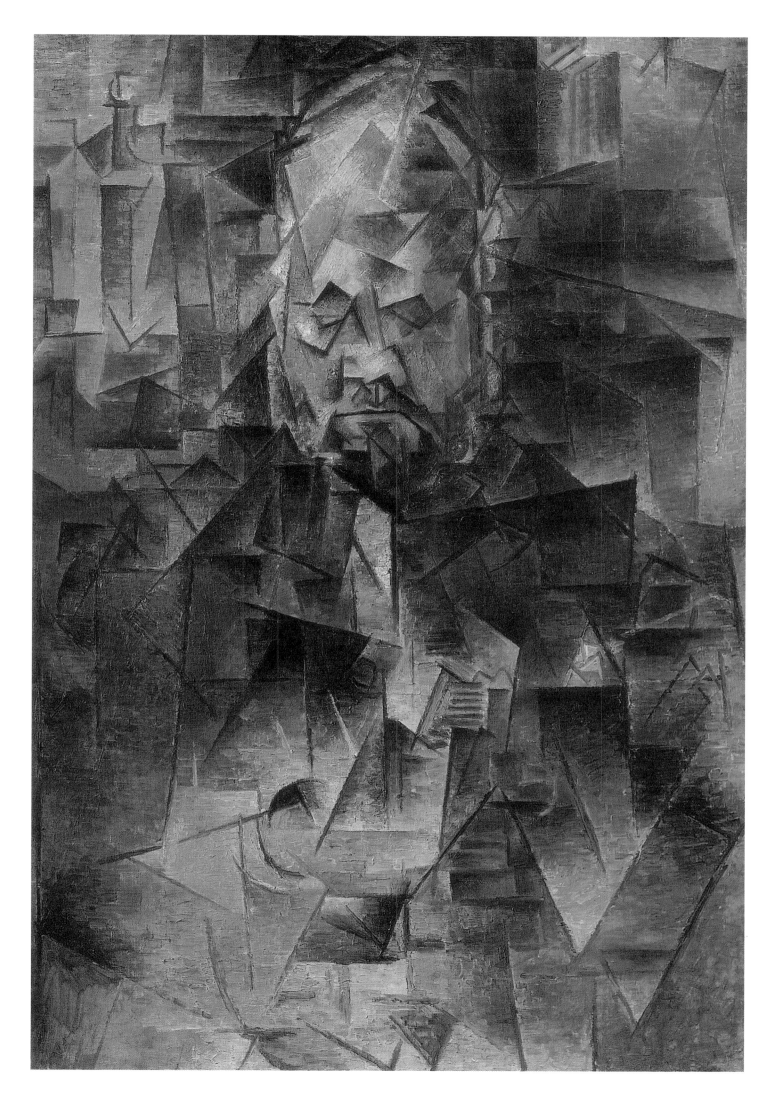

111

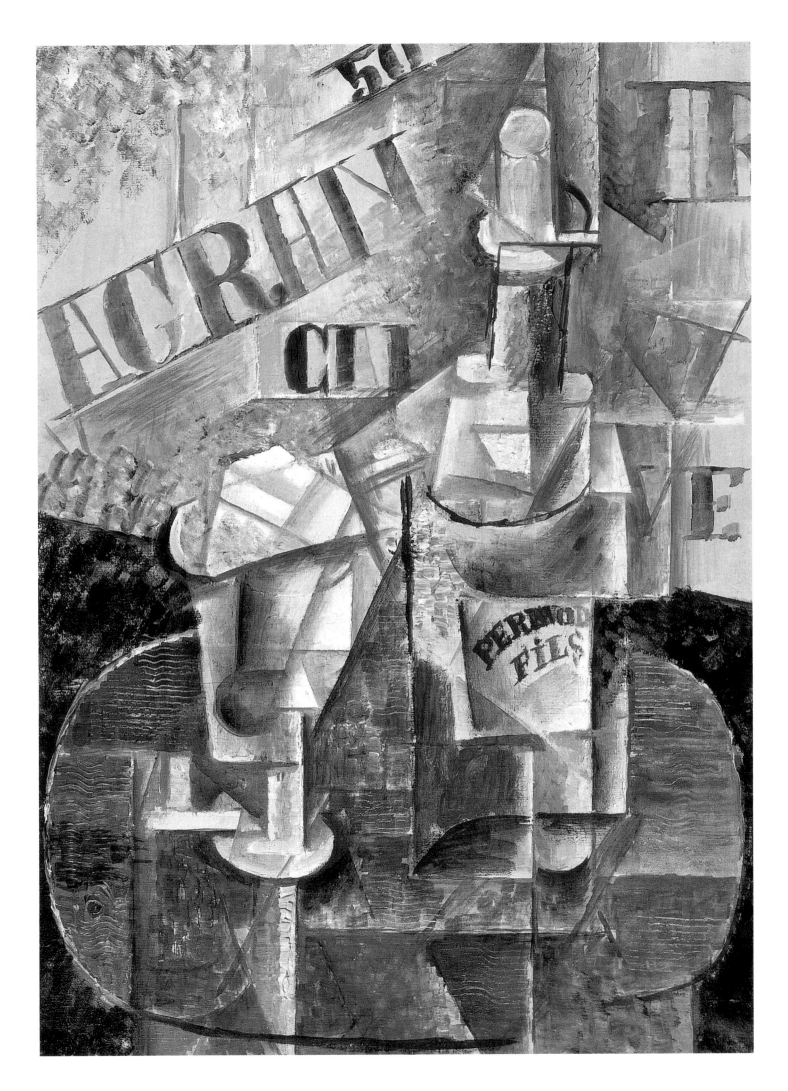

Picasso), also verbal images assuming meaningful relations with the painting's pictorial realities, giving the image a multiplicity of meanings.[103] Having acquired equality in the canvas with plastic forms, verbal print material at the same time heightens the associative meanings of object motifs, stimulates their literal character and, ultimately, their recognisability. Yet this combination of two pictorial levels also leads to the transformation of the picture into a charade with many meanings, a play on words, a total metaphor — an effect that Picasso highly prized.

In the painting *Bottle of Pernod (Table in a Café)*, created in the spring of 1912, the letters crossing the background behind the still life are part of advertisements painted on the invisible glass panel of the café window. They endow the picture with the unmistakable look of modern urban life, while the motif — the bottle of Pernod and the glass with its spoon and cube of sugar, placed on the oval table — reveals Picasso's new taste for a material, concrete environment. The artist was clearly enthralled with the contrast between the prismatic refractions of light in the glass objects and the solid, wave-like texture of the warm-toned wood.

At the same time, his imitation of window advertisements imparts an element not merely of reality but of new poetry: by their chaotic nature, as well as by their spatial and semantic relationship to alcohol, these bits and scraps of advertisements echo the perception of modern life as inherently intoxicating and bitter. Such ideas were not alien to Picasso — if only because in 1912 Apollinaire was preparing to publish his first volume of poetry, *Alcools* (preliminary title, *Eau-de-vie*), for which Picasso drew a Cubist portrait of the author.

In the opening poem of the volume, *Zone*, we read the following typical words:

> *Tu lis les prospects, les catalogues,*
> *les affiches qui chantent tout haut*
> *Voilà la poésie ce matin*
> *et pour la prose il y a les journaux*
> *Il y a les livraisons à 25 centimes…*
> *Et tu bois cet alcool brûlant comme ta vie*
> *Ta vie que tu bois comme une eau-de-vie…*

"We are not executors; we live our work" — let us here repeat Picasso's assertion, words reminding us that this artist's work is always the expression of his existence, his emotional experience, his intellectual and spiritual growth, or more accurately, the changing, the opening, the freeing of his individuality. According to the generally accepted classifications, during the first half of 1912, Picasso's Cubism underwent a mutation from Analytic to Synthetic. Somewhere at the very start of the year Picasso felt the need to work with tangible forms of reality — to sculpt. At the same time, his introduction into painting of letters and slogans as naked facts of reality opened the way to other facts of reality: in particular, the gluing on of different materials with their own ready-made printed forms, textures, ornaments — and so the collage technique appears. Such are the features of that transition, caused by a host of reasons and events, the most important of which were internal.

The appearance of reality — so direct and unequivocal — signalled the end of the illusory, hermetic and anonymous style of painting called Analytical Cubism, which Picasso developed for a year and a half in such intimate contact with Braque that the other virtually became his double (to the extent that it is difficult to distinguish between their works of 1910-1911). This new orientation was based on a sharpened sensual perception of the world, a reassessment of its external stimuli: its variety of colours and

Bottle of Pernod (Table in a Café), 1912.
Oil on canvas, 45.5 x 32.5 cm,
The Hermitage, St. Petersburg.

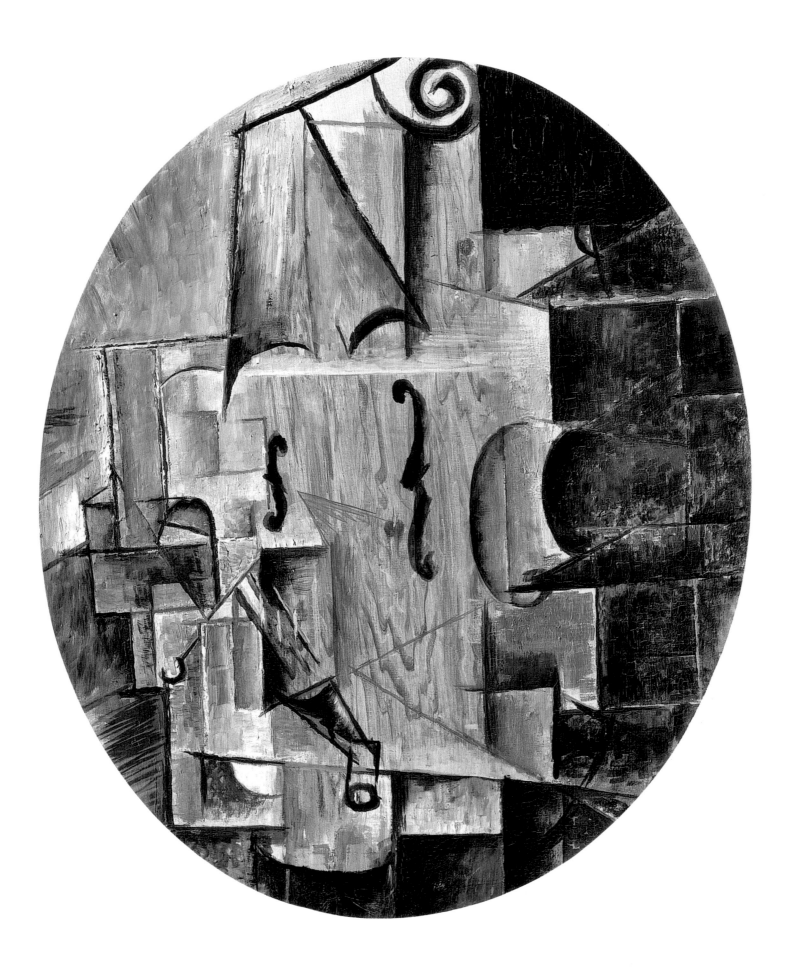

Violin, 1912.
Colour paper, 55 x 46 cm,
The Pushkin Museum of Fine Arts, Moscow.

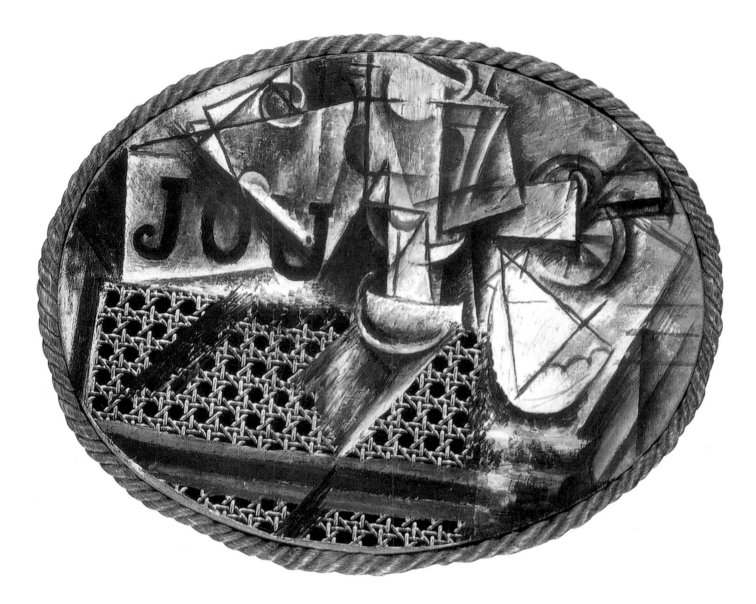

wealth of material qualities. This fresh vision was also the echo of an internal event indeed capable of transforming perception and thought, the echo of a new love. This rule had long been clearly established: love brings changes in Picasso's art. Love is what underlies his admiration of textures, for contrasting effects; love is the reason here for the appearance of livelier and more joyful colours. Together with the woman whose very name, Eva, had symbolic meaning for him, Picasso began a new life that introduces new overtones in his art.

In the summer and autumn of 1912, while living with Eva in the town of Sorgues-sur-l'Ouvèze, Picasso was literally possessed by one subject: some fifteen paintings of that season depict violins and guitars. This was lyrical painting, steeped in emotions relating the shapes of these instruments to the female form and aspiring to create a harmonic and tangible image out of different elements of form, rhythm, texture, both of material and painted surface, and colour. This art embraces the world's sensual diversity; not accidentally some of these still lifes bear the inscription: *J'aime Eva.*

Still Life with Violin is one of Picasso's first and most harmonious works of that period. As the Russian Cubist Alexei Grishchenko noted, here we see "consummate skill in realizing the painting's new concept, where the forms of objects, profoundly transformed by the artist, make up a clear, stylistically complete, moving composition; where painting introduces and constructively

Still Life with Chair Caning, 1912.
Collage of oil, oilcloth, and pasted paper simulating chair caning on canvas,
29 x 37 cm,
Musée Picasso, Paris.

115

fuses the analytically-arrived-at elements into one indivisible, synthetic whole; where the perspective is furnished in actuality by the in-depth sections of objects; where every bit of the canvas reflects the hand of a real artist."[104] The painting can hardly be classed as a still life: its formative idea is better expressed by the words *tableau-objet*, which Picasso himself used. Indeed the painted image of the violin is already furnished by the harmonious oval of the canvas; the instrument is recognizably presented in the compositional nucleus by the frank statement of its material qualities (the wavy texture and honey-coloured tones of the wood), as well as of its elegant details (the sound-holes and the curves of the sounding board). This nucleus seems to bulge spherically outwards owing to the passage of fractionalized forms that retreat rhythmically towards the edges of the work. Thus, the entire composition acquires equilibrium, not because of the stability of the object depicted, nor because of the overall pyramidal construction, but because of the daring oval shape (a real tectonic challenge), locked into place by its nucleus like a keystone supporting an arch.

This unstable, vertical ellipse of canvas, which cannot stand but only hang on a wall, tempted the artist to seek new compositional principles for sculptures that would seem to hang or float in the space of an oval form. Thus, in the picture *Musical Instruments*, on which Picasso worked that same summer in Sorgues, a cascade of forms, differing in shape, colour, volume and texture, is solidly held together by the intersection of two black stripes that serve as the structural base.

The characteristic features of the three instruments emerge from the wealth of formal details: a rose-white violin, a yellow-brown guitar, and a dark green, cream-coloured mandolin. They are presented here by dissociated aspects of their reality — masses, planes and surfaces, contours and elements, symbols of sorts. For Picasso, however, these symbols were also sensual equivalents, as is suggested by their unnatural, subjectively pictorial colour (the spicy pink, velvety blue and green, deep brown and sandy yellow) and the introduction of such a powerful and tangible irritant as the "sounds" done in bold relief in plaster-of-Paris. An entry in his sketchbook tells us that it was indeed in Sorgues that Picasso began to aspire to "find equilibrium between nature and one's imagination."[105]

Musical instruments, considered a lyrical subject by Picasso, continued to occupy his imagination for many months. In the autumn of 1912, in Paris, attempting to realize his new vision, he again turned to three-dimensional sculptural forms to create a family of spatial constructions in the shape of guitars. Made of grey cardboard, these new "sculptures" do not "imitate" real instruments, but recreate their images through spatially linked and partially overlapping flat silhouettes of planes that form open volumes. At the end of 1912, these new lyrical objects as well as the oval *tableau-objets*, destined only to hang on walls, furnished the impulse for endless new interpretations of musical instruments in pasted-paper works (*papiers collés*) and pictures (thus gainsaying the often accepted view that the guitars and violins were cut to pieces randomly, as if by some cruel vivisectionist, and then put together helter-skelter).

Among the works belonging to this period and style we find such pictures as *Violin and Wineglasses on a Table* and *Clarinet and Violin* (p.121), in which the clearly dominant structural principle of flat, frontal planes points to a link with pasted-paper techniques and sculptured constructions. But if the former seems only a more imposing, assured and decorative version of the small, oval *Violin* from the Moscow museum, the apparently modest canvas *Clarinet and Violin* is both a virtuoso sketch with a new compositional structure and a concise formulation of Picasso's latest

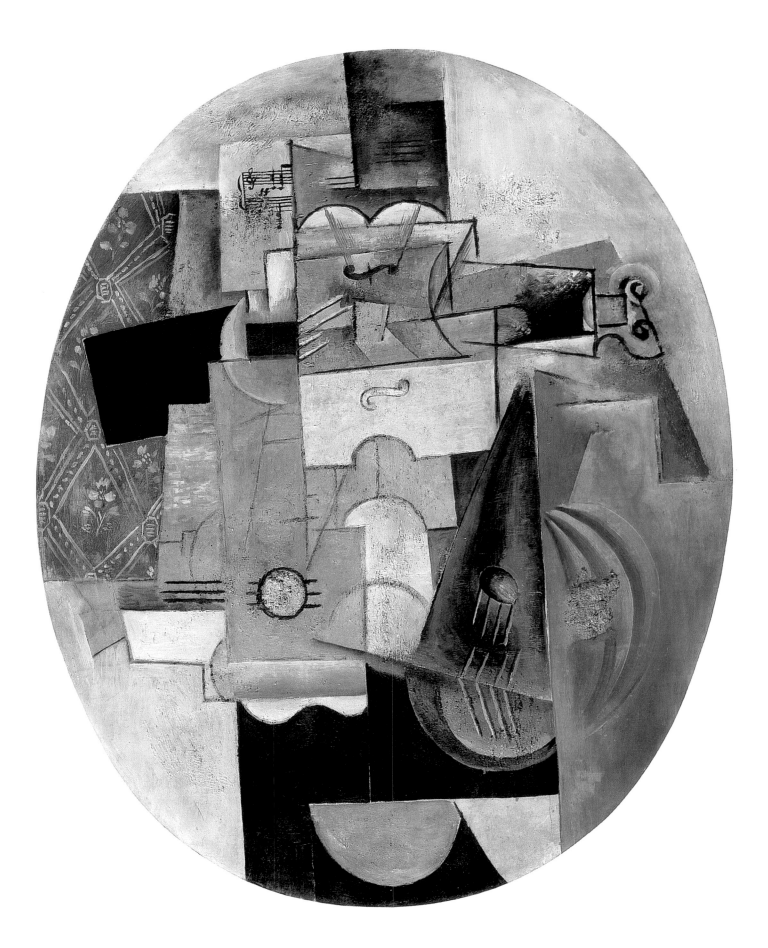

Musical Instruments, 1913.
98 x 80 cm,
The Hermitage, St. Petersburg.

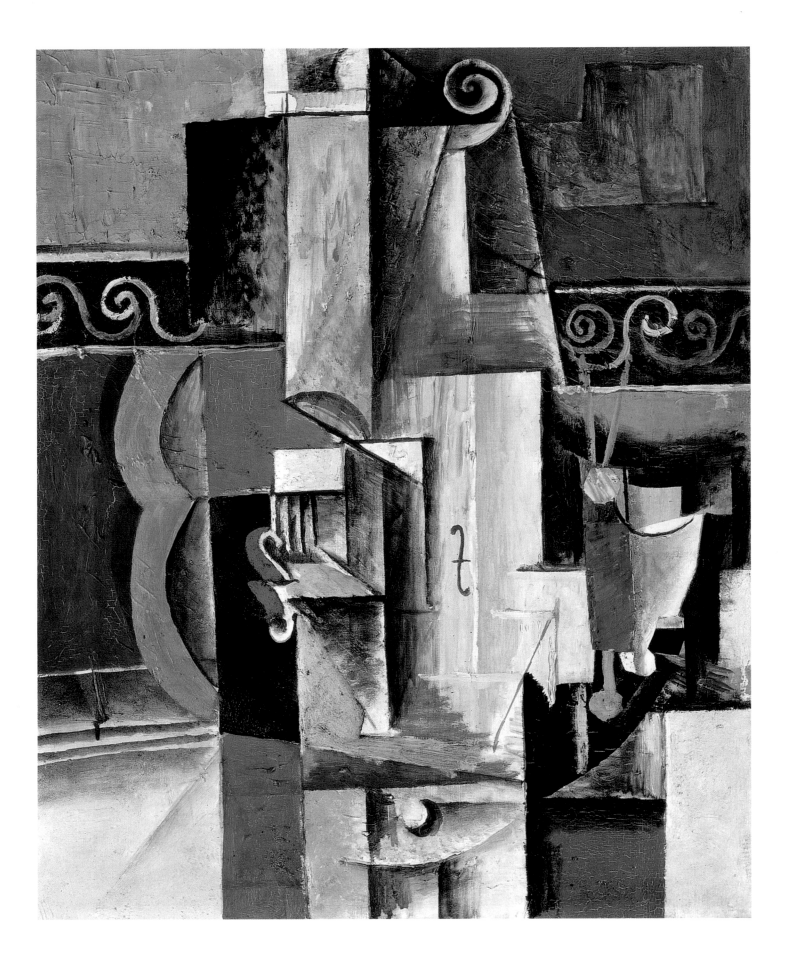

Violin and Guitar, 1913.
Oil on canvas, 65 x 54 cm,
The Hermitage, St. Petersburg.

pictorial conception (in broader terms, of plastic art), which had ripened over the six years of his Cubism.

An absolutely flat, black plane retreats behind a brown one, to which it is solidly linked by a small, cream-coloured square. This feeling of depth, achieved with such simplicity and skill, clarifies the spatial relations of both instruments, which are sparingly traced by a simple brush drawing. Meanwhile, the colours of the instruments (ebony for the clarinet and a grainy coffee-brown for the violin), although proportional in mass, are dissociated from their shapes and have even shifted from one instrument to the other and changed their spatial relationships.

Presented simultaneously, but not together, the colours of objects and forms, their masses and shapes, are conceived as independent forces that come into play with each other and with our imagination. This astonishing method clearly reveals the anatomy of the plastic metaphor that Picasso called *trompe-l'esprit*, which is actually nothing but a poetic image — that is, according to Garcia Lorca, one "based on the mutual exchange of appearance, destination and functions among Nature's different objects and ideas."[106]

It was with an amazing degree of freedom, resourcefulness and grace that Picasso applied the rule of plastic metaphor to the pasted-paper technique, which revolutionized the possibilities of painting. Here is his own comment: "Aside from rhythm, one of the things that strikes us most strongly in nature is the difference of textures; the texture of space, the texture of an object in that space — a tobacco wrapper, a porcelain vase — and beyond that the relation of form, colour, and volume to the question of texture. The purpose of *papier collé* was to give the idea that different textures can enter into a composition to become the reality in the painting that competes with the reality in nature. We tried to get rid of *trompe-l'œil* to find *tomple-l'esprit*."[107] Not a single one of the *papier collé* components is ever taken in its direct meaning; all are allegories and metaphors.

In the composition *Bowl of Fruit with Bunch of Grapes and Sliced Pear* the vertical piece of paper pasted in the centre represents the mass and colour of the porcelain fruit bowl, traced by graphic contours, while the cut-out of grey, marbled paper pasted below shows that the fruit bowl, with its grapes, pear and Picasso's personal card, stands on a mantelpiece with a moulded edge. While the glossiness of the fruit and of the stucco mantel are negatively rendered by a velvety, powdered-sawdust texture, the translucence of the space, its airy and sunlit plenitude, are given almost impressionistically through a fairy tale of light and mutually penetrating geometric planes, composed of tiny particles of bright and joyous colours. While not imitating the environment, the artist convincingly transmits the atmosphere of a cosy, sunlit room.

The feelings underlying *Tavern* (*The Ham*) (p.125) are quite different. This still life was done like a provincial tavern sign. The oval form freed the artist from such considerations as top and bottom, the need to fill corners, and so he arranged the still life with the most amazing ease, like a restaurant table plentifully but chaotically laden with food. A luxurious pink ham occupies the centre, a bottle of beer to the right, and to the left a goblet through which one can read the list of dishes written on a blackboard; in the foreground a lemon and a knife and fork lie on a crumpled napkin; there is a menu and, inscribed in blue letters on the window glass, part of the word "Restaurant". Everything is stated; moreover, it is tangible. The motif is brought as close to the viewer as possible, indeed it seems to fall out from the painting's surface, accentuating the reality of the ham and the lemon, the napkin and the wooden table, the sharp knife and the heavy

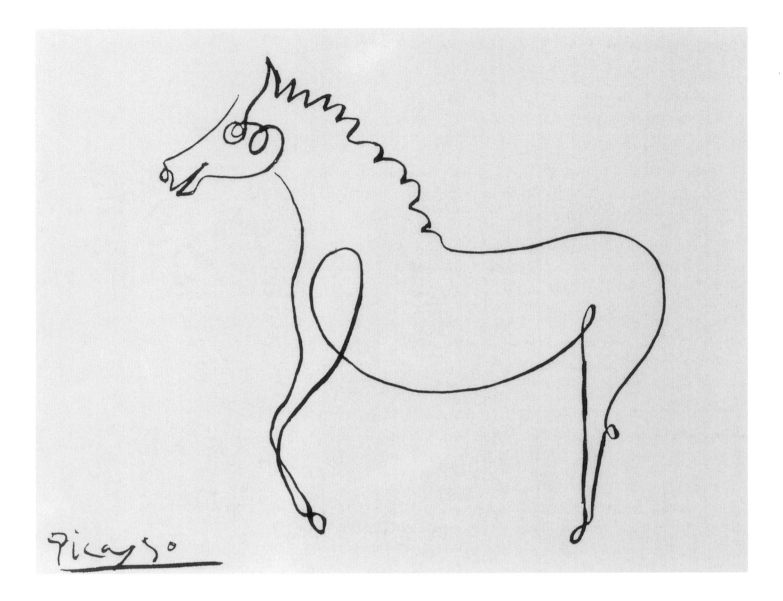

Picasso [signature]

Little Horse, 1924(?).
Indian ink on paper, 21 x 27.2 cm,
The Hermitage, St. Petersburg.

fork. Unlike the physically tangible real sawdust, the schematically rendered bottle and glass, deprived of any reality of their own, seem to be transparent ghosts — which indeed they are, when empty. While recalling the carnal richness of Flemish masters, Picasso's *Tavern* opposes them, for it invites us to overcome the routine forms of artistic vision that fetter our freedom of perception and to partake instead in a feast of the spirit.

Executed in the spring of 1914, *Tavern, Bowl of Fruit with Bunch of Grapes and Sliced Pear*, and another *papier collé, Wineglass and Sliced Pear on a Table*, were among the last purchases made by Sergei Shchukin (1854-1937), a wealthy Moscow industrialist who had acquired a collection particularly rich in modern art. Shchukin's Picassos arrived in Moscow on the eve of the First World War.

An outstanding art collector, a man with a free spirit and profound artistic intuition, Shchukin himself confessed to not always understanding the young Spaniard's stunningly innovative art. However, as very few in those times, he realized and strongly supported the artist's ultimate rightness. In the midst of the heated arguments caused by Picasso's revolutionary art, the Moscow patron expressed his regard by procuring fifty of the artist's works.

However, if he had ever voiced his views as a critic, they would have coincided with these words by an Englishman: "I frankly disclaim any pretension to an understanding or even an appreciation of Picasso. I am awed

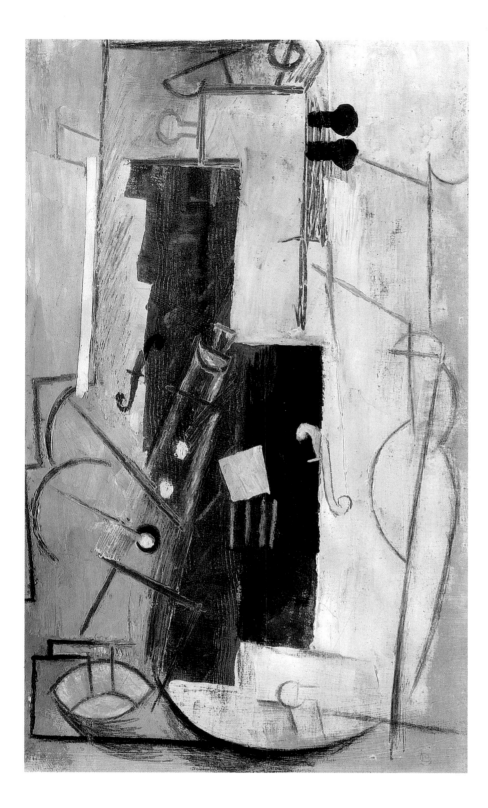

by him. I do not treat him as other critics are inclined to do, as a madman. His work is not a *blague*. Of that I am assured; and anyone who has spoken to him will share my assurance… Picasso has done everything. He has painted delicate watercolours of an infinite subtlety and charm. He has made drawings with a magical line that leaves one amazed by its sheer and simple beauty — and yet he has reached a point where none have explained and none, as far as I know, have truly understood. Yet he declares: 'I will go to the goal.' It is because I am convinced of the genius of the man, because I know what he has done in the past, that I stand aside, knowing too much to condemn, knowing too little to praise, for praise needs understanding if it is to be more than empty mouthing… I feel that Picasso is in some way greater than the greatest because he is trying to do something more."[108]

Clarinet and Violin, 1913.
Oil on canvas, 55 x 33 cm,
The Hermitage, St. Petersburg.

Composition: Bowl of Fruit and Sliced Pear, 1914.
Wallpaper, gouache and plumbago on cardboard, 35 x 32 cm,
The Hermitage, St. Petersburg.

Shchukin's domestic gallery, opened to visitors, became virtually the first public museum of modern art in the world, even before the First World War. Only three paintings — but true masterpieces — come from the collection of another major Moscow patron of the arts, Ivan Morozov (1871-1921): *Harlequin and His Companion* (p.17), *Acrobat on a Ball* (p.44), and *Portrait of Ambroise Vollard* (p.111).

Whereas in the Morozov gallery, Picasso's selected works occupied only one place, albeit a special one, in an anthology of modern French art subdivided into periods and directions, the Picasso room in the Shchukin collection spoke more of the owner's personal biases. "The entire collection," wrote B.N. Ternovets, who was well acquainted with the original Shchukin gallery, "puts one in mind of the petrified waves of the collector's passions: for the art of Monet, Gauguin, Matisse, Picasso, Derain."[109]

Fruit Vase and Bunch of Grapes, 1914.
Paper, gouache, tempera, sawdust and pencil
on cardboard, 67.7 x 57.2 cm,
The Hermitage, St. Petersburg.

These waves of passion, seemingly so contradictory, would sometimes overlap. But Shchukin never repudiated the previous one in favour of the latest, and while continuing to lovingly follow Matisse's career, he simultaneously added Picasso's work to his collection, and then that of Douanier Rousseau and of Derain.

As far as Picasso is concerned, it is easier both to explain and to understand why Shchukin was attracted to this young representative of the Parisian avant-garde (and of its "anti-Matisse" wing) if one knows of the collector's aesthetic *Wanderlust*, which often took him to unknown shores, and of his penchant for extremes. His fascination with Picasso could not have begun earlier than 1909.[110]

In the autumn of 1908, in Paris, Shchukin acquired several paintings by Matisse, as did Morozov; Morozov also bought an essentially Post-Impressionistic work by Picasso, *Harlequin and His Companion*, which we know to have been the first Picasso to appear in Russia. Yet by 1913 Shchukin's collection included thirty-five paintings and gouaches by Picasso. It grew to forty by the beginning of 1914 and half a year later had reached fifty.

The importance of that collection was apparent to its first viewers and remains unchallenged to this very day. In addition, it would be neither a mistake nor an exaggeration to state that, in those years, the visitors to Shchukin's domestic gallery were better acquainted with the works of the young Picasso than were art-lovers in other European cities, Paris included, because Picasso did not exhibit in the great Salons and refrained from participating in other group expositions. He lived for his craft, cultivating only his friends, preferring to sell his works through dealers, caring little about the fame brought by public display.

Although Shchukin admired Picasso and profoundly trusted him, not all of the painter's works, not all of his artistic approaches, were equally acceptable to this Russian patron of the arts — something we already suggested earlier. For example, Shchukin procured none of the works from 1910-1911, the most hermetic and abstract phase of Cubism, which he possibly considered too abstruse. On the other hand, the monumentally archaic proto-Cubism of 1908 and the refined Cézannesque style of 1909, which the collector may have perceived as a kind of continuation of his favourite Blue Period, are represented with extraordinary scope and by the most major works.

This choice of paintings reflected Shchukin's particular view of Picasso: a Spanish painter, a stern ascetic, a visionary spirit, but also somewhat demoniacal. Shchukin, who liked to express his thoughts in contrasts, stated aphoristically: "Matisse should decorate palaces, Picasso cathedrals."[111]

So, in his two-story Empire-style mansion, he placed Matisse's works in a large, bright, attractive room (the Rose Salon), while the Spaniard's canvases were relegated to a solitary, vaulted room that Tugendhold simply and expressively called "Picasso's cell".

Matisse and Picasso appeared before the Russian public, then, as the antithesis palace/cathedral, a situation that was to have significant consequences. No less significant, however, is the fact that Shchukin's concise formula generally reflects the receptiveness of Russian Post-Symbolist culture to Matisse and Picasso. And since the traditional criterion for an artistic work in Russia was how it answered the crucial question "why?", it is easy to understand that for Russian culture of the 1910s, a period of heightened spiritual search, the cathedral was incontestably superior to the palace. This truth is brought home again when one reads the assessments of the works of Matisse and Picasso by their first Russian critics.

Tavern (The Ham), 1914.
Oil and sawdust on cardboard, 29.5 x 38 cm,
The Hermitage, St. Petersburg.

The Yellow Sweater (Dora Maar), 1939.
Oil on canvas, 81 x 65 cm,
Special Collection, Geneva.

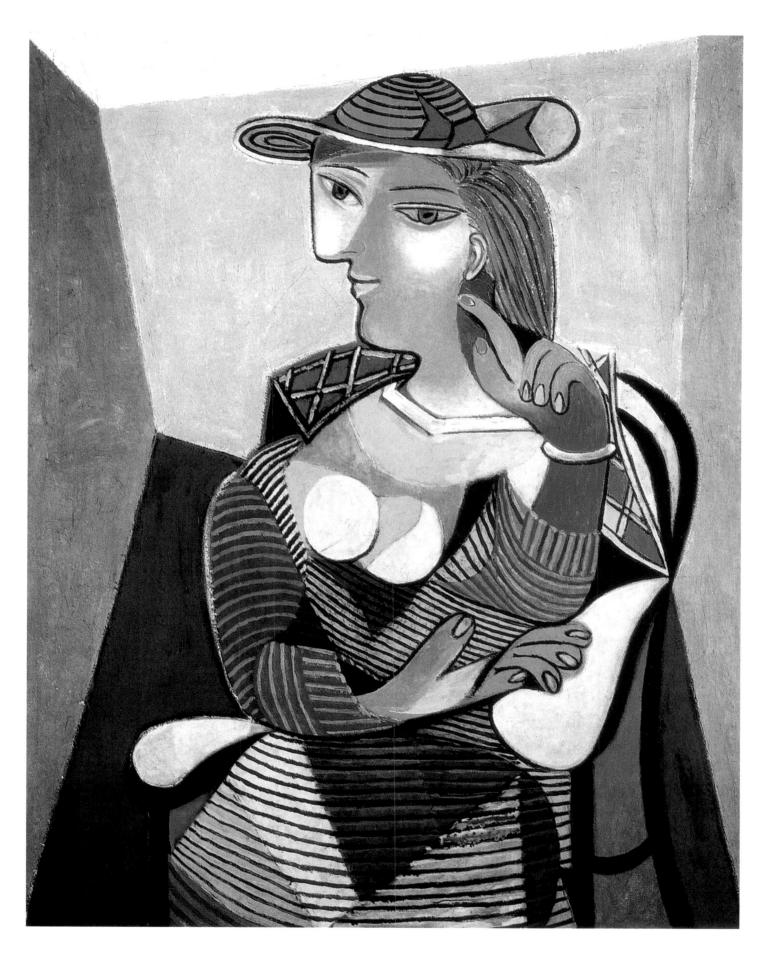

Portrait of Therèse Walter, 1937.
Oil on canvas, 100 x 81 cm,
Musée Picasso, Paris.

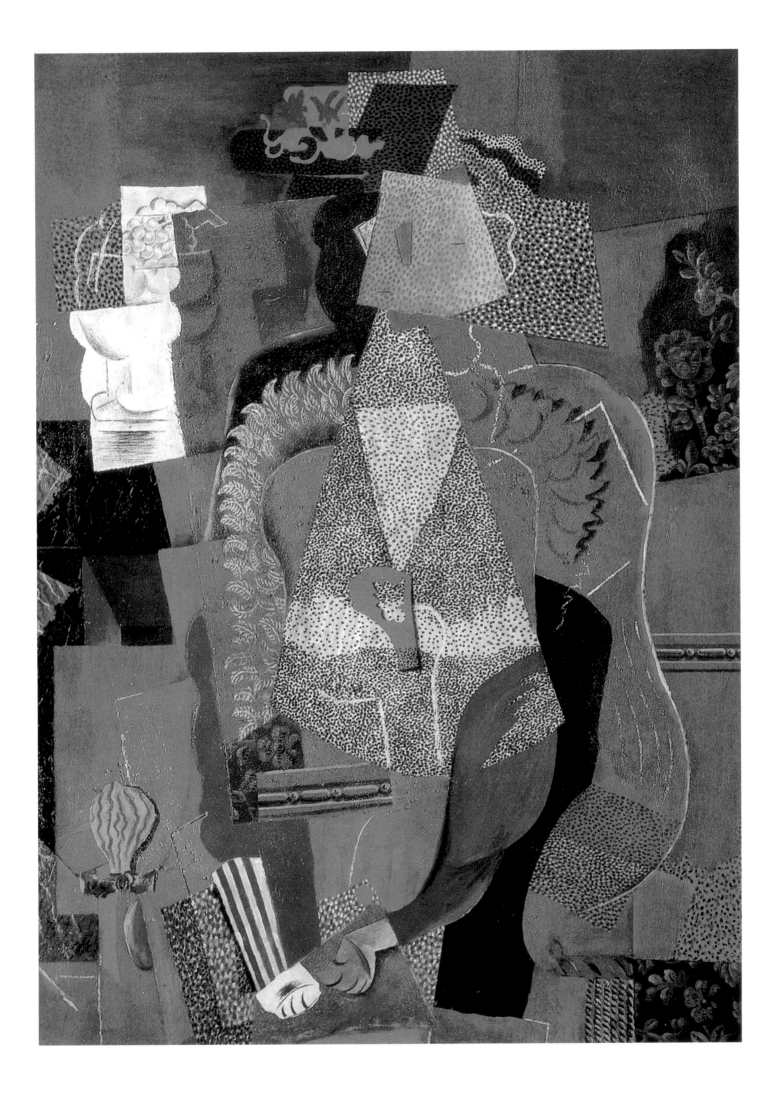

The serious critics, of course, acknowledged Matisse as a bold innovator, prized his artistic gift and appreciated the scale of his creative personality; however, the same critics, who certainly understood Matisse in essence, stubbornly and all the more significantly refused to see anything but his "palace" side, that is, the image of a decorative Eden, akin to Persian and Arabian scenes, with glazed walls and opulent carpets and fabrics.

In the first volume of *Apollon* for 1914, Yakov Tugendhold wrote: "It may not be possible to philosophise in Shchukin's Rose Salon, but neither can one surrender to Chekhovian feelings... Here, without leaving your armchair [a reference to Matisse's own comparison of his artistic ideal with a good, comfortable armchair] you travel to all the poles and tropics of emotions."[112]

Like Maurice Denis, Tugendhold admits Matisse's aspirations towards the absolute. But they are Oriental aspirations, as he will point out in a letter edition of his essay on the Shchukin gallery.[113] Ultimately, for Tugendhold, Matisse's work is not great art but rather joyous art, joyous craftsmanship. It finds its justification in its social function: to be decorative, to serve as satisfaction for the body and the spirit, something so necessary in the modern age of haste.

Another critic, Piotr Pertsov, was not captivated like Tugendhold by the purely painterly qualities of Matisse's pictures.[114] Pertsov represented a different milieu: the Symbolist literary culture of the 1900s, which had already faded.

In fact, when Pertsov reads Matisse's own words concerning his religious perception of the world, he not only refuses to believe him, but cannot hide his indignation: "It is difficult to imagine a more unfortunate self-characterization." As far as Pertsov is concerned, "His [Matisse's] colour cinematography has no script. There is nothing to 'say' about those pictures; they can only be looked at." And that, in the critic's view, is not sufficient for the art of painting. In Matisse's portraits, devoid of psychology, and in his compositions of arabesque-like, faceless figures, Pertsov sees only a pictorial synopsis of reality that is condensed, as in mathematics, to a few "algebraic" meanings. His final judgement is: this ornamental and decorative art is an example of portentous spiritual atavism.

Having "dealt" with Matisse, Pertsov turns to Picasso: "What an enormous difference of impressions, of entire spiritual content between these two major modern French artists!... It is as if whole worlds of space and time lay between them... Where the Oriental Matisse is 'contentless', the Occidental Picasso is packed with 'content', a true son of Aryan culture who does not even notice this involuntary 'serving of the spirit'."[115]

Art as a service to the spirit, art that has content, that is a philosophic realization of the world, an aesthetic response to metaphysical questions — those are Pertsov's general views of Picasso, and here the Russian critic, with his Symbolist feelings, has much to say. One must note that the perception of Picasso as an unconscious mystic whose works reveal more than their creator realizes was typical not only for Pertsov, but for a whole group of Russian cultural figures who recorded their views of Picasso for posterity. Some, like Pertsov, had ties with the Symbolist literary movement, including, for instance, Georgy Chulkov. Others represented the mystical and theosophist views of the 1910s: Sergei Bulgakov, Nikolai Berdiayev. Only Yakov Tugendhold was a professional art critic, but one with a penchant for cultural and philosophical generalizations.

Steeped in their painful spiritual problems, gripped by eschatological fears, these people entered "Picasso's cell" on the eve of the First World War. Out of their own thoughts and impressions, with rare bits and pieces of the

Portrait of a Young Girl
(Seated Girl in front of a Fireplace), 1914.
Oil on canvas, 130 x 96.5 cm.
Centre Georges Pompidou, Paris.

artist's real biography, they created their own image-interpretation, which resembles art criticism much less than a "confession of the children of the age" projected onto Picasso's work. I repeat: projected onto Picasso's work — for that is significant.

In essence, this attitude was adopted immediately; it was the first impression, which was, nonetheless, profound. "When one enters the Picasso room of the Shchukin gallery, one is gripped with horror; what one feels relates not only to painting and the fate of art, but to cosmic life itself and its fate,"[116] wrote Nikolai Berdiayev. "In this room you immediately feel transported beyond the limits of all other art... You behold something so strange, so unusual, so nightmarish, that at first you hesitate to call it art," wrote Pertsov, who developed his impression as follows: "One Russian writer, Sergei Bulgakov, compared Picasso's art with the ideas of Svidrigailov in Dostoyevsky's *Crime and Punishment*, who described eternity as a cramped log cabin filled with spiders. Yes, there is something of that log cabin in this room, and its 'spiderish' impression comes from those ominous canvases, now dark, now red, that hang on its walls and that strike the eye, first and foremost, by the sharp, long lines of the drawing."[117]

This comment pertains to the paintings of 1907-1909, which were referred to as Cubist, while the period from 1910 to 1914 was considered Cubo-Futuristic. These so-called Cubist works accounted for half of Shchukin's Picassos and overshadowed the rest.

However, this impression of horror, of something strange, unusual and nightmarish, did not lead to Picasso's being repudiated or condemned by Russian thinkers. On the contrary, they were clearly repelled by the joyous art of Matisse, which, in their eyes, had its counterpart in something polar to Picasso: Gauguin's golden dream, full of mysteriously symbolic meanings. Picasso, however, attracted them like a magnet, drawn by everything they found in him of the tense, the serious, the pessimistic, the philosophical. Indeed, he was their daily bread.

Standing before his pictures, they felt themselves to be on the edge of an abyss, as if facing black icons which radiated a black bliss that was almost physically tangible in that room — as Bulgakov put it and Pertsov repeated. Others used similar words to express their thoughts. Georgy Chulkov saw Picasso's pictures as Satan's hieroglyphs, for in his opinion these forms have no corresponding emotions outside of Hell; what is more, as Pertsov believed, there was too much real mysticism in his colourful geometry to fully believe its formal mask. He considered the metaphysical structure of Picasso's art an infernal revelation and used the term Cubism exclusively as an obeisance to his role of art critic. "Picasso's Cubist canvases create the sinister impression of some extra-terrestrial insight, some hellish, soul-burning flame."[118]

Here we must note that such a perception of what constituted true art, and its very vocabulary and thought patterns, were typical of Russian Symbolist poets of the 1890s.

In a programmatic article of 1907, entitled *On the Contemporary State of Russian Symbolism*, Alexander Blok wrote: "Art is Hell. It is not for nothing that Valery Briusov counselled the artist: 'Like Dante, a subterranean flame must burn your cheeks!'"[119]

Even the professional critic Tugendhold, when analysing Picasso's creative personality, seems less preoccupied with aesthetic laws and problems than with the mystic and demonic essence concealed in the artist's national character. "Picasso is an authentic Spaniard who combines religious mysticism with the fanaticism of truth." Or: "He always remained a fanatic and a Spaniard with a penchant for the transcendental."

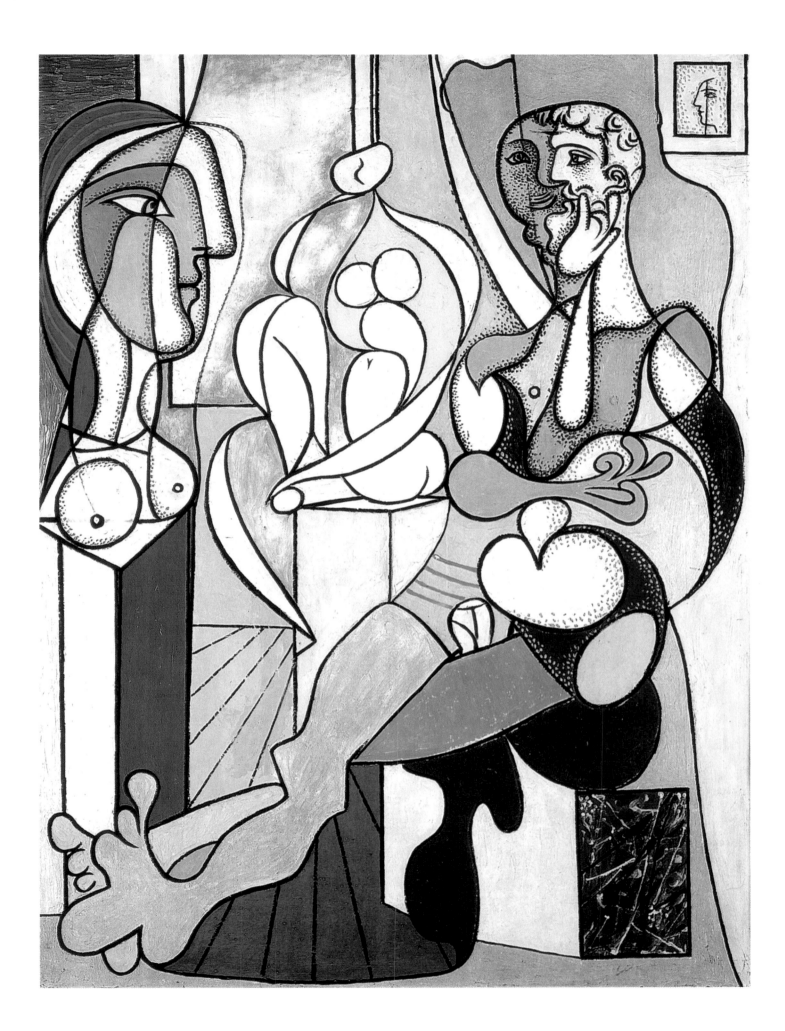

The Sculptor, 1931.
Oil on contreplaque, 128.5 x 96 cm,
Musée Picasso, Paris.

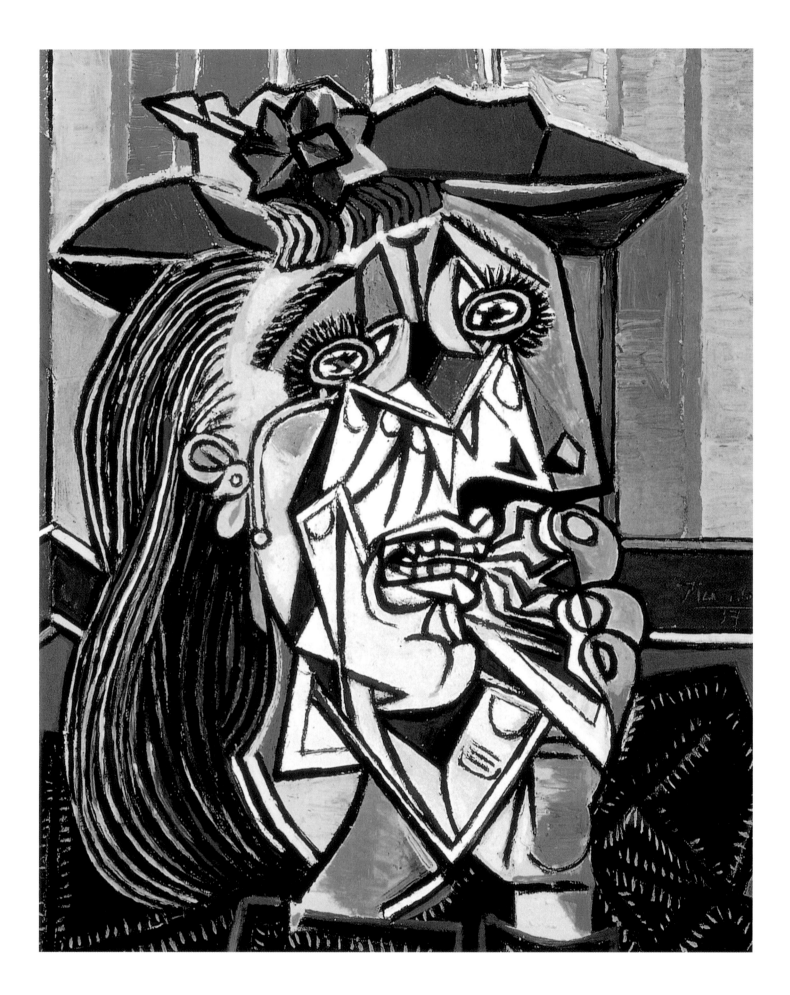

Crying Woman, 1937.
Oil on canvas, 60 x 49 cm,
Tate Gallery, London.

Or, also: "With the fanatical coldness of a Spanish inquisitor he becomes a fanatic of the pure idea."[120]

Mysticism and transcendence are for Tugendhold immutable qualities of Picasso's internal and creative personality — from his debut to his latest works. While, in his opinion, "the blue series promised a major and profound painter in Picasso... He could be a new Puvis de Chavannes, he could be deeper and more religious than Puvis de Chavannes...," the critic discerned nothing less than Faustian, gnomic truths in the formal construction of the early Cubist landscape *Factory*. His analysis of that work is amazing. "The lines of the factory's walls and roofs do not merge at the horizon... they diverge, running off into infinity. Here no mental point of convergence exists, no horizon, no optics of the human eye, no beginning and no end — only the cold and the insanity of absolute space. And even the sheen of that factory's mirror-like walls, countlessly repeated, reflected from the sky, makes *Factory* an enchanted labyrinth of mirrors, a mad hallucination... For indeed, one could lose one's mind from this thought and temptation that is worthy of Ivan Karamazov: there is no end, no unity, no human being as the measure of all things — there exists only the cosmos, only the infinite fractionalizing of volumes in infinite space!"[121]

Here we see, once again, something generally typical of all of Picasso's Russian critics — a readiness to define the inner creative essence of the painter's oeuvre by literary analogies. Raised in a great literary tradition, and writers themselves, they would refer to the protagonists of Dostoyevsky's "human tragedy" (Bulgakov, Pertsov, Tugendhold) or to Gogol's grotesque view of the world's diabolical face (Pertsov).

Thus perceived and described in their articles, Picasso is a kind of super-painter: for Chulkov, a genius who expressed pessimistic demonism; for Berdiayev, a genius who expressed the decay, the splintering, the atomisation of the physical, corporeal, real world; for Tugendhold, a fearless Don Quixote, knight of the absolute, devotee of mathematics, condemned by the eternal futility of his quest but simultaneously the leader of contemporary decadence.

All these definitions (and I could give more), whatever their few superficial differences, are facets of one common mental image drawn after a hidden model that served to create similar interpretations of Picasso. I would venture to suggest that this hidden model was none other than Vrubel's "Nietzschean demon", born first from the Russian Romantic tradition and born again at the threshold of the twentieth century by the Symbolist consciousness. This is a typically Russian hypostasis of the *artiste maudit* who is profoundly alien to any decorative heaven, the solitary artist-outcast, fated to perish in the hell of his art. Thus, Piotr Pertsov wrote of Picasso's possible end in terms of Gogol's prototype in *The Portrait*. Georgy Chulkov ended his essay in the following manner: "Picasso's death is tragic. Yet how blind and naive are those who believe in imitating Picasso and learning from him. Learning what? For these forms have no corresponding emotions outside of Hell. But to be in Hell means to anticipate death. The Cubists are hardly privy to such unlimited knowledge."[122]

Picasso's death — even if symbolic — inevitably had to crown this image, created by his first Russian critics of a great contemporary artist, one of the many images of Picasso in the minds of his contemporaries. Much of what was said about the artist in Russian during the 1910s remains absolutely true, and today we are discovering it anew.

"It is theoretically impossible to assume," Pertsov wrote, "that a simple still life, a bottle, a dish with fruit, some apothecary glassware, could be steeped in feelings of universal negation and immeasurable hopelessness. But enter the Picasso room — and you will see that miracle."[123]

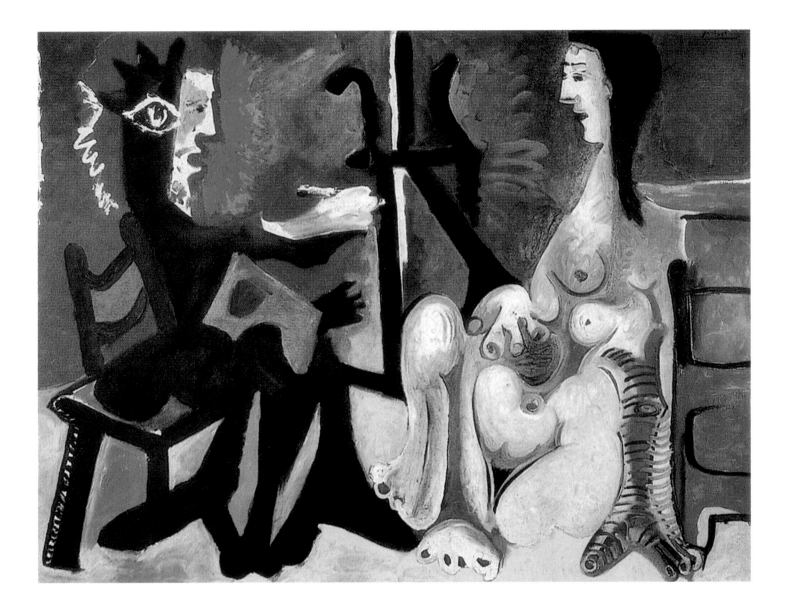

The Painter and his Model, 1963.
Oil on canvas, 130 x 162 cm,
Museo Español de Arte Contempraneo.

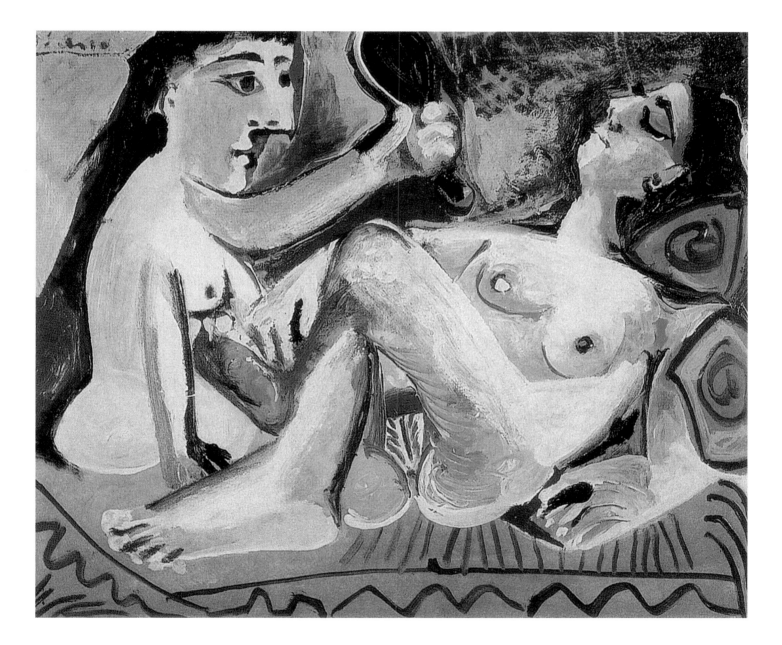

The Two Friends, 1965.
Oil on canvas, 130 x 195 cm,
Musée du Petit Palais, Geneva.

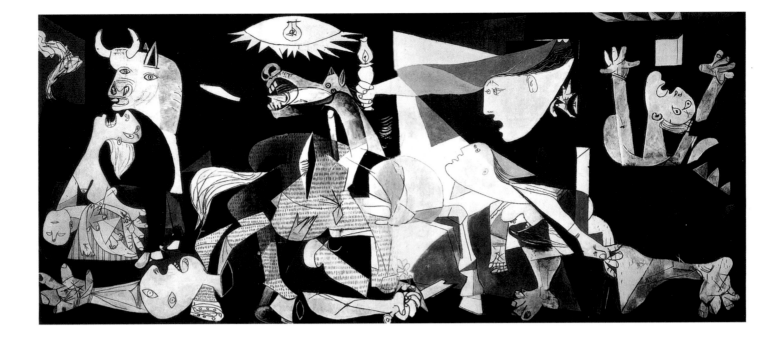

Guernica, 1937.
Oil on canvas, 349.3 x 776.6 cm,
Museo Centro de Arte Reina Sofia, Madrid.

Even earlier, Chulkov voiced the same amazement: "Picasso has a still life — clay jugs and bottles standing on the edge of a table, pushed into a corner. Ascetically severe colour, extreme simplicity of drawing, not even a hint of the deliberate — and, at the same time, an incredible, astonishing expressiveness of form with exceptionally significant emotions ideally corresponding to this form, such as only a genius could have hit upon! I know of no other painting as fearful as that still life of Picasso's."[124] Is it not truly amazing that all this pertains to an art perceived everywhere then, and for many, many years after, as essentially formal, a purely corporeal-plastic phenomenon? For historical reasons, that art came to be called Cubism, and the force behind a formal approach to it has not been fully overcome to this day. Yet Picasso told Tugendhold in that period: "A bottle on a table is just as significant as a religious painting."

Neither should one ignore the following piece of reasoning by Yakov Tugendhold, because it is essential for an understanding of Picasso's oeuvre: "He wants to depict objects not the way they appear to the eye but the way they are in out thoughts." Expressed in 1914, that comment by the Russian critic preceded by twenty to twenty-five years the artist's own statement: "I paint not what I see but what I think."[125]

But let us leave the penetrating views of the older generation of Russian critics of the 1910s who, deep inside, remained true to Symbolism, by then already yesterday's art. New movements in art and poetry were reaching their zenith, movements headed by a young generation filled with an incredible thirst for cultural innovation. These young people sought new paths, the revolutionary spirit was in their blood. One of their sources of inspiration was the Shchukin gallery, which Ternovets quite justly called a kind of academy of new art, which nurtured the luxuriant shoots of young Moscow painting. And not only painting.

No matter how broad the scope of avant-garde experiments — from Cézannesque influences to Suprematism — none of the movements of those years escaped the profoundly clarifying and purifying effect of Shchukin's collection of Picassos from different periods. Besides, Picasso's own example as a heroic innovator-creator stimulated the non-conformism of radical artists, revolutionized their aesthetic awareness, and infected

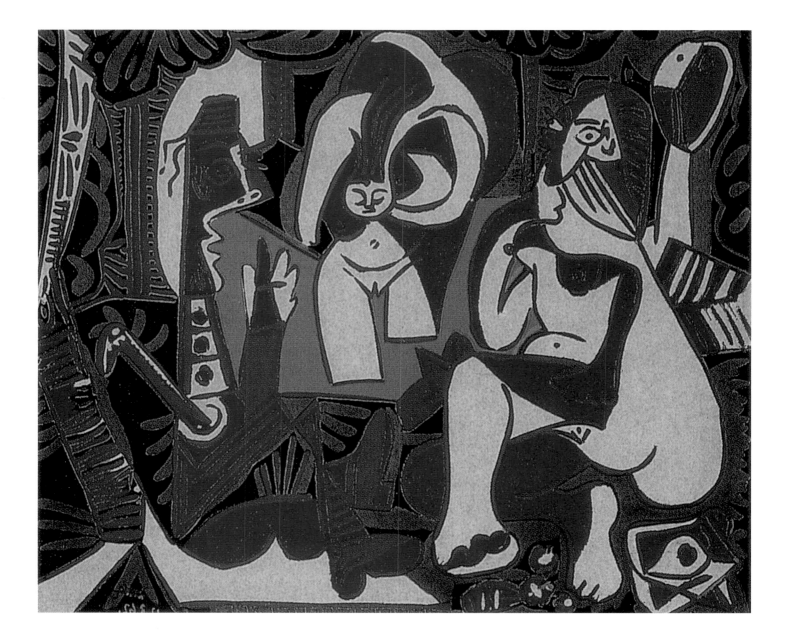

them with a thirst for action, and then more action. Understandably, their view of the young Parisian maitre differed profoundly from that of their older contemporaries, who were men of letters. For example, Alexei Grishchenko, as a painter and supporter of "pure form" art, vehemently differed from Berdiayev and Andrei Bely in a publication on the subject of Picasso: "The mention of Picasso's name after Ciurlionis, the simultaneous acknowledgement of both as geniuses, stands as an additional and weighty argument that Berdiayev understands absolutely nothing," he wrote. Ciurlionis and Picasso are two poles, mutually exclusive polar phenomena... Do not the words of this Russian philosopher make one think of the person who, not understanding a phenomenon, trembles before it and calls it supernatural?"[126] For Grishchenko, "Picasso is not a supernatural phenomenon. He is a good painter, one who has made several worthy paintings that fully correspond to our understanding of painting, that is the first thing; secondly, his painting is the natural fruit of the organic growth of form and the evolution of the artist's awareness. His best works have, like Cézanne's, become classics."[127] And he mentioned a *Violin*, perhaps the same *Violin* that Olga Rozanova was then copying and that is now exhibited in the Pushkin Museum in Moscow. In this *Violin* "the new conception of painting is solved with astonishing mastery... and every part of the canvas

Luncheon on the Grass (after Manet), 1962. Engraving on linoleum, 53.3 x 64.5 cm.

138

is the work of a real artist." As for what being a "real artist" implies and what the art of painting means, Alexei Grishchenko had a serious and lofty understanding: "Broadening and consciousness, establishing it in reality, in concrete painterly forms as a picture, obeying some internal voice and powerful call, the artist through his work instinctively achieves an understanding of the evolution of the world and of man, the evolution of his art. Through colour and structure — forms — he puts his images on canvas in authentic plasticity: the ultimate achievement of his consciousness."[128]

Moreover, Grishchenko's greatest admiration is reserved for that period of Picasso's Cubism which was not represented in Shchukin's gallery. "I have in mind," he wrote, "the artist's monochromatic paintings with their supreme and contemporary understanding of form, texture and structure that have flowered in the soil of the French genius of painting. One such is *The Clarinet* in Uhde's Paris collection" (now in a French private collection). It should be noted that Kasimir Malevich also valued Picasso's *Clarinet* highly.

Finally, one cannot ignore the first book on Picasso — not only in Russia, but in the world. It was published in the revolutionary year of 1917. This monograph, *Picasso and His Environs*, was written by Innokenty Aksionov, a poet belonging to the Moscow Cubo-Futurist association *Centrifuge*, in June 1914, according to the author's dating.[129]

Page 138:
Portrait of Jaqueline, 1963.
Oil on canvas, 92 x 60 cm,
Rosengart Gallery.

Page 139:
Portrait of Jaqueline with Flowers, 1954.
Oil on canvas, 146 x 114 cm,
Heir of Jaqueline Picasso.

This monograph is of an unusual type — a kind of essay-collage consisting of polemical notes, observations, pronouncements, and thoughts on aesthetic and "adjacent" themes. In his approach, the author seems bent on following the bohemian, sarcastic and paradoxical spirit of Picassoism. The 113 paragraphs of the first three parts proceed in this vein; in the fourth part, the author minutely and very professionally examines the formal and technical side of Picasso's craftsmanship over the entire period of his work. The book was motivated by Aksionov's boundless admiration for this most wonderful Spaniard (after El Greco), while its immediate cause was his desire to contradict Berdiayev and the other Russian "mystics" mentioned earlier.

It is precisely for that reason that Aksionov writes about Picasso as a pure artist, someone who creates from the spirit of painting, who "spent the entire power of his gift embodying the natural requirements of this external imperative, i.e. the spirit of painting, and was cast beyond the confines of painting because pictorial art is choking in the chains of oil tempera, as music is in the cage of 12-note tempered pitch. Picasso is an attempt to overcome obsolescent techniques and to lay the grounds for painting with any and all materials."[130]

There was nothing mystical about Picasso's creative process as far as Aksionov was concerned. He perceived the "red-brown period of 1908" as essentially intermediary and its representation in Shchukin's gallery by such a number of canvases as potentially misleading in respect of its importance to the process as a whole.

In contrast to Berdiayev's eschatological premonitions concerning Picasso, Aksionov essentially expressed not so much his views on art in general, and contemporary art in particular, as his simple admiration for an artist he knew personally and his instinctive love for the work. That, it seems, is what gave the author of *Picasso and His Environs* a special perspicacity, a correctness and subtlety so apparent in his brilliant judgements. These qualities are especially apparent in the comments concerning the very essence, the secret nerve, of the master's creative personality. Here are just a few examples, the most important.

On the metaphorical vision of Picasso-the-Cubist, Aksionov writes: "The mystique of Picasso's objects has the same root as the mystery of ghosts that consist of a chair, a coat and a dangling, starched shirtfront. Practical jokers have roared with laughter at the horror caused by these objects, but this phenomenon is worthy of attention."[131] Indeed, this presages the future Surrealist montages, and Picasso's sculptural ensembles of the 1930s-1950s. Here we read about the optical, that is, the real nature of Cubism's so-called distortions: "Picasso stares his objects in the eye, as we look into our lover's face."[132] Did not the artist confirm this himself with his portraits of women in the 1930s?

And a final example: Aksionov was unaware of the so-called Ingres drawings of 1915-1917, long before the beginning of the so-called Neo-Classicism of the 1920s, far from Paris. Yet he suggests — no, more accurately, predicts: "Now, stealthily, will not this portraitist of countless violins, who leads his careless companions into paper and tin jungles, suddenly turn on them in a frank burst of lofty realism?"[133]

In an epigraph to his book, Aksionov quoted the words of Grigory Nissky: "Some see God as a burning fire, others as a light." For Aksionov himself, however, Picasso was not an infernal, but a creative, flame. "And this flame," wrote Aksionov — and I agree with him in this — "is a positive force and forms the very basis of world order."

Anatoly PODOKSIK

Self-Portrait (Head), 1972.
Black crayon and colour crayon on paper,
Fuji Television Gallery, Tokyo.

Chronology of the Artist's Life

1881	25 October. Birth of Pablo Ruiz Picasso at Málaga. Parents: José Ruiz Blasco, a teacher of drawing at the School of Fine Arts and Crafts and curator of the local museum, and Maria Picasso y Lopez.
1888-1889	The first of little Pablo's paintings, *Picador*.
1891	The Ruiz-Picasso family moves to La Coruña, where Pablo studies drawing and painting under his father.
1894	The third year of his studies at the School of Fine Arts in La Coruña. Passing the Drawing and Ornament class and the Life Drawing class, he paints oil portraits of his parents and models, sketches battle scenes. Overwhelmed by his son's talent, Don José gives him his own brushes and palette, declaring that he himself will never paint again.
1895	The family moves to Barcelona. Pablo visits Madrid, where in the Prado he sees the paintings of Velázquez and Goya for the first time. Enrolls at the School of Fine Arts in Barcelona, popularly called "La Lonja", skipping the early classes in favour of the most advanced. His father rents a studio for him.
1895-1896	Paints his first large academic canvas, *First Communion*.
1897	At the beginning of the year paints a second large academic work, *Science and Charity*; it receives honourable mention in the national exhibition of fine arts in Madrid, in June, and later receives a gold medal at Málaga. Picasso is admitted to the Royal Academy of San Fernando in Madrid.
1898	After a hard winter in Madrid, and a bout of scarlet fever, he returns to Barcelona in June. Together with Manuel Pallarés goes to Horta de Ebro (renamed Horta de San Juan in 1910) and spends eight months there.
1899	In Barcelona joins a group of avant-garde intellectual artists who frequent the café Els Quatre Gats. Modernist tendencies appear in

his works: portraits of his friends and a large painting *The Last Moments.*

1900 Leaves for Paris and settles at 49, Rue Gabrielle in Montparnasse. Meets his first dealers: Pedro Manach and Berthe Weill. Cabaret and Montparnasse themes. *The Last Moments* is exhibited at the Paris Exposition Universelle.

1901 During the winter in Madrid, makes portraits of high-society women; together with Francisco Soler publishes the review *Arte Joven*; makes the acquaintance of Pio Barojo and others of the generation of 1898. That spring in Barcelona, uses divisionist brushwork. Spanish brutalism prevails in the subject matter. Returns to Paris in May; development of pre-Fauvist style; Cabaret period. 24 June-14 July, sixty-five of his works exhibited

Page 144, top: Pablo Picasso. Photograph from 1885.

Page 144, bottom: Pablo Picasso and his sister Lola. Photograph from 1888.

Page 145, left: Maria Picasso Lopez, Pablo Picasso's mother.

Page 145, right: José Ruiz Blasco, Pablo Picasso's father.

at the Galerie Vollard. Friendship with Max Jacob. Félicien Fagus publishes review in *La Revue Blanche*. Visits the St. Lazare prison. Influenced by Lautrec and Van Gogh. The Casagemas death cycle. First Blue paintings. Inmates and Maternities of St. Lazare.

1902 Develops Blue style in Barcelona. First preserved statue: *Woman Seated*. Again returns to Paris in October. Has an exhibition at Berthe Weill's; Charles Morice reviews the show in *Mecure de France* and presents Picasso with a copy of Paul Gauguin's *Noa Noa*. Lives in poverty in Paris with Max Jacob.

1903 Blue Period in Barcelona.

1904 In April leaves for Paris, moves into the Bateau-Lavoir in Montmartre. End of Blue Period. Takes up engraving. Friendship with Apollinaire and Salmon. Meets Fernande Olivier (1881-1965).

1905 In February exhibits his first paintings on the travelling circus theme at Galeries Serrurier. Apollinaire writes first reviews of Picasso for *La Revue Immoraliste* (April) and *La Plume* (15 May). In summer goes to Holland. Completes the large canvas *Family of Saltimbanques*. End of the Circus Period. Meets Leo and Gertrude Stein.

1906 Rose Classicism. Gertrude Stein introduces Picasso to Matisse, who with delight shows him an African figurine; meets André Derain. Spends the summer in Gosol (in the Andorra Valley in the Eastern Pyrenees). That autumn in Paris completes portrait of Gertrude Stein, begun in the winter, and paints a self-portrait reflecting Iberian archaic sculpture.

1907 *Les Demoiselles d'Avignon*. That summer visits the ethnographic museum at Palais du Trocadéro, where he discovers for himself African sculpture. Meets D.-H. Kahnweiler and Georges Braque. Cézanne retrospective at Salon d'Automne. Death of Alfred Jarry (1 November). Carves wooden sculpture.

Page 146: Pablo Picasso. Photograph from 1922.

Page 147, top: S.I. Shchinkin. Photograph from 1900.

Page 147, bottom: M.A. Morozov surrounded by his family (second row in the center). Photograph From circa 1910.

1908	Proto-Cubism. Spends August at La Rue-des-Bois, north of Paris. In November Braque exhibits at Kahnweiler's gallery his L'Estaque works that were not accepted by the Salon d'Automne; the term Cubism is born. Picasso gives a banquet at the Bateau-Lavoir in honour of Douanier Rousseau.

1909 From May to September works in Horta de Ebro, develops Analytical Cubism. In the autumn leaves the Bateau-Lavoir and moves to 11, Boulevard de Clichy. Sculpts *Head of Fernande*. Sergei Shchukin first shows interest in Picasso.

1910 Travels in summer to Cadaques in Derain. "High" phase of Analytical Cubism. Nine works shown at the Grafton Galleries, London, in the *Manet and the Post-Impressionists* exhibition.

1911 Spends the summer at Ceret, where he is joined by Braque and Max Jacob. Apollinaire arrested in connection with the theft of the *Mona Lisa* (7-12 September). Opening of Salon d'Automne with large Cubist section; although Picasso does not exhibit, the foreign press consistently ties his name to the exhibition. That autumn meets Eva Gouel (Marcelle Humbert, 1885-1915).

1912 In winter, makes his first collage, *Still Life with Chair Caning*. Leaves with Eva for Ceret, then goes to Avignon and Sorgues-sur-l'Ouvèze (May-October). Transition of Cubism to Synthetic phase. In September moves to a new studio at 42, Boulevard Raspail. First *papiers collés* and constructions.

1913 Painting influenced by his own three-dimensional constructions and *papiers collés*. In March departs for Ceret with Eva. Death of his father in Barcelona in May. In August moves to his new studio at 5 bis, Rue Schoelcher.

1914 New group of *papiers collés* and coloured cardboard reliefs. Spends the summer in Avignon

with Eva (June-November). Rococo Cubism combines with Cubist structures in a foreshadowing of Surrealist methods. War declared on 2 August. His friends, Braque, Derain and Apollinaire are mobilized.

1915 "Ingres" portraits. Death of Eva (14 December).

1916 Picasso visits Jean Cocteau, who introduces him to Diaghilev and Erik Satie. Moves to Montrouge.

1917 Joins the Diaghilev troupe in Rome, works on décor and costumes for the ballet *Parade* (scenario by J. Cocteau, music by E. Satie). Visits Naples and Pompeii. Scandalous opening of *Parade* at Théâtre du Châtelet, Paris (18 May). Follows the Ballets Russes to Madrid and Barcelona. Meets ballerina Olga Khokhlova (1891-1955). Cubism, "Ingres" style, Pointillism, Classicism.

1918 Wedding of Picasso and Olga (12 July). Summer in Biarritz. Death of Apollinaire (9 November). Picasso and his wife move to 23, rue La Boëtie.

1919 From May to August Picasso in London with the Ballets Russes to design décor and costumes for the ballet *Le Tricorne* (composed by Manuel de Falla). Spends the autumn at Saint-Raphael. "Ingres" style, Classicism, Cubism; ballet and commedia dell'arte themes, still lifes.

1920 Continues to work with Diaghilev: the ballet *Pulcinella* by Stravinsky. Summer in Juan-les-Pins. Linear Classicism in mythological subjects. Cubism in still lifes and commedia dell'arte subjects.

1921 Birth of son Paulo (4 February). Lives at a villa in Fontainebleau. Continues to work for Diaghilev (*Cuadro Flamenco*). Classicism (mother-and-child subjects), Cubism and Neo-Classicism of "gigantic" order.

1922 Spends the summer in Dinard (Brittany) with wife and son. Neo-Classical mother-and-child scenes.

Pablo Picasso. Photograph from 1960.

148

1923	Spends the summer at Cap d'Antibes. Meets André Breton.
1924	Summer at Juan-les-Pins. Continues to do theatre work, designs décor and costumes for the ballets *Mercure* and *Le Train Bleu*. Publication of Breton's *Manifeste du Surréalisme*.
1925	Goes to Monte Carlo with the Ballets Russes. Classical drawings of ballet scenes and the large Surrealist painting *The Dance*. Spends the summer at Juan-les-Pins. Recognized by the young Surrealists, participates in their exhibition.
1926	Spends summer at Juan-les-Pins, October in Barcelona. Paints the large canvas *The Milliner's Workshop*. First issue of *Cahiers d'Art*, founded by Christian Zervos.
1927	In January meets seventeen-year-old Marie-Thérèse Walter. Death of Juan Gris (11 May). Summer in Cannes. Theme of biomorphic bathers. First etchings for *Le Chef-d'oeuvre Inconnu* by Balzac.
1928	Executes the huge collage *Minotaur* — the forerunner of this figure in Picasso's works of the 1930s. Studio theme appears in his painting, and welded constructions in sculpture (aided by Julio González). Summer at Dinard.
1929	Continues to work with González on sculptural constructions. Paints compositions featuring aggressive biomorphic nudes. Summer at Dinard.
1930	*Crucifixion* based on Matthias Grünewald's Isenheim Altarpiece; continues to work in González's studio. Buys the Château de Boisgeloup, near Gisors. Summer at Juan-les-Pins. Series of etchings illustrating Ovid's *Metamorphoses*.
1931	Continues to work in González's studio and, later, at the Château de Biosgeloup. Summer at Juan-les-Pins. Does engravings that will become part of the Vollard Suite. Images with

Paul Éluard and Pablo Picasso in the painter's studio on the rue des Grands-Augustins. Photograph from 1938.

features of Marie-Thérèse Walter appears in his paintings, drawings and sculptures.

1932 Major retrospective (236 works) in Paris and Zurich. Lives and works at Biosgeloup: the theme of woman (Marie-Thérèse) is combined with motifs of plant life and slumber. Biomorphic/"metamorphic" style. Returns to Grünewald Crucifixion theme in drawings. Zervos publishes the first volume of the Picasso *catalogue raisonné*.

1933 Sculptor's Studio theme in etchings of the Vollard Suite. An Anatomy series of drawings. First issue of the Surrealist magazine *Minotaure* published with a cover designed by Picasso and with reproductions of his works. Lives and works in Paris and Biosgeloup. Summer in Cannes, trip to Barcelona, where he sees old friends. Bullfight and female toreador themes appears in his paintings. Fernande Olivier publishes her memoirs, *Picasso et Ses Amis*. Also published is Bernhard Geiser's *catalogue raisonné* of Picasso's engravings and lithographs.

1934 Paintings, drawings, engravings of bullfights. Six etchings for Aristophanes' *Lysistrata*. Trip to Spain with wife and son. Engravings on the Blind Minotaur theme as part of the Vollard Suite.

1935 Engraves *Minotauromachy*. That summer completely abandons painting in favour of writing. Maia, daughter of Picasso and Marie-Thérèse Walter, born (5 October). Jaime Sabartés, a friend of Picasso's Barcelona youth, becomes his companion and secretary.

1936 Beginning of friendship with Paul Eluard. With support of the Popular Front, a Picasso exhibition and a series of lectures are organized in Barcelona. That spring, at Juan-les-Pins, gradually returns to painting; drawings, watercolours and gouaches on the Minotaur theme. Does engraving for Buffon's *Histoire Naturelle*. Beginning of the Civil War in Spain

Guillaume Apollinaire. Photograph from 1910-1911.

(18 July); the Republican Government appoints him director of the Prado Museum. Spends the end of summer in Mougins: meets Dora Maar (née Markovic), who becomes his mistress. Together they discover the town of Vallauris, a nearby ceramics centre. Works in Vollard's house at La Tremblay-sur-Mauldre. Together with Dora, a professional photographer, experiments with photo techniques.

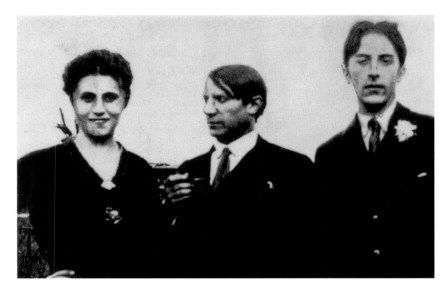

1937 Etches the *Dream and Lie of Franco*. The Spanish Republican government commissions Picasso to paint a mural for the Spanish Pavilion at the Paris Exposition Universelle of 1937. Finds new studio at 7, Rue de Grands-Augustins, where he works on *Guernica* throughout May. Summer in Mougins with Dora and the Eluards. Portraits of Dora and *Guernica* motifs in paintings. Travels to Switzerland in October, where he visits Paul Klee, who is critically ill. Addresses a statement to the American Artists' Congress concerning Franco's propaganda on the fate of Spain's artistic heritage: "Artists who live and work with spiritual values cannot and should not remain indifferent to a conflict in which the highest values of humanity and civilization are at stake."

1938 Makes a wall-size collage, *Women at Their Toilette*. Series of seated women (Dora) and portraits of children (Maia). Summer in Mougins with Dora and the Eluards. Exhibition of *Guernica* and sketches for it at the New Burlington Galleries in London.

1939 Death of Picasso's mother in Barcelona (13 January). Barcelona and Madrid fall. *Guernica* exhibited in America. Death of Ambroise Vollard (22 July). Summer in Antibes, Monte Carlo, Nice, Mougins. Paints large canvas *Night Fishing at Antibes*. Outbreak of World War II finds him in Paris. Leaves for Royan, near Bordeaux, where he stays, on and off,

Olga Khokhlova, Pablo Picasso and Jean Cocteau in Rome. Photograph from 1917.

until December. Major retrospective, *Picasso: Forty Years of His Art*, at the Museum of Modern Art, New York.

1940 Works in Royan and Paris. Returns to occupied Paris, refuses financial aid from the occupation authorities, as well as advice that he had better emigrate to America.

1941 Works in Paris, where he writes, paints, clandestinely has bronzes made of his plaster models.

1942 Death of the sculptor Julio González (27 March). Picasso attacked in the press. Maintains contact with friends in the Resistance. First drawings on the theme Man with Sheep.

1943 Continues to work on Man and Sheep motif, creating drawings and statues. Paints interiors, still lifes, women's portraits. Makes the acquaintance of the young painter Françoise Gilot.

1944 Max Jacob arrested, dies in Drancy concentration camp (5 March). Paints ascetic still lifes and views of Paris, which is liberated on 25 August. Gouache after Poussin's *Bacchanal*. Sees Resistance friends. Opening of Salon d'Automne (Salon de la Libération), where Picasso exhibits 74 paintings and 5 sculptures. Joins the French Communist Party in October, stating this is the logical conclusion of his whole life and work. "I have always been an exile," he explained, "and I have found in [the French Communist Party] those that I most value, the greatest scientists, the greatest poets, all those beautiful faces of Parisian insurgents that I saw during the August days; I am once more among my brothers."

1945 Paints the anti-war *The Charnel House*. In summer leaves for Cap d'Antibes. Is attracted to lithography that autumn, in the studio of the printer Fernand Mourlot. The first lithograph is a portrait of Françoise Gilot. Lithograph of a bull.

Pablo Picasso in his studio in the villa "California". Photograph from 1955-1958.

1946	Painting *Monument aux Espagnols*. Spring at Golfe-Juan with Françoise. Visits Matisse in Nice. Begins living with Françoise Gilot. She appears in his paintings and drawings. Death of Gertrude Stein (27 July). That autumn in Antibes creates works for the Palais Grimaldi, soon renamed the Musée Picasso; the themes include fauns, naiads, centaurs.

1947 Lithograph *David and Bathsheba* after Cranach the Elder. Donates ten paintings to the Musée National d'Art Moderne in Paris. Birth of Claude, first child of Françoise and Picasso (15 May). With Françoise and the baby leaves for Golfe-Juan. Takes up ceramics in Vallauris, revitalizing the ceramics industry of the ancient town.

1948 Completes series of lithographs illustrating Pierre Reverdy's *Le Chant des Morts* and 41 etchings for Gongora's *Vingt Poèmes*. Lives in Vallauris. Together with Eluard, flies to Wroclaw, Poland, for the Congress of Intellectuals for Peace; visits Auschwitz, Krakow, Warsaw; receives Commander's Cross with Star of the Order of the Renaissance of the Polish Republic. Creates paintings, lithographs, ceramics. Exhibits 149 ceramics in November in Paris.

1949 Lithograph of a dove for the poster of the Peace Congress in Paris. This image quickly becomes known as the *Dove of Peace* — a symbol of the struggle against war. Birth of Paloma (19 April), daughter of Picasso and Françoise Gilot. Works on sculptures in Vallauris.

1950 Lives and works in Vallauris. Attends the Second World Peace Conference in Sheffield, England. Awarded the Lenin Peace Prize.

1951 Paints *Massacre in Korea*, exhibited at Salon de Mai, Paris. Most of the time lives in the Midi, works at Vallauris, visits Matisse in Nice.

1952 Panels *War and Peace* conceived for Peace Temple in Vallauris. Creates paintings, litho-

Pablo Picasso in his studio on the rue des Grands-Augustins. Photograph from 1938.

graphs, sculptures; does literary work. Paul Eluard dies (18 November).

1953 Major retrospectives in Rome, Milan, Lyons, São Paulo. Works in Vallauris and Paris. Trip to Perpignan. Separation from Françoise Gilot.

1954 Drawings in Painter and Model series. Portrait of Jacqueline Roque, whom Picasso met a year earlier. They begin to live together. Death of Derain (8 September) and Matisse (3 November). Series of paintings based on Delacroix's *Women of Algiers*.

1955 Death of Olga Khokhlova-Picasso in Cannes (11 February). Major retrospective (150 works) at the Musée des Arts Decoratifs, Paris. Henri-Georges Clouzot's film *Le Mystère Picasso*. Moves with Jacqueline to La Californie, a villa overlooking Cannes.

1956 Paints and produces sculptures in Cannes: portraits, studio scenes, bathers. Major exhibitions in Moscow and St. Petersburg on the occasion of Picasso's 75th birthday.

1957 *The Maids of Honour (Las Meninas)* after Velázquez.

1958 *Fall of Icarus* mural for the UNESCO building in Paris.

1959 Moves to Château de Vauvenargues in the shadow of Mont Sainte-Victoire near Aix-en-Provence. Begins long series of works, using different techniques, on theme of Manet's *Déjeuner sur l'Herbe*. Experiments with linocuts.

1960 Major retrospective in London. Paintings, sketches for "graffiti" and monumental sculpture.

1961 Wedding of Picasso and Jacqueline Roque (2 March). Moves to villa Notre-Dame-de-Vie near village of Mougins, above Cannes. Works on folded and painted metal cutouts.

1962 Awarded the Lenin Peace Prize for the second time.

The great café room "Els Quatre Gats". Photograph from 1899.

1963	Opening of Museo Picasso in Barcelona. Death of Braque (31 August) and Cocteau (11 October). At Mougins, works on engravings.
1964	Works on the model for a giant sculpture to appear in Chicago's Civic Centre. Exhibitions in Canada, Paris, Japan.
1965	Last trip to Paris: operation at clinic in Neuilly. Death of Fernande Olivier. Self-portrait in front of a canvas.
1966	Major retrospective in Paris in honour of 85th birthday.
1967	Paints and draws in Mougins: nudes, portraits, bucolic and circus scenes, artists' studios. Sculpture exhibition in London.
1968	Death of Jaime Sabartés (13 February). In his memory Picasso donates his Las Meninas series to the Museo Picasso in Barcelona. Paints and draws in Mougins: the 347 Engravings series (March-October).
1969	Mougins: paintings, drawings, engravings. Illustrations for *El Entierro del Conde de Orgaz* (*The Burial of Count Orgaz*).
1970	Picasso's relatives in Barcelona donate all paintings and sculptures to Museo Picasso, Barcelona. Some 45 drawings and 167 oils, made between January 1969 and end of January 1970, exhibited at the Palais des Papes in Avignon. The Bateau-Lavoir destroyed by fire on 12 May. Death of Christian Zervos (12 September).
1971	Exhibition in the Grand Gallery of the Louvre in honour of Picasso's 90th birthday.
1972	Continues to work in Mougins: engravings, drawings, paintings. Prepares a new exhibition of most recent works for the Palais des Papes in Avignon.
1973	Exhibition of 156 engravings at Galerie Louise Leiris, Paris. 8 April: Picasso dies at Notre-Dame-de-Vie in Mougins. Buried on 10 April in the grounds of the Château de Vauvenargues.

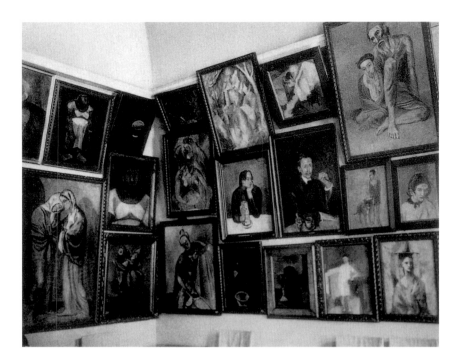

Picasso's room in S.I. Shchukin painting gallery.

Bibliography - Key to abbreviations

G. Apollinaire, *Les Peintres cubists (Méditations esthétiques)*, Paris, 1913.

B. G. Bloch, *Pablo Picasso. Catalogue de l'œuvre gravé et lithographié*, Bern, 1968-1972, vols. 1-3.

A. Barskaya, A. Izerghina, B. Zernov, *The Hermitage. Leningrad. French 20th Century Masters*, Prague, 1970.

M. Bessonova, *Impressionists and Post Impressionists in Soviet Museums*, Aurora Art Publishers, Leningrad, 1985.

A. Blunt, Ph. Pool, *Picasso. The Formative Years*, London, 1962.

E. A. Carmean, *Picasso. "The Saltimbanques"*, Washington, 1980.

J.-E. Cirlot, *Picasso. Birth of a Genius*. New York, Washington, 1972.

P. Daix, *La Vie de peintre de Pablo Picasso*, Paris 1977.

P. Daix, G. Boudaille, *Picasso. The Blue and Rose Periods. A Catalogue Raisonné of the Paintings. 1900-1906*, Greenwich, Conn., 1967.

P. Daix, J. Rosselet, *Le Cubisme de Picasso. Catalogue raisonné de l'œuvre. 1907-1916*, Neuchâtel, 1979.

B. Geiser, *Picasso. Peintre graveur. Catalogue illustré de l'œuvre gravé et lithographié. 1898-1931*, 2 vols., Bern, 1933.

E. Georgijevskaya, I. Kuznetsova, *La Peinture française au Musée Pouchkine*, Leningrad, 1980 (engl. ed.: E. Georgijevskaya, I. Kuznetsova, *French Painting from the Pushkin Museum of Fine Arts, Moscow*, 17th to 20th century, Leningrad, 1979).

A. Izerghina, A. Barskaya, *La Peinture française. Seconde moitié du XIXe-début du XXe siècle. Musée de l'Ermitage, Leningrad*, Leningrad, 1975.

R. Johnson, *The Early Sculpture of Picasso. 1901-1914*, New York, London, 1976.

B. W. Kean, *All the Empty Palaces, The Merchant Patrons of Modern Art in Pre-revolutionary Russia*, Barrie & Jenkins, 1983.

Kubismus. *Künstler, Themen, Werke. 1907-1920*, Cologne, 1982.

Picasso, Masterpieces from the Marina Picasso Collection and from Museums in USA. and U.S.S.R. Tokyo: 2 April-29 May 1983. The National Museum of Modern Art, Tokyo-Kyoto.

Musée Picasso. Catalogue sommaire des collections. Introduction de Mominique Bozo, Paris, 1985.

F. Olivier, *Picasso et ses amis*, Paris, 1933.

J. Palau i Fabre, *Picasso en Cataluña*, Barcelona, 1966 (2nd ed.: 1975).

J. Palau i Fabre, *Picasso. The Early Years*, 1881-1907, New York, 1981.

P. Pertsov, *The Shchukin Collection of French Painting. The Museum of Modern Western Painting*, Moscow, 1921 (in Russian).

Picasso on Art: A Selection of Views (ed. by D. Ashton, New York, 1980).

"Picasso in Retrospect" (adv. editors: Sir Ronald Penrose, Dr. John Golding), "Icon", 1980 (first published: *Picasso, 1881-1973*, London, 1973).

Pablo Picasso. A Retrospective (edited by William Rubin; chronology by Jane Fluegel), New York, 1980.

A Picasso Anthology: Documents, Criticism, Reminiscences (edited by M. McCully), London, 1981.

Picasso's Picassos. An Exhibition from the Musée Picasso, Paris. Hayward Gallery, Londres, 17 juillet-11 octobre, London 1981.

Der junge Picasso: Frühwerk und Blaue Periode (Herausgegeben von Jürgen Glaesemer, Sachberatende Mitarbeit Marilyn McCully), Bern, 1984.

M. Raynal, *Picasso*, Paris, 1922.

L. Réau, *Catalogue de l'art français dans les musées russes*, Paris, 1929.

F. Russoli, F. Minervino, *L'Opera completa di Picasso cubista*, Milan, 1972.

J. Sabartés, *Picasso, portraits et souvenirs*, Paris, 1946.

D. Sutton, P. Lecaldano, *The Complete Paintings of Picasso Blue and Rose Periods*, London, 1971.

W. Spies, *Pablo Picasso. Das Plastische Werk*, Stuttgart, 1971.

G. Tinterow, *Master Drawings by Picasso*, Cambridge, Mass., 1981.

Vercors, D.-H. Kahnweiler, H. Parmelin, *Picasso. Œuvres des musées de Leningrad et de Moscou*, Paris, 1955.

Ch. Zervos, *Pablo Picasso (Catalogue général illustré)*, Paris, 1932-1978, vols. 1-3.

THE COLLECTIONS OF THE RUSSIAN MUSEUMS: HISTORY, PUBLICATIONS

The State Hermitage. Department of Western European Art. Catalogue of Paintings, vol. 1, Leningrad, Moscow, 1958 (in Russian).

The State Hermitage. Western European Painting. Catalogue. Vol. 1: *Italy, Spain, France, Switzerland*, Leningrad, 1976 (in Russian).

The Pushkin Museum of Fine Arts. Catalogue of the Picture Gallery: Paintings, Sculptures, Moscow, 1961 (in Russian).

The Pushkin Museum of Fine Arts. Catalogue of the Picture Gallery: Paintings, Sculptures, Miniatures, Moscow, 1986 (in Russian).

"Catalogue of Paintings by French Artists from the Shchukin Collection", *Apollon*, 1914, Nos. 1-2, pp. 38-46 (in Russian).

S. Makovsky, "French Artists from the Morozov Collection", *Apollon*, 1912, Nos. 3-4 (in Russian).

B. Ternovets, "Le Musée d'Art Moderne de Moscou", *L'Amour de l'Art*, 1925, No. 12.

B. Ternovets, *Letters. Diaries. Articles. Compilation and commentaries* by L. Alioshina and N. Yavorskaya, Moscou, 1977 (in Russian).

Y. Tugendhold, "The Shchukin Collection of French Paintings", *Apollon*, 1914, Nos. 1-2, pp. 5-37 (in Russian).

Y. Tugendhold, *First Museum of Modern Western Painting (Former S. I. Shchukin Collection)*, Moscow-Petrograd, 1923 (in Russian).

Picasso in Russia. Opere del Museo d'Arte Occidentale di Mosca (Album), Rome, 1954.

GENERAL AND BASIC MONOGRAPHS

I. Aksionov, *Picasso and His Environs*, Moscow, 1917 (in Russian).

D. Ashton, *Picasso on Art. A Selection of Views*, New York, 1972.

A. H. Barr, *Picasso. Fifty Years of His Art*, New York, 1946.

F. A. Baumann, *Pablo Picasso. Leben und Werk*, Stuttgart, 1976.

P. Cabanne, *Le Siècle de Picasso*, Paris, 1975, vol. 1.

J. Cassou, *Picasso*, London-Paris-New York, 1940.

G. Chulkov, "Demons and Contemporaneity (Some Ideas on French Painting)", *Apollons*, 1914, Nos. 1-2, pp. 64-75 (in Russian).

P. Daix, *Picasso*, Londres, 1965 (first published Paris, 1964).

C. Roy, D. Vallier, *Picasso* (collection Génies et Réalités), Paris, 1967.

N. Dmitriyeva, *Picasso*, Moscow, 1971 (in Russian).

F. Elgar, R. Maillard, *Picasso*, London, 1957 (first published Paris, 1956).

P. Eluard, *A Pablo Picasso*, Geneva-Paris, 1944.

I. Erenburg, M. Alpatov, *Picasso's Graphic Works*, Moscow, 1967 (in Russian).

A. Fermigier, *A Picasso*, Paris, 1969.

M. M. Gedo, *Picasso. Art as Autobiography*, Chicago-London, 1980.

T. Hilton, *Picasso*, London, 1975.

H. Kay, *Picasso's World of Children*, New York, 1965.

A. Level, *Picasso*, Paris, 1928.

J. Leymarie, *Picasso. Métamorphoses et unité*, Geneva, 1971.

E. D'Ors, *Pablo Picasso*, Paris, 1930.

Palau i Fabre J., *La Extraordinaria vida de Picasso*, Barcelona, 1972.

R. Penrose, *Picasso. His life and work*, London, 1958.

A Picasso Anthology. Documents, Criticism, Reminiscences (ED. BY MARILYN MCCULLY), LONDON 1981.

M. RAPHAEL, *Von Monet zu Picasso*.

P. REVERDY, *Pablo Picasso*, PARIS, 1924.

W. RUBIN, E. L. JOHNSON, R. CASTLEMAN, *Pablo Picasso in the Collection of the Museum of Modern Art*, NEW YORK, 1972.

J. RUNNQVIST, *Minotauros. En Studie i Förhallandet mellan ikonografi och form i Picasso knost, 1900-1937*, STOCKHOLM, 1959.

J. SABARTÉS, *Picasso. Documents iconographiques*, GENEVA.

J. SABARTÉS, W. BOECK, *Picasso*, PARIS, 1956.

G. STEIN, *Picasso*, PARIS, 1938 (ENGL. ED. BOSTON, 1969).

Gertrude Stein on Picasso (EDITED BY EDWARD BURNS), NEW YORK, 1970.

A. VALLENTIN, *Pablo Picasso*, PARIS, 1957.

N. YAVORSKAYA, *Pablo Picasso*, MOSCOW, 1933 (IN RUSSIAN).

A. BANIN, "ABOUT THE REVERSE SIDE OF PICASSO'S CANVAS *The Absinthe Drinker*", *Proceedings of the State Hermitage*, 1978, ISSUE 43, PP. 21-23 (IN RUSSIAN).

A. BABIN, "ABOUT THE PROCESS OF PICASSO'S WORK ON *The Visit*" *Proceedings of the State Hermitage*, 1977, ISSUE 42, PP. 14-18 (IN RUSSIAN).

A. BABIN, "NEW INFORMATION ON THE *Portrait of a Young Woman* BY P. PICASSO", *Proceedings of the State Hermitage*, 1980, *issue* 45, PP. 24-26 (IN RUSSIAN).

A. BABIN, "ABOUT *Girl on a Ball* BY P. PICASSO" IN: *Classical Antiquity. The Middle Ages. Modern Times* (A COLLECTION OF ARTICLES), MOSCOW, 1977, PP. 250-256 (IN RUSSIAN).

D. CHEVALIER, *Picasso. The Blue and Rose period*, LUGANO, 1969.

A. CIRICI-PELLICER, *Picasso avant Picasso*, GENEVA, 1950.

S. FINKELSTEIN, *Der junge Picasso*, DRESDEN, 1970.

A. GRISHCHENKO, *About Relations of Russian Painting with Byzantium and the West*, MOSCOW, 1913 (IN RUSSIAN)

R. JOHNSON, "PICASSO'S PARISIAN FAMILY AND THE *Saltimbanques*", *Arts Magazine*, JANVIER 1977, PP. 90-95.

A. KANTOR-GUKOVSKAYA, "ABOUT PICASSO'S SKETCH IN THE HERMITAGE COLLECTION OF DRAWINGS", *Proceedings of the State Hermitage*, 1981, ISSUE 46, PP. 22-24.

A. PODOKSIK, "DIE ENTSTEHUNG DER BLAUEN PERIODE PICASSO UND DAS PARISER GEFÄNGNIS VON ST. LAZARE", IN: *Picasso (junge)*, 1984, PP. 177-191.

A. PODOSIK, "THE ORIGINS OF PICASSO'S BLUE PERIOD AND THE ST. LAZARE PRISON IN PARIS", *Transactions of the State Hermitage, XXV,* 1985, PP. 128-139 (IN RUSSIAN).

V. PROKOFYEV, "PICASSO. THE FORMATIVE YEARS", IN: *From the History of Classical Art of the West (a collection of articles)*, MOSCOW, 1980 (IN RUSSIAN).

TH. REFF, "THEMES OF LOVE AND DEATH IN PICASSO'S EARLY WORK", IN: *Picasso in Retrospect*, PP. 5-30, 177-183.

CUBISM

D. SUTTON, *Picasso, peintures, époques Bleue et Rose,* PARIS, 1944.

N. BERDIAYEV, "PICASSO", *Sofia*, 1914, NO. 3, PP. 57-62 (IN RUSSIAN).

S. BULGAKOV, "THE CORPSE OF BEAUTY", *Russkaya mysl*, 1915, No. 8 (IN RUSSIAN).

G. BURGESS, "THE WILD MEN OF PARIS", IN: *The Architectural Record*, NEW YORK, MAY 1910, P. 400-414.

P. CABANNE, *L'Epopée du cubisme*, PARIS, 1963.

J. CAMÓN AZNAR, *Picasso y el cubismo*, MADRID, 1956.

D. COOPER, *The Cubist Epoch*, LONDON- LOS ANGELES-NEW YORK, 1971.

P. DAIX, "IL N'Y A PAS 'D'ART NÈGRE' DANS *Les Demoiselles d'Avignon*" IN: *Gazette des Beaux-Arts*, OCTOBER 1970, PP. 247-270.

P. DAIX, "BRAQUE AND PICASSO AT THE TIME OF PAPIERS COLLÉS", IN: *Braque.*

The Papiers Collés, WASHINGTON, 1982, PP. 23-43.

S. FAUCHEREAU, *La Révolution cubiste*, PARIS, 1982.

E. FRY, *Cubism*, NEW YORK-TORONTO, 1966.

J. GOLDING, *Cubism. A History and an Analysis*, 1907-1914, BOSTON, MASS., 1968.

S. GOHR, "FIGUR UND STILLEBEN IN DER KUBISTISCHEN MALEREI VON PICASSO UND BRAQUE", IN: *Kubismus. Künstler, Themen, Werke, 1907-1920*, COLOGNE, 1982.

A. GRISHCHENKO, "CRISIS OF ART AND MODERN PAINTING", *Problems of Painting*, MOSCOW, 1917, ISSUE 4 (IN RUSSIAN).

D.-H. KAHNWEILER, *Der Weg zum Kubismus*, MUNICH, 1920.

D.-H. KAHNWEILER, *Les années héroïques du cubisme*, PARIS, 1954.

J. LAUDE, *La Peinture française (1905-1914) et l'Art Nègre*, PARIS, 1968.

A. MARTINI, *Picasso e il cubismo*, MILAN, 1967.

A. OZENFANT, CH.-E. JEANNERET, *La Peinture moderne*, PARIS, 1925.

A. PODOKSIK, "ON PICASSO'S PAINTING CONCEALED UNDER HIS STILL LIFE *Pitcher and Bowls*", *Proceedings of the State Hermitage*, 1978, ISSUE 43, S. 23-25 (IN RUSSIAN).

A. PODOKSIK, "CONCERNING THE STORY OF *Woman with a Fan* BY PICASSO", *Proceedings* OF *the State Hermitage*, 1980, ISSUE 45 S. 26-30 (IN RUSSIAN).

A. PODOKSIK, "*Queen Isabeau* BY P. PICASSO", IN: *Studies of the Paintings in the Pushkin Museum of Fine Arts*, MOSKAU, 1986, S. 201-220 (IN RUSSIAN).

R. ROSENBLUM, *Cubism and Twentieth-Century Art*, NEW YORK, 1960 (1976, 3rd ED REVISED).

R. ROSENBLUM, "PICASSO AND THE TYPOGRAPHY OF CUBISM", IN: *Picasso in Retrospect*, PP. 33-47, 183-188 (NOTES).

W. RUBIN, "CÉZANNISM AND THE BEGINNINGS OF CUBISM", IN: *Cézanne. The Late Work*, NEW YORK, 1977.

W. RUBIN, "PABLO AND GEORGES AND LEO AND BILL", IN: *Art in America*, MARCH-APRIL 1979, PP. 128-147.

P. W. SCHWARTZ, *Cubism*, NEW YORK-WASHINGTON, 1971.

L. STEINBERG, "THE PHILOSOPHICAL BROTHEL", *Art News*, SEPTEMBER 1972, PP. 20-29; OCTOBER 1972, PP. 38-47.

L. STEINBERG, *Other Criteria*, NEW YORK, 1972.

L. STEINBERG, "RESISTING CÉZANNE: PICASSO'S *Three Women*", *Art in America*, NOVEMBER-DÉCEMBER 1978, PP. 115-133.

L. STEINBERG, "THE POLEMICAL PART", *Art in America*, MARCH-APRIL 1979, PP. 115-127.

L. STEINBERG, "CÉZANNISMUS UND FRÜHKUBISMUS", IN: *Kubismus, Künstler, Themen, Werke, 1907-1920*, COLOGNE, 1982.

M. L. TEUBER, "FORMVORSTELLUNG UND KUBISMUS ODER PABLO PICASSO UND WILLIAM JAMES", IN: *Kubismus. Künstler, Themen, Werke, 1907-1920*, COLOGNE, 1982.

THEATRE

D. COOPER, *Picasso et le Théâtre*, PARIS, 1967.

J. STAROBINSKI, *Portrait de l'artiste en saltimbanque*, GENEVA, 1970.

Index

Academic Study, 1895.	p.8
Acrobat Family with a Monkey, 1905.	p.49
Acrobat on a Ball, 1905.	p.44
Ambroise Vollard, Photograph.	p.110
Bottle of Pernod (*Table in a Café*), 1912.	p.112
Boy Leading a Horse, 1906.	p.52
Boy with a Dog, 1905.	p.39
Chest of a Woman, Study for *Les Demoiselles d'Avignon*.	p.66
Chest of a Woman, Study for *Les Demoiselles d'Avignon*, 1907.	p.63
Clarinet and Violin, 1913.	p.121
Clown with a Young Acrobat, 1905.	p.48
Composition with a Death's Head, 1907.	p.71
Composition with a Death's Head, sketch, 1907.	p.70
Composition: Bowl of Fruit and Sliced Pear, 1914.	p.122
Compotier, Fruit and Glass, 1909.	p.99
Crying Woman, 1937.	p.132
Death of Casagemas, 1901.	p.22
Decanter and Tureens, 1908.	p.91
Luncheon on the Grass (after Manet), 1962.	p.137
Factory in Horta de Ebro, 1909.	p.106
First Communion, 1896.	p.11
Flowers in a Grey Jug and Wineglass with Spoon, 1908.	p.94
Friendship, 1908.	p.77
Friendship, Sketch, 1908.	p.72
Friendship, Sketch, 1908.	p.76
Fruit Vase and Bunch of Grapes, 1914.	p.123
Glassware, Still-Life with a Porrón, 1906.	p.57
Green Bowl and Black Bottle, 1908.	p.90
Guernica, 1937.	p.136
Harlequin and His Companion (*Two Performers*), 1901.	p.17
Head of an Old Man with a Crown (*The King*), 1905.	p.43
Head, Study for *Les Demoiselles d'Avignon*, 1907.	p.62
Horta de Ebro.	p.12
House in a Garden, 1908.	p.93
House in a Garden, 1909.	p.100
Interior Scene: Nude Woman beside a Cat and a Nude Man, 1905.	p.51
La Fermière (full-length), 1908.	p.89
La Fermière (half-length), 1908.	p.88
La Vie (*Life*), 1903.	p.31
Les Demoiselles d'Avignon, 1907.	p.64
Little Horse, 1924(?).	p.120
Man with Crossed Arms, 1909.	p.96
Musical Instruments, 1913.	p.117
Naked Woman, 1906.	p.58
Nude (half-length), 1907.	p.67
Nude in a Landscape (*Dryad, or Nude in the Forest*), 1908.	p.79
Nude Woman Sitting in an Armchair.	p.108
Nude Woman with Crossed Legs, 1903.	p.32
Naked Youth, 1905.	p.54
Nude, 1908-1909.	p.97
Old Jew with a Boy, 1903.	p.37
Pablo Picasso, Photograph, 1904.	p.6
Pierrot and Dancer, 1900.	p.18
Portrait of a Young Girl (*Seated Girl in front of a Fireplace*), 1914.	p.128
Portrait of a Young Woman, 1903.	p.40
Portrait of Ambroise Vollard, 1910.	p.111
Portrait of Jaqueline with Flowers, 1954.	p.139
Portrait of Jaqueline, 1963.	p.138
Portrait of Soler, 1903.	p.34
Portrait of the Artist's Father, 1896.	p.7
Portrait of the Poet Sabartés (*Glass of Beer*), 1901.	p.24
Portrait of Thérèse Walter, 1937.	p.127
Portrait of the Artist's Mother, 1896.	p.10
Poverty-Stricken Woman, 1902.	p.27
Prostitutes at the Bar, 1902.	p.26
Queen Isabeau, 1908-1909.	p.101
Reading Woman, 1900.	p.16
Rendez-Vous (*Embrace*), 1900.	p.15
Self-Portrait (*Head*), 1972.	p.141
Self-Portrait with a Palette, 1906.	p.60
Self-Portrait, 1896.	p.13
Self-Portrait, 1906.	p.61
Sitting Woman with Crossed Legs, 1906.	p.59
Still-Life with Chair Caning, 1912.	p.115
Study of a Nude, Seen from the Back, 1895.	p.9
Tavern (*The Ham*), 1914.	p.125
The Absinthe Drinker, 1901.	p.19
The Absinthe Drinker, 1901.	p.21
The Bath, 1908.	p.83
The Burial of Casagemas (*Evocation*), 1901.	p.23
The Dance of the Veils, 1907.	p.69
The Family of Saltimbanques (*The Tumbler*), 1905.	p.45
The Family of Saltimbanques (*The Tumbler*), 1905.	p.46
The Painter and His Model, 1963.	p.134
The Sculptor, 1931.	p.131
The Soler Family, 1903.	p.38
The Tragedy, 1903.	p.35
The Two Friends, 1965.	p.135
The Visit (*Two Sisters*), 1902.	p.28
The Yellow Sweater (*Dora Maar*), 1939.	p.126
Three Women, 1908.	p.86
Three Women, Sketch, 1908.	p.85
Two Brothers, 1906.	p.53
Two Figures in Profile, and the Head of a Man, Studies, 1901.	p.42
Versions and Projects for *Three Women*.	p.82
Versions and Projects for *Three Women*.	p.84
Violin and Guitar, 1913.	p.118
Violin, 1912.	p.114
Woman Holding a Fan (*After the Ball*), 1908.	p.80
Woman of Majorca, 1905.	p.50
Woman with a Mandolin, 1909.	p.104
Woman Seated (*Nude Woman Seated*), 1907-1908.	p.75
Woman Sitting in an Armchair, 1909-1910.	p.107
Woman with a Fan, 1909.	p.103
Woman with the Head of a Horse (*The Acrobat's Woman*), 1904.	p.29

PICASSO